DIGITAL
NATURE
PHOTOGRAPHY

DIGITAL
NATURE
PHOTOGRAPHY

JON COX

AMPHOTO BOOKS
an imprint of Watson-Guptill Publications
New York

Jon Cox is a photographer, writer, and instructor who spends his winters and summers teaching nature/wildlife photography courses for the University of Delaware. His teaching destinations have included Tanzania, Antarctica, and the national parks of both the United States and Canada. During the remainder of the year, he is on staff with *Digital Camera* magazine as their adventure photographer/writer, and he also owns a freelance digital photography business. When not traveling, he photographs the natural world near his home in Unionville, Pennsylvania.

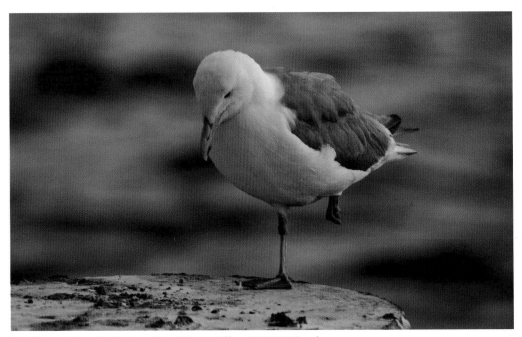

Gull, Edmonds Ferry, Washington. Nikon D1X with Nikkor AF VR 80–400mm lens

Text and photographs copyright © 2003 Jonathan Cox
First published in New York in 2003 by
Amphoto Books, an imprint of Watson-Guptill Publications,
a division of VNU Business Media, Inc.
770 Broadway
New York, NY 10003
www.amphotobooks.com

Library of Congress Cataloging-in-Publication Data
Cox, Jon, 1975–
 Digital nature photography / Jon Cox.
 p. cm.
 Includes index.
 ISBN 0-8174-3791-6 (pbk.)
 1. Nature photography. 2. Photography—Digital techniques. I. Title.
TR267 .C69 2003
778.9'3—dc21

 2002151855

Printed in Singapore

4 5 6 7 8 / 10 09 08 07 06

Page 1: Wolf (captive), Bear, Delaware. Nikon D1X with Nikkor AF VR 80–400mm lens

Pages 2–3: Sunrise, Grand Teton National Park, Wyoming. Nikon D1X with Nikkor 28–70mm 1:4.5 macro lens

Page 5: Hay bales in frost, Unionville, Pennsylvania. Nikon D1X with Nikkor 28–70mm 1:4.5 macro lens

Front cover: Lake Jenny, Grand Teton National Park, Wyoming (see page 64 for camera information). *Back cover (clockwise from top left):* Emerald tree boa (captive), Baltimore Aquarium, Maryland (page 129); Bull elk, Yellowstone National Park, Wyoming (page 107); Sea star, Olympic National Park, Washington (page 45); Elephants, Tanzania (page 134); Wildflowers, Grand Teton National Park, Wyoming (page 62)

Senior Editor: Victoria Craven
Project Editor: Alisa Palazzo
Designer: Jay Anning, Thumb Print
Production Manager: Hector Campbell

To Susan Baldwin—who gave me my first shot and has helped me every
step of the way—thanks for being my mentor, inspiration, and friend

Lemarie Channel, Antarctica. Nikon D1X with Nikkor 28–70mm 1:4.5 macro lens

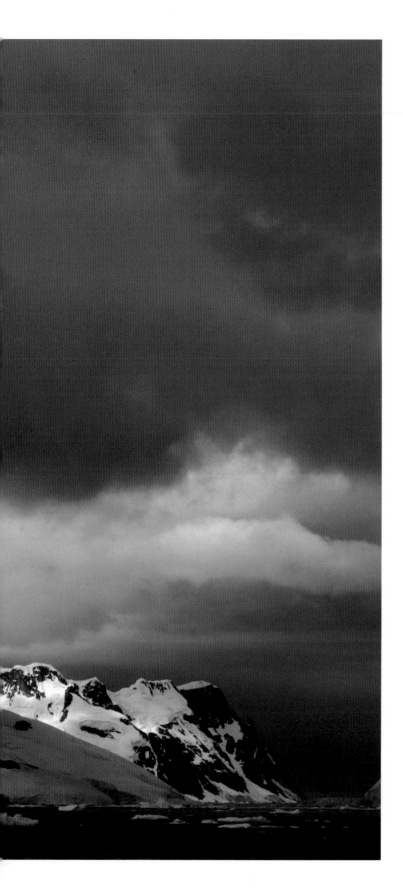

CONTENTS

PREFACE

I spent most of my childhood exploring the countless facets of nature: collecting insects and snakes, and watching an abundance of creatures interact with their environment. My love of nature led me to study the natural sciences throughout my college career. At the age of twenty-one, I enrolled in a wildlife photography course and purchased my first 35mm SLR camera, the Pentax K1000. From this point, I knew what I wanted to do with the rest of my life: photograph nature.

After graduating with a bachelor's degree in entomology and plant pathology, I began working as an arborist, diagnosing diseases of trees and shrubs for a local tree company. My goal was to work for eight years, save enough money to quit at the age of thirty, and follow my dream of becoming a nature photographer. Well, I lasted only a year and half when I left the arborist position to become a part-time photographer for the University of Delaware.

Wanting to introduce the school's photography system to the new digital age, I purchased the new Nikon Coolpix 950. I fell in love with the new technology. It's rare for me to shoot a roll of film nowadays. In fact, I've shot only five rolls in the last two years.

I spend my winters and summers teaching nature/wildlife photography courses for the University of Delaware in Tanzania, Antarctica, and the national parks of the United States. During the remainder of the year, I'm on staff with *Digital Camera* magazine as their adventure photographer/writer. I also run a freelance digital photography business shooting a variety of subjects.

The advanced technology of digital nature photography has taken me out of the office and brought me closer to nature. I take my laptop into the field, which gives me my own twenty-four-hour darkroom, film processor, and CD burner (to make sure I have a hard copy of my images). With everything at my fingertips; my only worry is whether or not I've brought along enough food to sustain myself in the backcountry.

My goal as a nature photographer is to introduce as many people to the natural world as possible. The more that people see and understand nature, the more likely they are to help preserve it. As stewards of the Earth we must conserve and protect what we have left—not only the endangered pandas and tigers of the world, but the creatures that live in our own backyards.

Wildflowers, median strip on Route 301, Maryland. Nikon D1X with Nikkor 28–70mm 1:4.5 macro lens

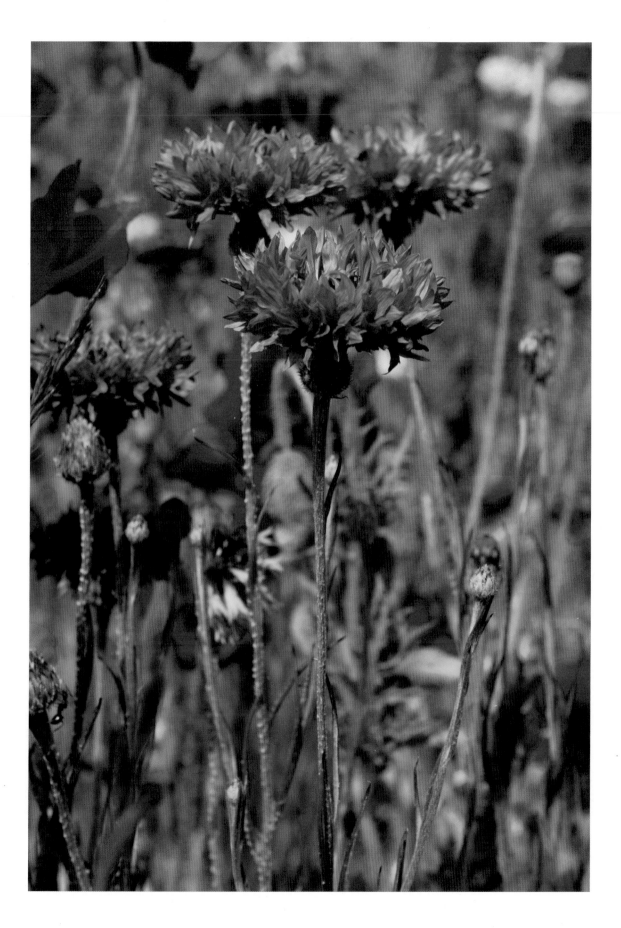

INTRODUCTION

I used a variety of digital cameras—from the 2.54 Megapixel Nikon Coolpix 950 to the 5.47 Megapixel Nikon D1X—to shoot all the images in this book. For years, many photographers involved themselves in only part of the photographic process. If they shot negatives or slides, they would most likely send the film away to a lab for processing and prints. With the advent of the digital camera, even beginning photographers can be in charge of the entire photographic process just as professional photographers have been for over a hundred years.

As a digital nature photographer, you capture the scene, download your shot, adjust for quality, and print out the photograph. Seeing your image through the entire photographic process is gratifying—and very possible with today's digital technology.

I'm going to guide you through the stages needed to capture, print, and store your digital nature images for years to come. My book teaches the reader to shoot in a variety of lighting situations using a variety of digital photographic techniques. Since every camera is different, this book will not teach you how to use the settings on your specific camera; rather, it offers a guide on how to use the general settings on many cameras to consistently capture fabulous digital nature images. I am not promoting certain cameras or equipment. I take you through the process I go through to capture images like the ones you'll see in these pages.

Each new line of digital cameras features greater resolution and more options to put the creativity in the hands of the photographer. However, the skills of how to approach a digital nature shot and of understanding how light affects a subject will remain constant, regardless of camera brand. The book is organized so that the reader starts with the chapter on equipment, moves to chapters on basic techniques and lighting, working through to the chapter on composition. After an

Cattails with spiderweb, Unionville, Pennsylvania. Nikon D1X with Nikkor AF VR 80–400mm lens

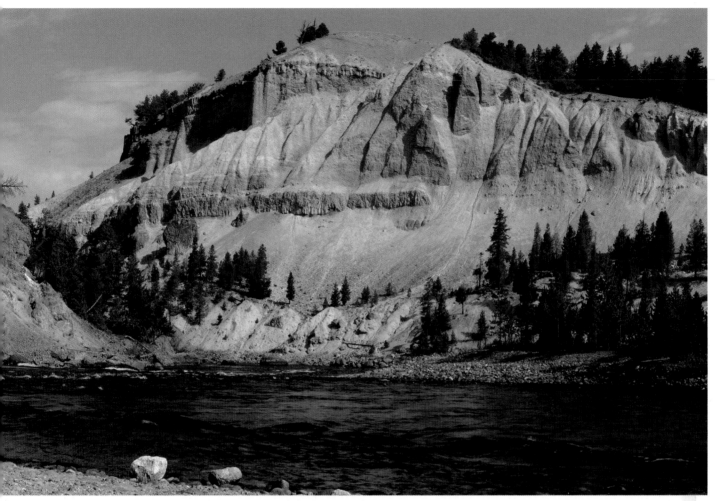

Yellowstone National Park, Wyoming. Nikon D1X with Nikkor 28–70mm 1:4.5 macro lens

understanding of these subjects is reached, chapters on more specific topics—on the making of particular types of images—follow, and these can be read in any order to enhance the basic skills.

Aside from a deeper appreciation of nature, the next best thing about being a nature photographer comes from learning how to view light. Say you're stuck in a traffic jam on your way home from work. Suddenly a calming effect settles. You gaze at the setting sun, taking in the surrounding silhouettes and saturated colors. While you may not have your camera handy, you'll have a better ride home.

WHICH CAMERA AND WHY DIGITAL?
You will find plenty of good digital cameras on the market. You just have to pick the one that suits your needs and price range. You don't need a top-of-the-line camera to capture a great shot, and having a top-of-the-line camera doesn't mean you will capture a great shot. I started using my first digital camera, the Nikon Coolpix 950, in May of 1999 and have continued to use Nikon's line of digital cameras. I have been very happy with the results and the advancements Nikon makes with each new line. Nikon also makes most of my digital camera gear; and I do buy all of my own equipment.

Why use a digital camera? At the end of my 35mm wildlife photography courses, I ask my students the same question: If you found a bundle of cash washed up on the beach, what piece of photography equipment would you buy and why? Nearly 100 percent of my students answer, One of those cool digital cameras you have so that I can see the results immediately. I agree. This is, by far, the finest aspect of a digital camera. Subject allowing, you can shoot all day until you capture the image you want. You can also erase as many shots as needed, saving memory for another subject.

By seeing the image immediately, you have exponentially increased your learning curve. You don't have to take your film to be developed then wait a day or two to see the results and figure out how you would have changed the settings to capture the image. Seeing the image immediately allows you to make adjustments while the light falling on the subject stays virtually the same. Photographers use digital cameras for many other reasons, which will pop up throughout the book, so keep reading.

CHAPTER ONE

Working in the field

EQUIPMENT

J UST AS I USE A PROCESS for shooting digital nature photographs, I use a process for choosing equipment. I'll tell you what equipment I use and why. What I carry in my bag today is different from what I carried a year ago and will probably be different from what I carry a year from now. However, my logic remains constant: I use the best tool for the job without being too extravagant.

HOW A DIGITAL CAMERA WORKS

With the advent of any new technology there arises a slew of fresh and often confusing terminology: artifacts, ppi, dpi, CCD, for example. You may not care about any of these words and acronyms until you're faced with having to understand them to purchase new equipment. While you may prefer to spend your time in the field shooting images, you need to know what terms mean to make an educated decision on your next piece of imaging gear. I have included a glossary in the back of the book so you can easily look up a term to understand the new digital photography lingo.

Digital cameras record light by using sensors on the CCD, or charge-coupled device. Once the sensors capture light, the information is stored on the digital media (see page 16) as pixels, a term coined from the words picture elements. The more sensors arranged on a CCD, the higher the resolution. Resolution determines quality; the higher the resolution, the higher the quality. Pixels measure camera resolution, which is determined by multiplying the number of horizontal pixels by the number of vertical pixels. For example, a digital camera with 1,000 x 1,500 pixels has a resolution of 1,500,000 or 1.5 megapixels.

DIGITAL VS. 35MM

Is digital photography more expensive than 35mm SLR photography? If you compare the equipment needed for digital photography with 35mm photography equipment, you'll find that digital equipment costs more. However, the savings comes in when you compare the cost of film to the cost of reusable digital media (see page 16).

Since 1999, I've taken about 150,000 digital images—the equivalent to shooting 4,166 rolls of 36-exposure slide film. At a cost of $12 for the film and developing, it would have cost me $49,992. My digital gear—including computers, cameras, tripods, flashes, lenses, bags, and printers—is worth about $19,000. By going digital, I've saved over $30,000 in three and a half years. For $30,000, I could trek to all seven continents. The more images you take, the more money you'll save if you compare digital photography with film.

Antarctic storm. Nikon D1X with Nikkor 28–70mm 1:4.5 macro lens

Being able to view your image on the camera's LCD screen is an indispensable tool when shooting images with high contrast; I was sure I had captured the exposure I wanted.

CAMERAS

With so many good cameras on the market, you have to pick one within your price range that meets your needs. I've taken shots with a consumer camera that costs under $1,000 and has fewer features (my Nikon Coolpix 950) that I like just as much as images I've taken with a professional camera costing around $5,000 with more features (my Nikon D1X). You don't have to spend a ton of money on equipment to capture a great shot; however, an advanced digital camera system can open up a world of photographic possibilities.

I'm not an equipment junkie. Rather, I go the cheaper route and see how to make the camera gear work for me. That's not to say I don't have a lot of digital camera gear. I do, but only because I need it. When I find my equipment no longer fulfills my expectations and begins to limit me creatively as a photographer, I upgrade my system. I'm not going to sneak up on a lion with my 28mm wide-angle lens to capture a close-up—risking not only my life but also stressing out the animal—just so that I can have a shot to take home. I'm going to use a lens in the 400mm range to get close without endangering either of us.

Buy a camera that allows you the freedom to manually adjust all the settings to capture exactly what you want and not what the camera wants. If you buy a point-and-shoot digital camera, you limit yourself creatively. Even with a device as advanced as a digital camera, we, the photographers, have the artistic eye, not the camera. You must be able to override the camera's choices with manual settings when the need arises. I also suggest buying a camera with the highest resolution you can afford. A high camera resolution will allow you to print a larger size image, thus not compromising the quality of the image.

This is not to say that a high resolution is the only feature to look for in a digital camera. You have to look at all the aspects: size, battery power, digital media, and accessories. If you have large fingers, a compact model on which the buttons are extremely close together may be difficult for you to operate. On the other hand, maybe you just want something you can put in your bag or pants pocket. You wouldn't go into a car dealership and buy the first car you see. Take the same time to consider all aspects before purchasing a digital camera.

CAMERA CARE

Once you have your camera, you need to know how to care for it. You've invested a lot of time and money into your camera, so treat it well. To remove particles of dirt or dust, use a blower brush. Then, wipe down the camera with an older microfiber cloth that's no longer suitable for cleaning lenses. Although I have seen ads that say you can wash these cloths, I don't recommend it, because the cloths could pick up grit from the washer and scratch your equipment. Also, I recommend taking the batteries out of the camera if you aren't going to use it for a couple of days. Storing your batteries in your camera can lead to corrosion—a big headache—which takes a chunk out of your wallet to fix.

Under extremely dusty, rainy, or salty conditions, use a transparent plastic bag to cover your camera, punching a hole out for the end of the lens. You can still operate the controls through the bag as long as you can see them. I was shooting on the Olympic National Park coastline in Washington State when a storm blew in, sending sand and salty air all over the place. Since I wanted to capture the moment and didn't have a bag handy, I took my chances and pulled out my camera in the midst of all the chaos. Well, I didn't have the ace in my hand that day. Sand found its way into my camera's little facets, destroying the manual adjustments. Worse yet, I never got the shot I wanted, and I had to have a new camera sent overnight to me, wrecking my shooting plans for the following two days. Learn from my experience. If you are going to take on Mother Nature's wildest moments, be prepared with a plastic bag. If you are using a professional digital camera with interchangeable lenses, make sure you clean the CCD. If you don't, you may have dust particles that stick to it and cause black spots on all of your images.

DIGITAL MEDIA, CARD READERS, AND PORTABLE STORAGE DEVICES

Since there are many different types of digital "films," including memory sticks, smart media, compact flash cards, and IBM microdrives, I will refer to the storage devices for digital images as digital media. The more megabytes of data your digital media can store, the more images you'll be able to shoot without having to change the storage device or download your shots. The type of camera you chose will, ultimately, determine what type of digital media you purchase. The IBM microdrive and the compact flash cards currently have the greatest storage capacity. I use compact flash cards because they are virtually indestructible and can hold a large amount of data. Even a Lexar Media compact flash card that I accidentally sent through the washing machine still works. I don't recommend a dip in the wash cycle, but it's astounding it wasn't harmed—something you wouldn't be able to say about 35mm film.

Buy more than one digital storage device for your camera; these devices occasionally become corrupted and won't work. This is not to say the data is lost; Lexar Media and DriveSavers Data Recovery (see Resources on page 158) can recover data from a card that cannot be read. Instead of just erasing your images to clean out a card, format it to be sure the card isn't corrupted in any way.

Don't turn your camera off or remove a card until you save the shots onto the digital media. Also, avoid sending your digital media through the United States mail; the government has been irradiating it since September 11, 2001, so use a carrier that doesn't irradiate packages.

Once you fill up your digital media, you need to download the images onto your computer. There are a variety of methods for this; USB and FireWire cables directly connected to the camera are my preferred methods. However, you may not have this option, in which case you need an additional card reader to connect to your computer. Small and fairly inexpensive, some card readers can read a variety of digital media types. If you're in the field and don't want to take along a laptop, you can purchase a portable storage device that can currently store as much as 40 gigabytes. If you travel, these devices are an excellent means of storing digital images, and the savings are tremendous.

▲ A Maasai warrior holds two Lexar Media compact flash cards, demonstrating how portable they are.

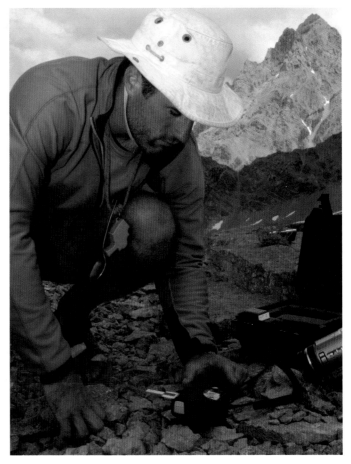

▶ Twenty-five miles from the nearest AC power source, Benjamin Kuprevich (a professional backcountry guide) downloads his digital images onto the Image Tank (a portable hard drive used for storing images). Over the course of a six-week backpacking trip, he took over 12 gigabytes of digital images and video, all of which he stored on the Image Tank. After a trip, you can hook up the portable storage devices directly to your computer and use it as an external hard drive.

BATTERIES

Don't fool yourself by purchasing disposable batteries for your digital camera. Digital cameras are power-hungry little machines, and they will undoubtedly eat you out of house and home if you don't buy rechargeable batteries. I use car chargers, solar chargers, and AC chargers for my array of rechargeable batteries. I keep my batteries on a constant charging rotation so that I'm never without power in case a photo opportunity arises.

Along with an array of digital camera batteries, I also have three extra batteries for my laptop, which I carry on extended photo trips. You never get as much time or as many shots as the camera and battery manufacturers claim, so pack more than you think you'll use. There's nothing worse than being in the right place at the right time with plenty of memory on your digital media and then running out of juice. On a wildlife photography course in Tanzania, one of my students, after only three days into the trip, said his camera's meter wasn't working. After checking it, I discovered it was just the battery. And, guess what? He forgot to pack extras. Finding a camera battery in the United States is often difficult, but finding one that fits your camera in remote parts of the world is nearly impossible. If you travel abroad, determine how many extra batteries you think you'll need, then bring double that amount to make sure you have enough power.

Recharging all of your batteries on the road is often difficult. I like to stop at mom-and-pop places to try a little local cuisine. I often ask if I can use an electrical outlet, while I eat, to recharge some of my batteries. No one has ever said no. In fact, my asking usually results in an engaging conversation. When I travel out of the country, I always carry my multi-AC power adapter that covers almost all types of power sources. When planning travel abroad, check the power source of the country in which you'll be traveling so that you are electronically prepared.

If you're going to be in the backcountry for an extended period of time, you might want to try the Solar Battery Charger by ICP Technologies. This device charges cell phones, boat and snow mobile batteries, and of course AA batteries.

FLASH

Once you find that the sun and moon are no longer adequate for all of the shots you want to capture, you will want to purchase an external flash. Make sure the flash you purchase is compatible with your digital camera.

The technology of TTL (through-the-lens) flash metering makes flash photography much easier than in the past. You can use filters and extension tubes, and shoot from various distances using a variety of *f*-stops and shutter speeds; the exposure will be the same provided the flash is within range. This occurs because a meter in the camera reads the available light entering the lens, then the camera tells the flash how long to stay on to illuminate the subject to capture the correct exposure. The flash and camera are communicating with each other, leaving you to focus on your subject. Many of these "smart" flashes still offer the option of switching to a manual setting when you want to be in total control of the flash output.

If you have ever used a manual flash with a light stick, you'll be shocked by the results of a TTL flash system. If you haven't used a manual flash, consider yourself lucky, and take full advantage of this TTL technology. You can either soften contrast or create deep shadows, depending on the effect you want. That's what's so great about flash. Unlike with the sun or moon, you are in control of the position and illumination of the light hitting your subject.

FLASH BRACKETS

Now that you have a flash or, shall I say, your own personal miniature sun, you need a bracket to put in on. This will allow you the creative freedom to position the flash instantly at various angles, as well as provide the flexibility to change from landscape to portrait to close-up mode without having to remove the flash from the bracket. You'll also want immediate access to the batteries and digital media, and to have the option of using the bracket on a tripod.

There are plenty of brackets on the market; however, I use one I designed myself specifically for the Nikon Coolpix 990 and 995, and one I designed for the Nikon D1 series. The problem I've found with many brackets is that they work fine for most cameras, but unless they are specifically designed for your camera, they might not work well enough for you to be satisfied with the results.

Research the market before you commit to a flash bracket for your camera system. Don't end up like me, with four extra brackets that I never use. Unlike fine wine, flash brackets don't get better with age, but I just can't bring myself to throw them out.

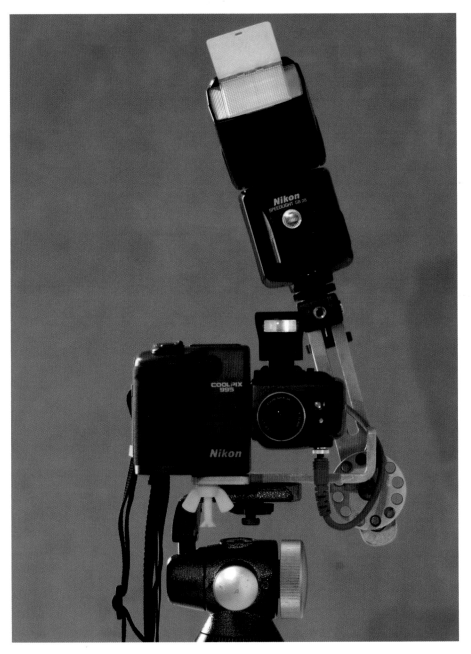

Nikon Coolpix 995 with flash, flash bracket, and Gitzo ball head.

TRIPODS

I've heard every excuse in the book. I have even used some of the excuses myself: A tripod is a pain to set up. It's too heavy. I just don't need it today. No matter what the excuse, your images won't be as good as they could be unless you use a tripod. A tripod not only supports the camera to avoid photographer shake, it also aids in composition, enabling you to make slight adjustments.

Just as digital camera designs are constantly evolving, something as seemingly simple as a tripod also changes. I used to say, Buy the heaviest tripod you can afford. I have changed my mind. Buy the most comfortable and easy-to-use tripod that suits your camera system. By this however, I do not mean buy the cheapest tripod you can find, because, most likely, it will either break or you'll never use it because it's awkward to maneuver.

Obviously, if I'm shooting with my lighter Nikon Coolpix, I don't need a tripod that weighs a ton. However, if I'm using my larger, heavier Nikon D1X with a 400mm lens, I need a tripod that will support the added weight. Since most of my photography excursions involve backpacking into remote places, I opt to use a lightweight Bogen carbon fiber tripod with a Gitzo ball head. I am able to position my tripod close to the ground, which is essential for many close-ups. The ball head is extremely versatile for almost any camera angle. The carbon-fiber material, despite its light weight, can support up to 13 pounds of camera gear. I compensate for lack of weight in the tripod by simply hooking my camera bag or backpack to the center tripod column to add additional support to the tripod when I'm using my heavy equipment. This method of adding extra support will work for almost any tripod.

Before you buy a tripod, take your digital equipment into the camera shop and ask to try out different tripod models with your equipment. If you have more than one camera, you may want to think about buying a tripod head with a quick-release option. Look for comfort and ease of use. If the tripod you own isn't easy to maneuver and comfortable to handle, you won't use it.

Take care of your tripod just as you would care for your lenses or camera. A good tripod will last a long time, and it is a substantial investment. I completely take apart my tripod at least once a year—and even more if I've been shooting along the coast. Salt water and sand are brutal on all types of gear. I soak all the metal parts in a lubricant and wipe down the legs with hot soapy water, making sure I remove all dust and grit caught in the nooks and crannies. After I put everything back together, I lubricate all the parts with Tri-Flo Teflon lubricant (see Resources for supplier).

Most importantly, think of your tripod as your best friend, and take it on every photo shoot you can. No matter how hard you look, you won't find a camera support that is as versatile as a good tripod. If you haven't used a tripod yet, try one. You'll be surprised at the increase in the quality of your images.

Using a tripod in the field.

LENSES

A typical pocket-sized digital camera has a zoom lens with a focal length range of 30–100mm. Many digital cameras have additional lenses you can purchase to either zoom in closer or capture a wider view. Before choosing a digital camera system, check to see if you will be able to purchase additional lenses with it to broaden your photographic possibilities.

If you purchase a digital SLR (single-lens-reflex) camera, the focal length of the lens may be different than if you used the same lens on a 35mm SLR film camera. This is because the picture angle can be different when using digital cameras. Since each camera brand is different, you will have to check what your lens conversion will be.

No matter what type of camera system you own, the reason for purchasing an additional lens will most likely be the same: to capture a view that your current lens simply can't attain. If I want to capture a wide-angle view of the sunrise in Badlands National Park, South Dakota, I'm not going to just back up farther to, say, Wyoming to encompass more of the drip castle formations. A wide-angle lens makes it possible for me to stay at camp and enjoy my morning coffee while I shoot the rising sun. If I want to capture a close-up of a female grizzly bear feeding on an elk with her cubs, I cannot walk up with my 100mm lens; chances are I would not be walking back. It's much better to use a 400mm lens. Better yet, to add a 2X teleconverter to stay even farther away.

You don't have to purchase all your lenses right away. In fact, you don't have to purchase any right away; you can rent lenses from a local camera store to see if you actually need them in your arsenal of camera gear. You may never need a 400mm lens for the subjects you shoot. You also may find you don't need a wide-angle lens. A good range with which to start is exactly what equips most pocket-sized digital cameras, which is 30–100mm.

If, however, you long to include more of the scene, you'll want a wide-angle lens. I suggest a lens in the 17–35mm zoom range. On the other hand, if you find you constantly want to get closer to your subject, purchase a zoom in the area of 70–210mm. To get closer still, a 200–400mm lens and even a 1.4X or 2X teleconverter will do the job.

The teleconverter is placed between the camera body and the lens. A 2X teleconverter will increase the focal length two times: for example, a 400mm lens with a 2X teleconverter will become an 800mm lens. However, a 2X teleconverter will cost you two stops of light, which means you either increase the ISO setting, decrease the shutter speed, or use a larger aperture.

Instead of bringing your subject closer, you may want to increase its size. Many pocket-sized digital cameras have a built-in close-up mode. I have been delighted with the close-up mode results of the Nikon Coolpix 990 and 995. If your digital camera doesn't have a close-up mode, you may be able to use a macro lens. If you're using a digital camera with detachable lenses, you can also use extension tubes to increase the size of a subject by focusing closer. Extension tubes are hollow tubes placed between the camera body and the lens that magnify the size of a subject.

Another hollow tube used in photography—a lens hood—fits directly on the end of your lens to reduce flare caused by light directly hitting the glass element. A lens hood can also provide additional protection for the lens by blocking tree branches and briars that would scratch the glass.

Even in today's digital world, you can purchase manual lenses that will work with your camera model. However, if your camera system allows, take full advantage of autofocus, focus-tracking, and vibration-reduction lenses. These technologies allow countless new possibilities for nature photography.

An autofocus lens system automatically focuses on the subject or area at which you aim. Many digital cameras allow the photographer to select a particular area of the frame on which to focus. These focus-area selections allow the photographer to compose a subject in an area other than the center of the frame. If you shoot in the close-up mode, you may want to turn the autofocus off to prevent the camera from controlling the shot.

BAGS

Now that you have all this great new digital camera equipment, what are you going to carry it in? I use a few different camera bags, depending on what and where I'm shooting. If I'm out for just the day in a canoe, I have a small, watertight Pelican case (see Resources), which fits my Nikon Coolpix, SB-28 flash, and extra batteries. In a canoe on multiday excursions, however, I carry my gear (including my laptop) in a large watertight Pelican camera case. I carry Roadwired's pro-photo bag when taking all my equipment, and believe me, it holds it all. I take this bag on trips around the world, and I have always been able to use it as a carry-on. If I'm heading to the office or just out for the day, I carry my megamultimedia bag made by Roadwired, which holds my laptop and the various computer cables and adapter I need for presentations.

As with the rest of your equipment, make sure you clean your bag. Most of the time I just need to vacuum it out, but every once in a while I use a light soapy solution to remove dirt.

A few questions to consider when buying a camera bag are: Is it weather resistant? Will it fit all of your gear? Is it comfortable to carry? And, most of all, does it squeak? There's nothing worse than a bag that squeaks every time you take a step.

Focus tracking allows the photographer to lock onto a subject and follow it with the camera. The subject will stay in focus as long as the shutter is depressed half way. This feature is ideal for shooting a flying bird, a running gazelle, or a jumping frog.

A lens with a vibration-reduction setting comes in handy if you don't have a tripod and there's not enough available light to use the handheld rule (see page 39). The Nikkor 80–400mm VR lens I use allows me to shoot at a shutter speed of three stops lower than the handheld rule states. The lens detects photographer shake and combats it by reducing the vibration. A long, heavy zoom lens requires a tripod collar, which attaches to the lens and then attaches directly to your tripod. This creates a better center of gravity for the lens and places less of a strain on the camera body.

The lens hood reduces flare and provides protection for the lens, here an 80–400mm VR zoom.

The extension tube fits between the camera body and the lens, in this case a 28–70mm macro.

LENS CARE

First and foremost, never—and I mean *never*—use your T-shirt to wipe off your lens. A T-shirt or any piece of your clothing is filled with sweat, oil, and general grime—at least my clothes are! Instead of using your clothing, invest a few dollars in a can of air and a microfiber cloth. These are far superior to lens tissue, and you can use them multiple times. When my microfiber cloth is past its peak for lens use, I use it to wipe down the rest of the camera. I keep the new and old cloths in two separate bags so that I don't confuse them. If your microfiber cloth won't take a smudge away, use a drop of lens cleaner to remove the spot. Never use your breath or saliva to clean a photographic lens. Mouths are full of bacteria and enzymes that can degrade the protective coating on a lens.

I deliberately disobeyed the handheld rule and used a shutter speed three stops slower than I would have needed to capture the top image sharply. The image is blurry, just as I suspected it would be. When I turn on the vibration-reduction setting (bottom), I'm able to handhold the camera and use a shutter speed three stops slower than the handheld rule states.

Pheasant, Unionville, Pennsylvania. Nikon D1X with Nikkor AF VR 80–400mm lens extended to 400mm, *f*/5.6 at 1/60 sec. with vibration reduction setting off (top) and on (bottom)

FILTERS AND SHUTTER-RELEASE CABLES

I don't often use filters. I can easily add a warming or cooling effect with the camera's metering system or in Photoshop, which I will discuss in the lighting techniques and manipulation chapters. However, it's always easier to capture a good image initially, instead of trying to retouch the image to make it work. In some instances, a filter added to the lens will capture effects you would never be able to mimic using Photoshop or your camera's technology. Picking the right filter for the right situation can be confusing. Understanding what each filter does and how it is used is vital before attaching an extra piece of glass to the end of your lens.

UV FILTER

A UV filter is for general use, protecting the lens, and absorbing ultraviolet rays. The absorption of UV rays results in images with increased contrast and decreased haze. Another advantage to the UV filter is that it doesn't cost the photographer any light and can be used in almost any situation. You can use it all the time as long as you keep it clean, and it can save your lens if something happens (for example, a branch hits your lens, or you trip and land on your camera). Think of a UV filter as an insurance policy; it's much cheaper to replace a damaged filter than it is to replace an entire lens.

POLARIZING FILTER

A polarizing filter increases color saturation, reduces reflection, and darkens a blue sky. A circular polarizer will allow you to change the amount of polarization by turning the filter until you get the desired result. Sounds like a photographer's dream come true, right? However, polarizers do cost light. For best results, keep the subject perpendicular to the sun. Point your left arm at the sun and your right arm at the subject; when they form a right angle, you're in the best position to use a polarizer. Polarizers are most often useful during sunny days to emphasize clouds, remove highlights on foliage, and saturate the color of the image. A sunny summer day spent canoeing on a lake, for example, provides a perfect situation to break out the polarizer. Since polarizers reduce reflection, they also are ideal for use in an aquarium or at a zoo, where glass can reflect light and cause lens flare.

NEUTRAL-DENSITY FILTER

A neutral-density filter reduces the ambient light without compromising the rendition of color. A few neutral-density filters are available, differing only in the amount of light they reduce. Use the neutral-density filter when there is too much ambient light. How can there be too much light? When trying to show motion in an image, there may be too much light for the slow shutter speed. For example, when trying to blur water cascading over rocks, I use a shutter speed of 1/30 sec. or lower. Even at an f-stop of f/11, on a sunny day, the image will be grossly overexposed. Popping on a neutral-density filter will reduce the amount of light, which enables me to use a slow shutter speed and capture a silky effect in the water.

SHUTTER-RELEASE CABLES

A shutter-release cable eliminates photographer shake. Photographer shake occurs when the photographer moves the camera while depressing the shutter button, which causes a blurring effect in an image. The shutter-release cable connects directly to the camera, allowing the photographer to take the shot by pressing a button at the end of the shutter-release cable rather than pressing the shutter button on the camera. This is a very useful tool for shooting long exposures or when positioning yourself away from the camera.

If your camera is on a tripod and you have a shutter-release cable, use it. Anything you can do technically to increase the odds for capturing a great shot is worth doing. If your camera doesn't have the option of using a shutter-release cable, use the timer to eliminate photographer shake. The drawbacks to using a timer are that it requires more battery power and there's a delay between the time you press the shutter and the time the camera captures the image.

COMPUTERS

Like the legendary rift between the Hatfields and McCoys, there is a long-standing feud between PC and Mac users. I'm definitely a McCoy; I am devoted to Macintosh computers. I use the Mac G4, the imac, and the ibook. My current favorite computer is the ibook with the built-in CD burner, which gives me the versatility and speed for our fast-paced society. Often, I'm on a shoot for a local magazine or newspaper that needs the shots the same day. I can get the images, immediately burn them onto a CD, and drop them off for press or e-mail them without ever having to stop by the office. I can also spend the day in the park writing articles, doing my taxes, or editing images. If I'm on a seventeen-hour flight to South Africa, I can take along a DVD to watch or a couple of CDs to listen to.

Before you purchase a new computer, gather all the information. How fast is the processor? How much data can you store on the hard drive? Is the system easy to upgrade? Is there a built-in CD or DVD burner? Does it have FireWire and USB ports? How big is it? How much does it weigh? And, most of all, how much does it cost? Like digital cameras, computers are evolving at an incredible rate. The processors keep getting faster, the hard drives store more data, the physical sizes are getting smaller, and the prices seem to keep dropping.

IMAGING PROGRAMS

Many computers are sold with imaging software. You may find that you only want to crop, rotate, and change the brightness and contrast of your images. If this is the case, you will most likely be satisfied with your current imaging program. However, if you find you crave more creativity with your images, invest in a more sophisticated imaging program. Research what you want to do with your images, and decide on how much you want to spend before committing to a software package.

While digital imaging programs abound, I find Adobe Photoshop to be the most versatile. With it you have an entire darkroom at the touch of a finger. This is not to say that anyone can create a masterpiece using Adobe Photoshop. With any program or piece of equipment, it takes a while to become a seasoned user.

Editing your images is just plain fun. You can manipulate an image, adding or removing subjects. You can make your own greeting cards, posters, and calendars, to name just a few of the possibilities. I'll go into more detail on how to use Adobe Photoshop in the chapter on manipulation (see page 138).

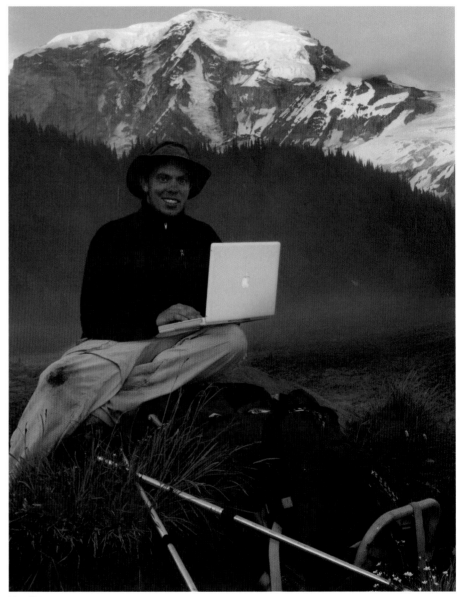

My office

My love of nature inspired me to become a nature photographer. Even if I'm not taking pictures, my equipment allows me the luxury of working outside.

IMAGE RESOLUTION

Once back from a photo shoot, you will want to download your shots from the digital media in your camera onto a computer. On the computer, you'll see the resolution of your image, which is measured in ppi (pixels-per-inch). Don't confuse the camera's resolution—measured in the total number of pixels on the CCD—with the image's resolution, measured in ppi.

To use the image for a website, change the vertical and horizontal size to whatever your desired size is, then change the ppi to 72 or 100, which is ideal for viewing the image on a monitor. Lowering the ppi and size of an image for Web use saves on memory and on the time it takes to download or view the image.

To print out the image, set the ppi to 300 for optimal results. Your camera's maximum resolution determines the image's resolution. For example, if I'm shooting with a 2.5 megapixel camera and I shoot the image as the highest jpeg file when I set the ppi to 300 in an imaging program, the final image size will be about 5 x 4 inches. If I use a 3.3 megapixel camera, the final image size will be about 7 x 5 inches when I set the ppi to 300. If I'm shooting with a professional digital SLR 6 megapixel camera, the final image size will be about 11 x 7 inches when I set the ppi to 300. A higher camera resolution will give you a higher image resolution, enabling you to make a larger print at optimum quality.

I print out all of my images at 300 ppi. You can get away with printing at 200 ppi, but the results won't look as good. If you print higher than 300 ppi, the difference is minimal and you use more memory, which means the image will take longer to print.

For a print in which the image resolution is too low for the size of the print, try upsampling your image, also known as interpolation. Interpolation increases the size you want the image printed. For example, to print a 300 ppi 8 x 10 taken with a 2.54 megapixel camera, there isn't enough camera resolution to make the image resolution you want. In fact, you have only half of the image resolution you need to produce a 300 ppi 8 x 10 print. Double the 4 x 5 image size to 8 x 10 and immediately set the image ppi to 300 before resaving the image. This adds pixels to the image that were never supposed to be there; this is upsampling. If the image is blurry, use a sharpening filter in an imaging program to combat the blurry effect. I use this technique to print out images at two times their actual size. The result is good, as long as the image was flawless to start. If twice the actual image size still isn't large enough for you, purchase plug-ins for your imaging program that enlarge an image four times its original size without compromising quality too much.

Prairie dog, Badlands National Park, South Dakota. Nikon Coolpix 990

As you decrease the image resolution, measured in ppi, you will begin to see actual pixels appear in the image.

PRINTERS, MATS, AND FRAMES

Printing is the last stage of creating a digital image. Take every step to ensure proper exposure, composition, and subject matter. Put some thought into choosing your materials. A master portraitist wouldn't paint on a sheet of toilet paper. This must be one of your best shots, otherwise you wouldn't be printing it out. So, make sure to choose the right printer, paper, and ink to ensure your image looks the best it possibly can. If you take as much care with the printing process as you do with your photography, you'll be pleased with the result.

If you are a beginning digital nature photographer, try out one of the on-line photo services before you invest in a photo printer. With these services, you e-mail the images you want printed to the service, and select the size and paper type. In a few days, your digital images will arrive in your mailbox as prints, without your even having to leave the comfort of your home. I tried one just to see how it worked and results were good. If you want only a few prints a year, there's no need to spend a few hundred dollars on a photo printer. It's cheaper to have a photo service print them for you.

If, however, you decide to be in control of the printing process, look for a high-quality printer that offers archival quality, and choose a paper type that is archival and will "keep" the image true. I mention archival quality because you want your print to last for a while. Some printers produce images that begin to fade within a few weeks. Even if you are simply making a vacation photo album, you will want to look back twenty years from now and see the same quality prints.

The quality of a printer is measured by resolution using dots-per-inch (dpi). For example, a printer with a resolution of 1440 dpi lays down 1,440 dots for every square inch of the print. As the dpi of a printer increases, so does its ability to produce a higher-quality print.

I take printing very seriously, therefore I currently print my images with the Epson Stylus Photo 2200, which uses archival ink. Epson claims the ink will last 100 years when used on archival paper. Now that's something I can have confidence in when selling prints. I'll be long gone before my images begin to fade.

Once you have printed out your digital image, you'll want to frame it. I always use acid-free archival mat board, archival tape, and nonglare UV glass when matting and framing my images. It costs more, but the end result is an image that will last much longer and look much better. You can experiment with matting and framing yourself, take your image to a local frame shop, or e-mail your image to a printing and framing service.

You can even purchase a digital picture frame (an LCD screen in a nice frame that you can put on a wall or your desktop) that uses your camera's digital media device (a CD or an internal hard drive) to display hundreds or even thousands of your images. If you don't want to settle on a single image in your picture frame, this may be the way to go.

IMAGE RECOVERY AND STORAGE TOOLS

RECOVERY

Within a few months of shooting digital images, I accumulated about 4 gigabytes (GBs) of images on my hard drive. I learned about DriveSavers, a data-recovery company, the hard way. I needed their help when my 10 GB Mac G4 hard drive crashed. The screen went blank; a sterile hum filled the air. Instantly, my knuckles turned white, my face turned red, and sweat began to pool on my brow. A full-blown crash, panic set in. How could this have happened? What could I have done? Why me?

I tried everything the tech people suggested yet nothing worked. Fortunately, I found a company that specializes in the exact trouble I was having. DriveSavers works on all types of systems—Mac OS, Dos, Windows, and UNIX—to recover from hard drives, RAIDs, floppy disks, and all types of digital media. Thankfully, they saved 100 percent of my hard drive data, which included four irreplaceable gigabytes of digital images.

If you worry about a crash, get a backup hard drive. It's also imperative that you keep your digital camera and digital media at a temperature that feels comfortable to you. Don't leave your camera on your dashboard in the middle of summer and expect it to operate without problems.

You never know what's going to happen. Fire, water, your dog—it's just comforting to know there's a digital angel out there saving data and restoring peace of mind. If you are in such bad shape that you can't get on their website, call them (see Resources on page 158 for their contact information).

STORAGE AND LOSS PREVENTION

When your hard drive is filled to capacity, you'll have to find another place to safely store your images. Paranoia set in after my crash, so I burn a copy of every image I keep onto a CD or DVD within a day or so of shooting it. I use a database to store and organize my images, but I also like having a hard copy. When you

burn a copy onto a CD or DVD, it's not just a copy; it's an exact replica of the original image. You never have to worry about losing valuable images in the mail as long as you back them up. If you want to send a portfolio of your best 200 images, you don't have to spend $200 on slide copies. For about $1 you can burn a CD with all of your images and include a nice case you design with your image on the front cover.

I shoot using a jpeg format to save memory on the digital media. However, before I save any image on my computer, I change the format to a tiff file. This reduces the possibility of acquiring artifacts in an image. Artifacts are brightly colored or overexposed pixels sporadically occurring throughout a digital image. Each time you resave an image on your computer as a jpeg file, it is compressed again. This means that if you change the contrast or color balance, the negative effect of artifacts may show up in the image.

Overexposed pixels occurred after repeatedly opening and resaving this image as a jpeg file. You can clearly see these artifacts (the bluish dots) throughout the image in the detail above.

Cowboy, Wyoming.
Nikon Coolpix 995

CHAPTER TWO

Olympic Forest, Olympic National Park, Washington. Nikon D1X with Nikkor 28–70mm 1:4.5 macro lens

CHOOSING FILE FORMAT

Selecting the file format of your image will determine how much information you record; this is resolution. As mentioned previously, resolution is measured in pixels, a combination of the words picture and elements. The ultimate resolution is determined by multiplying the number of horizontal pixels by the number of vertical pixels.

There a variety of file format types from which to choose: tiff, raw, and jpeg. Since tiff and raw file formats are uncompressed, they use up a lot of memory on your digital media. If you shoot using a jpeg file format, the image will be compressed, allowing more images to be stored on the memory card. Many digital cameras allow you to select the quality of compression. For example, 1:4 compres-

sion (the compressed image is 1/4 the original size) has a much higher quality than 1:16 compression (the compressed image is 1/16 the original size). I see little difference between shooting the highest quality jpeg format and shooting an uncompressed tiff or raw image. I always use the highest quality jpeg file format available on my camera. By shooting with a compressed file format, I can fit many more images on a single compact flash card without compromising image quality.

So, what file format should you choose, if you're photographing, say, a rabbit for a website? In this situation, you could use the lowest quality jpeg, because Web images don't require a high-quality file. If, all of the sudden, a red-tailed hawk swoops down, snatching the rabbit off the

ground, you'd catch the shot, but it would be low quality. No matter what I intend to use an image for, I always shoot it as a high-quality jpeg; it is much easier to lower the quality of an image than to increase the quality of an image.

When I save the image onto my desktop or hard drive, I switch the jpeg to a tiff file to preserve the quality of the image. Every time you alter something in an image and then resave it as a jpeg file, the image is compressed again. When you repeatedly compress a file, you run the risk of unwanted artifacts appearing in the image. Artifacts, again, are overexposed pixels randomly scattered throughout the image (also see page 27). Saving the image as an uncompressed tiff file format eliminates the possibility of unwelcome artifacts.

Buffalo, Yellowstone National Park, Wyoming. Nikon D1X with Nikkor AF VR 80–400mm lens

The prairies of Yellowstone National Park are filled with commotion. By shooting with a high-quality jpeg format, I was able to stay on top of the action, shooting over 100 images on my compact flash card without compromising quality. Another benefit of shooting with a high-quality jpeg is that the download time to the digital media is much faster because less data is stored. If I had been shooting using tiff format, I may have missed the shot because of the slower download time, or I may have had to switch out my compact flash card for an empty one.

METERING

Metering a scene means measuring the amount of incident light and light being reflected by the subject. A meter reading provides a suggested *f*-stop and shutter speed. On a bright sunny day, when the ISO is set to 100, the meter may suggest an *f*-stop of *f*/16 and a shutter speed of 1/125 sec. However, on a cloudy day, you may have a shutter speed of 1/15 sec. and an *f*-stop of *f*/4. The two will produce very different results. On a sunny day, you can capture action with a fast shutter speed and high *f*-stop for high depth of field while handholding the camera, because there's plenty of light with which to work. If you handhold the camera on a cloudy day, you'll have to use a low *f*-stop, giving low depth of field, and a slow shutter speed, because there's less available light.

There are different ways to meter light being reflected by a scene. For most of my metering needs, I use the matrix metering setting, which equally measures the light in the entire frame without emphasizing a particular region. A center-weighted metering system measures the light in the entire scene but places emphasis on the center of the frame. Spot metering meters light only from the area that you choose in the scene. Spot metering is useful when shooting a subject in high contrast, with extreme light and dark areas.

Grand Teton National Park, Wyoming. Nikon D1X with Nikkor 28–70mm 1:4.5 macro lens

▲ *The overall scene is a mid tone, so I used the matrix metering setting. I didn't have to over- or underexpose from my meter reading; it was the exact exposure I wanted.*

◄ *To capture the correct exposure for this turbulent scene I used the spot metering setting. I metered the white water, then opened up one stop to capture the white as a true white and not as a gray tone. I treated the scene as I would a scene with snow.*

Artist Point, Yellowstone National Park, Wyoming. Nikon D1X with Nikkor AF VR 80–400mm lens

EXPOSURE

Exposure—the tonality of the image—is controlled by two functions of the camera: the *f*-stop and the shutter speed. A so-called correct exposure will capture detail in both the bright and dark areas of an image. In an overexposed image, the brighter areas lose detail and appear washed out. In an underexposed image, the shadows lose detail because they are too dark. However, there's no correct or incorrect exposure. The proper exposure is one that conveys the image as you want it to appear. You determine whether or not to include over- or underexposed areas in your image. If your exposure appears the way you envisioned, then your exposure is correct.

One way to ensure that you get the exposure you want is to bracket your shots, which means taking a few shots of the exact same subject using varying shutter speeds or *f*-stops to capture different exposures. Once you pick the exposure you like best, simply delete the other shots to make room on your digital media for another subject.

Using a tripod to compose the scene and steady the camera, I chose a slow shutter speed to capture high depth of field. I set the camera on aperture priority—which means I chose the f-stop and the camera chose the shutter speed—to obtain the exposure. I took the shot my camera suggested, and then tried half a stop brighter and half a stop darker to increase my chances of catching the exposure I wanted. Of this three-shot sequence, I prefer the exposure in the image for which the camera suggested the meter reading (the middle image).

Beech forest, Unionville, Pennsylvania. Nikon D1X with Nikkor 28–70mm lens

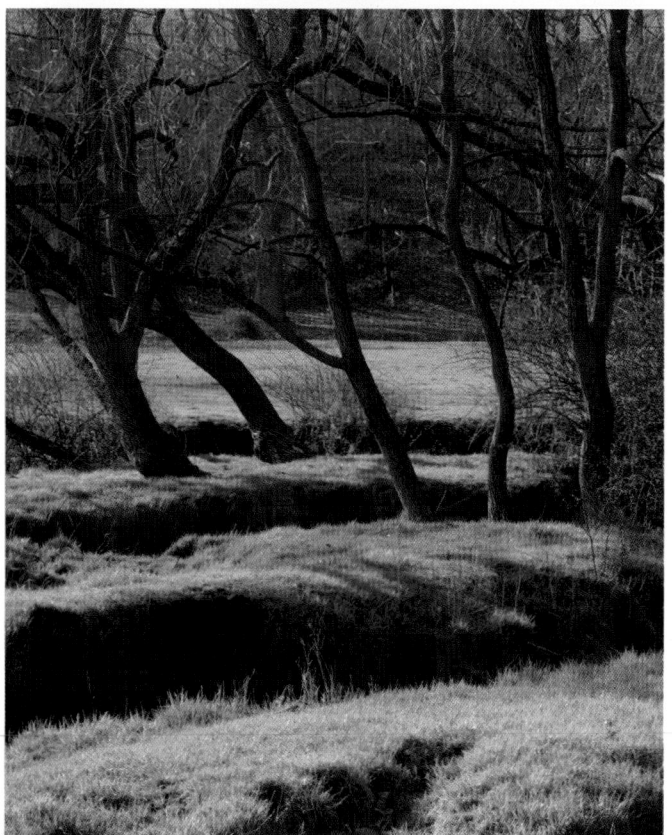

A landscape filled with light and dark areas is difficult to meter. To ensure the exposure I envisioned, I bracketed my shots. Since the angle I needed wasn't suitable for tripod use and I was choosing a high f-stop to obtain high depth of field, I used a nearby black walnut tree to help me steady the camera. I took the shot my meter suggested, then underexposed and overexposed to increase the probability of capturing the image. I prefer the underexposed image (bottom left). You can't always trust your camera to give you correct exposure. Having a camera with manual settings puts the creativity in your hands, allowing you to capture what you imagine.

Meandering creek,
Unionville, Pennsylvania.
Nikon D1X with Nikkor
28–70mm lens

ƒ-STOP

The ƒ-stop—the aperture size of the lens—controls the intensity of light hitting the film or CCD in the case of digital. Small apertures (indicated by large aperture numbers) will allow only a small amount of light to be recorded, whereas large apertures (small aperture numbers) will allow a great deal of light to be recorded. A small aperture is ƒ/16 whereas a large aperture is ƒ/2.

Where does the term ƒ-stop come from? An ƒ-stop is a fraction determined by the size of the aperture in relation to the focal length of the lens. An ƒ-stop of ƒ/8 means the aperture size is 1/8 the focal length of the lens. If you are using a 200mm lens with an ƒ-stop of ƒ/8, divide the focal length of the lens (200mm) by 8 to get the actual size of the aperture in mm. In this case, the size of the aperture would be 25mm, which is 1/8 of the focal length of the 200mm lens. Lens length divided by ƒ-stop equals aperture.

A large aperture is indicated by a low ƒ-stop number and will give you a low depth of field (see opposite for discussion of depth of field). A small aperture is indicated by a high ƒ-stop number and will give you a high depth of field.

ƒ/1.4

ƒ/2

ƒ/2.8

ƒ/4

ƒ/5.6

ƒ/8

ƒ/11

ƒ/16

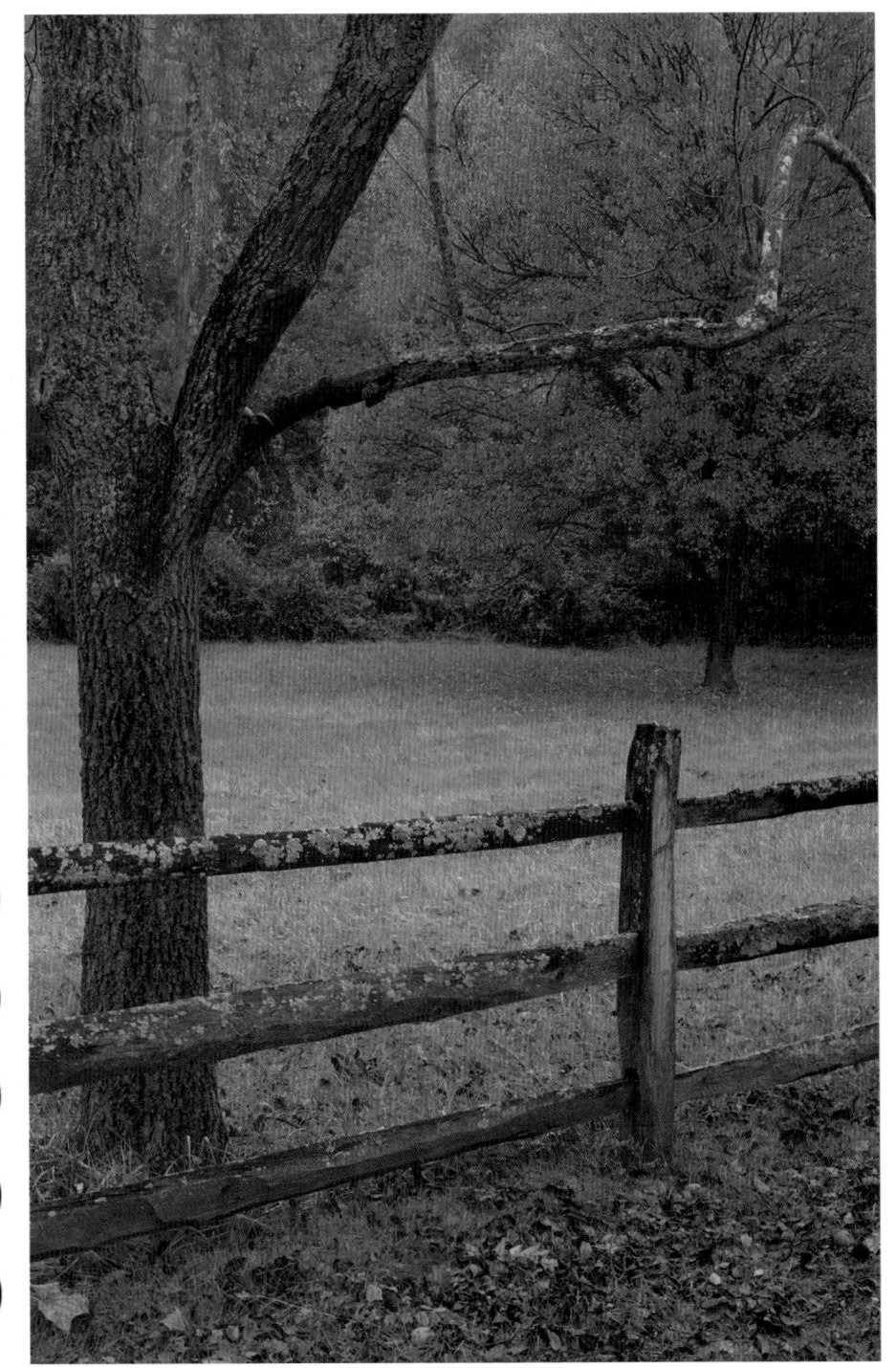

Fall scene, Unionville, Pennsylvania. Nikon D1X with Nikkor 28–70mm 1:4.5 macro lens

I wanted to capture both the lichen-covered fence in the foreground and the turning maple tree in the background in sharp focus. This left me one choice; I had to use a high ƒ-stop to obtain a large depth of field. I used a tripod, an ƒ-stop of ƒ/22, and a shutter speed of 2 seconds to capture the exposure.

DEPTH OF FIELD

Depth of field—the plane of the image (the area from front to back) perceived as being in sharp focus—is controlled by the f-stop. A smaller f-stop, such as f/16, produces a greater depth of field, or a larger plane that's considered to be sharp. A large f-stop, such as f/2, yields a smaller depth of field, or smaller plane that's considered sharp.

For example, to take a photograph of wildflowers in the foreground with rolling hills in the background and have both the flowers and the hills appear sharp, use a small aperture, such as f/16. To completely separate the flowers from the hills, use a large aperture, such as f/2, to represent the hills as a blur of color void of any detail.

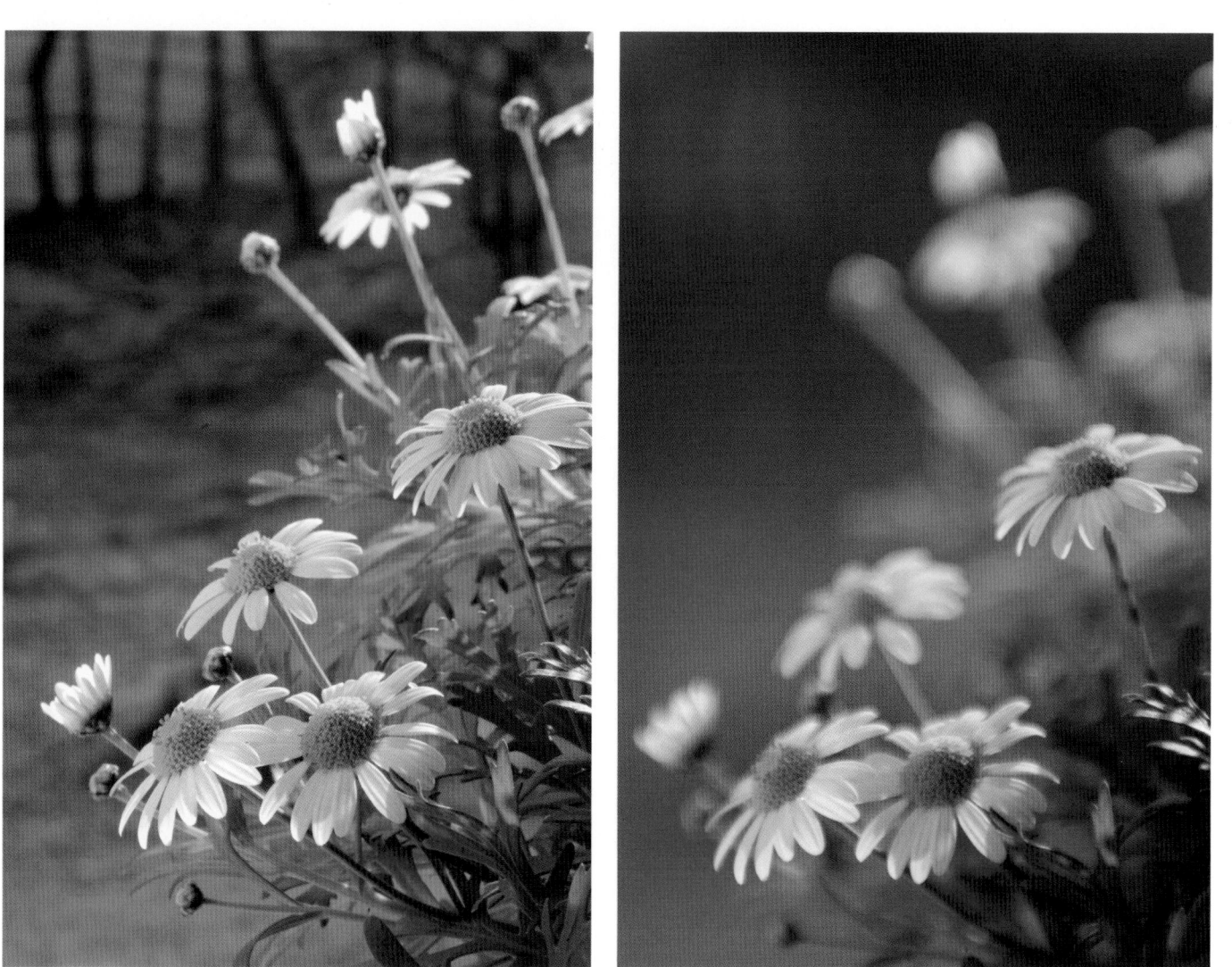

Daisies, Unionville, Pennsylvania. Nikon D1X with Nikkor 28–70mm lens

For the image above, I used an f-stop of f/22 to obtain a high depth of field, which captured all of the daisies in sharp focus and revealed a row of black walnuts more than 100 feet away in the background. For the other, I used an f-stop of f/2.8 to render only a few of the daisies in sharp focus, completely blurring the background into soft browns and greens. I like the soft feel of this image. Which one do you prefer?

SHUTTER SPEED

Shutter speed controls the amount of time light is being recorded. A long shutter speed allows more light to be recorded, whereas a short shutter speed will allow less light to be recorded. To visualize this, imagine a faucet: Turn a faucet on full blast for one second and you'll have, say, one cup of water; turn the same faucet on full blast for two seconds, and you'll have two cups. The same holds true for the amount of time the shutter is open: The longer the shutter speed, the more light is recorded. A two-second shutter speed records twice the amount of light as a one-second shutter speed. An example of a fast shutter speed is 1/1000 sec.; a slow shutter speed is 1 second.

I selected a slow (longer) shutter speed of 1/2 sec. to record seawater and sand flowing over a clam shell just as the wave returned to the sea. I used a tripod to position the camera directly over the clam shell on a misty morning before the sun had a chance to burn off the moisture. I don't recommend submerging your tripod in the ocean as I did for this shot; you'll have to take it apart and clean out the sand and salty water from the nooks and crannies.

Clam shell. Nikon Coolpix 990

Watching these young males spar for top position in the bachelor herd was a once-in-a-lifetime opportunity. Fortunately, I was using the Nikon D1 with a zoom lens that allowed me to get a close-up of my subjects. I used autofocus and a shutter speed of 1/500 sec. to stop the action of the clashing gazelles. Knowing how your camera's settings work before you are in the field is crucial to achieve action shots.

Grants gazelle, Tanzania. Nikon D1
with Nikkor AF VR 80–400mm lens

HANDHELD RULE

If you can't bring your tripod with you on a photo shoot, you'll have to follow the handheld rule to get a sharp image. This rule states that shutter speed equals 1/lens focal length. If you're handholding a pocket-size digital camera, and you have the lens zoomed to the widest possible angle of 30mm, you'd need a shutter speed of at least 1/30 sec. If you're using a 500mm lens, your shutter speed would have to be at least 1/500 sec.

This rule is critical because as the image becomes magnified, so does any movement that was made by the photographer. Not following the handheld rule when a tripod is unavailable can result in shots that are perfectly exposed and composed, yet blurry.

In the first shot, I used a high f-stop to capture as much of my subject in sharp focus as possible. Using the highest possible f-stop required a shutter speed of 1/15 sec. Photographer shake caused blurriness because the shutter speed was too slow for the focal length. Increasing my shutter speed to 1/60 sec. and decreasing my f-stop two stops to maintain the same exposure was just achieved a sharp image even though depth of field wasn't as large as I would have liked. The background, a spruce tree in the shade, appeared black.

THE RELATIONSHIP BETWEEN SHUTTER SPEED, f-STOP & ISO

Sharpness also is controlled by shutter speed. A short shutter speed of 1/1000 sec. stops motion; a long shutter speed of 8 seconds blurs motion. Depth of field is affected by shutter speed, as well. For example, when shooting landscapes, I use a small aperture. I then use a long shutter speed for the correct exposure; this increases depth of field, or the plane that is considered in sharp focus.

Shutter speed and f-stops work hand in hand. Say you have a meter reading of f/16 and 1/125 sec. to record the correct exposure of an image. You could change this to f/22 and 1/60 sec. or f/8 and 1/250 sec. depending on desired effect.

A stop is either a doubling or halving of light. Look at the chart on the right. The ISO starts at 100. Double that to get 200. Double that to get 400. The difference between ISO 100 and ISO 400 is two stops. The difference between f/5.6 and f/11 is two stops.

The difference between a shutter speed of 1/125 sec. and 1/500 sec. is two stops. Once again, a stop of light is the same change of light, whether you use an ISO, an f-stop, or a shutter speed.

When you start your photography, take along a journal to write down camera settings and what you try to accomplish with each shot. As you review your images on the computer, you can see what techniques worked. As you become more familiar with what works and what doesn't, you can leave the notebook behind.

Measuring Stops of Light

ISO	f-stop	Shutter Speed
100	4.5	1/30 sec.
200	5.6	1/60 sec.
400	8	1/125 sec.
800	11	1/250 sec.
1600	16	1/500 sec.
3200	22	1/1000 sec.

Honey bee on aster. Nikon Coolpix 995 in close-up mode

CHAPTER THREE

Canoe in Snake Bite Bay, Everglades National Park, Florida. Nikon Coolpix 995

LIGHT & COLOR

A DIGITAL IMAGE is merely reflected light bouncing off a subject that is recorded by the camera's light sensors. It's your responsibility as a photographer to capture reflected light in a manner that crystallizes the character of your subject. You must choose the correct direction, color temperature, and type of lighting for a subject just as you would choose the right tool for a particular job. You wouldn't build a birdhouse using a sledgehammer, just as you wouldn't try to capture the vibrant color of an orchid using light from the moon.

THE CHANGING QUALITY OF LIGHT

Light is a dynamic element of nature; you will never see the exact same light falling on a subject from day to day or even minute to minute. You might have to wait ten minutes, an hour, or even a year before you find the perfect light to capture your subject. I return to the same spots time and time again in search of the perfect light; sometimes I find it, often I do not. The key is to stick with it and enjoy the photographic journey. Most of the time when I head out into the field I have a particular subject in mind. I often find that I forget my original plan because I'm sidetracked by some other intriguing facet of nature. Be patient with light, and just shoot scenes that capture your attention.

I took these two images three seconds apart. The first I shot when the bottom of the trees was shaded by a cloud. As the cloud moved, the shadow shifted, shading the middle section and causing a dramatic contrast between the light and dark areas in the scene. I could not anticipate that this would happen; I was lucky to be set up and shooting the landscape when something interesting occurred.

Field. Nikon D1X with Nikkor AF VR 80–400mm lens

THE COLOR WHEEL

How humans view color is fascinating. A warm spring morning with sunbeams sifting through newly opened red tulips and yellow daffodils will make just about anyone linger to enjoy the scene. However, a cold rain that clings to the bleak landscape in the middle of January might convince the photographer to linger in a cozy bed for the rest of the day.

Colors are often referred to by temperature, with hues in the red, orange, and yellow families often considered warm colors, and hues in the blue, green, and violet families often considered cool colors. The different color temperatures will elicit different responses from the viewer. An image with red, orange, and yellow colors will invoke a warm feeling. The same image but with green, blue, and violet colors will elicit a cool feeling. So, as the light changes in a scene, so does the mood because light affects the appearance of color. Recognize this change and capitalize on the emotion you want to invoke in the viewer.

In addition to falling into certain temperature categories, colors have relationships to one another. The color wheel (right) helps us better understand these relationships. Why, for example, does a ripening orange look so good against a blue sky? What is it that draws our attention to a red strawberry dangling from a lush green vine? What invites us to look closer at yellow flecks streaking down a violet iris? These combinations all contain complementary colors, which are colors that fall opposite each other on the color wheel and serve to complement one another when placed side by side. Therefore, blue is complementary to orange, red is complementary to green, and yellow is complementary to violet. Combining complementary colors in the same image creates a dramatic effect.

Many fruits and berries are complementary in color to their plant's foliage. It's in the plant's best interest for its fruit to stand out so that it attracts enough attention to be eaten (by animals, insects, people) and have its seed spread to different areas. Think of a mouthwatering wild red raspberry. The red of the fruit is a complement to the green leaves, providing maximum attractive color contrast. On the other hand, a green cherry displays only a subtle tonal change compared to the tree's foliage and will attract no one.

If you're trying for a subtle effect in an image, seek out colors that are located close to one another on the color wheel. A little blue heron against a blue lake or a bright sun backlighting an orange daylily are examples of the use of similar colors to create a subtle effect with slight tonal and shade differences.

The coloring of animals sometimes displays hues closely positioned on the color wheel, which helps with camouflage. Some animals can even change their colors accordingly. When a brown chameleon moves onto a green shrub, it changes its appearance to a shade of green closely resembling the shrub's color. (Don't let a chameleon's subtle colors fool you; it's only blending with its environment to attack unsuspecting prey.) Female birds tend to have muted colors that allow them to go unnoticed by predators while sitting on a nest full of eggs. On the other hand, male birds use their bright dramatic colors to distract predators away from the nest and also to attract females for mating.

Once you understand how colors work together to give an image an emotional feel, you can shift your attention to how the direction of light emphasizes different aspects of a subject.

The color wheel—something we all learned in elementary school—is still an extremely useful tool in many aspects of our lives. Whether you're taking photographs, decorating your living room, or preparing a delicious meal, the color wheel can be a valuable tool. Warm temperature colors are red, orange, and yellow; cool temperature colors are blue, green, and violet. Complementary colors—pairs of colors that are opposite one another on the color wheel— provide maximum contrast; these pairs are blue and orange, red and green, and yellow and violet.

The complementary colors of the orange poppy against the blue sky create a dramatic effect. Just as I composed this scene, the sun hid behind a cloud. Then, as it finally emerged, the wind picked up. I relaxed and waited until the spring weather decided to cooperate and let me capture this shot. I used a low depth of field to soften the sky and seemingly blur some of the petals, and I accentuated the poppy's delicate nature. This was as close as I could get with my 1:4.5 macro lens without adding an extension tube.

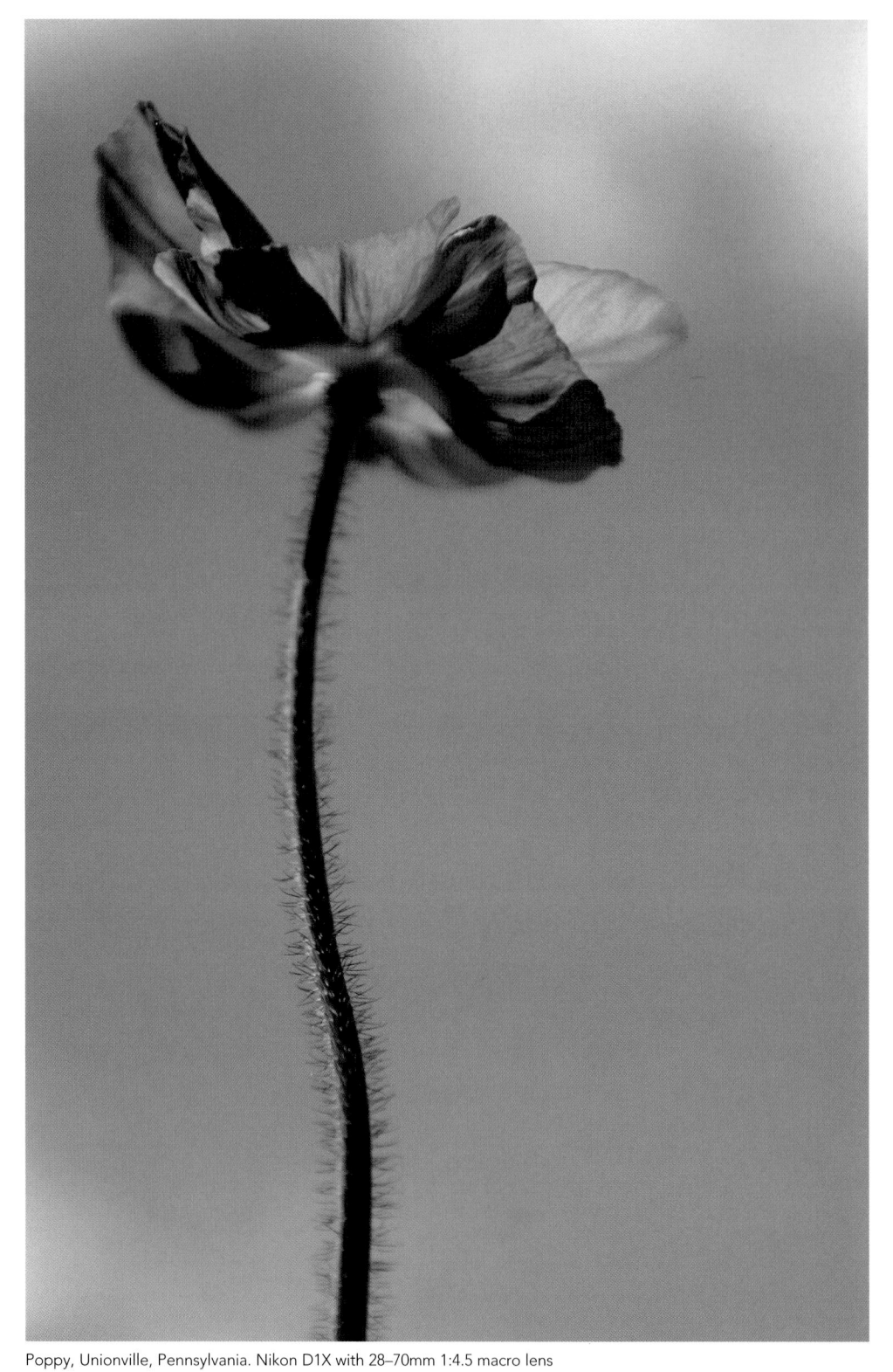

Poppy, Unionville, Pennsylvania. Nikon D1X with 28–70mm 1:4.5 macro lens

Nature exhibits some striking color combinations, especially when dreaming up flowers. The complementary colors of this yellow and violet water lily grabbed my attention. Using the diffused light source of a cloudy day, I emphasized the harmonizing colors. Few people have water lilies in their backyards. If you have a local public garden you can find some spectacular specimens to shoot, and you don't have to take care of them!

Water lily, Longwood Gardens, Kennett Square, Pennsylvania. Nikon Coolpix 950

I wanted to fill the frame with as much of the red sea star as possible. Using a tripod enabled me to take my time and compose what drew me to this subject. A red sea star clinging to a (complementary) green rock is something only nature could conjure up so beautifully. When you shoot the tidal pools of the West Coast, take along a tidal chart. It's easy to get caught up in your work and end up stranded in a remote area until the next tide rolls in.

Sea star on the coast of Olympic National Park, Washington. Nikon Coolpix 995 in close-up mode

TYPES OF LIGHT

Two sources of light are used in photography: natural light, meaning light from the sun or the moon, and electronic flash or another artificial light source. While no one can control the output of the sun or moon, you can harness the light to produce a myriad of effects. I prefer natural light, whether it's sunny, cloudy, raining, or snowing. No natural light will be exactly the same from day to day. The angle of the sun changes with the motion of the planet, the humidity increases and decreases, and most of all, your perspective on a particular subject changes.

When you understand how different lighting situations make a subject appear, you can use the light creatively to capture the image you imagine.

Light falls in two categories: hard and soft. Hard light is what you see on a bright, sunny day. Used for emphasizing the texture and form of a subject, hard light casts shadows and creates overexposed highlights on a subject. Soft light is what you see on a cloudy day. Since soft light produces faint shadows and creates dim highlights on a subject, it's ideal for drawing attention to subtle detail and color.

I wanted to accentuate the sharp texture and shape of the cactus, so I used the hard light of a bright sunny day. This light casts dark shadows and forms overexposed highlights on the cactus, showing the surface and form. Waiting for the right light to capture your subject is essential if you want to accentuate the character of the subject. When you shoot something stationary, such as a cactus, you can always return to shoot again when the light is right.

Cactus, Longwood Gardens, Kennett Square, Pennsylvania. Nikon D1X with Nikkor 28–70mm 1:4.5 macro lens

The diffused light of a hazy, hot, and humid morning was ideal for heightening the rich violet color of the morning glory contrasted with the smooth detail of the water droplets. I handheld the camera for this shot, because I couldn't achieve a high enough angle with my tripod. I used the handheld rule with a shutter speed of 1/125 sec., which meant I had to use a low f-stop to capture the exposure I wanted. This resulted in low depth of field, showing only the water droplets toward the back of the image in sharp focus.

Blue morning glory, Elliot Key, Biscayne National Park, Florida. Nikon Coolpix 995, close-up mode

DIRECTION OF LIGHT

The direction from which light hits a subject has critical impact on the resulting image. Light sources can be broken up into three main directions: frontlighting, sidelighting, and backlighting. The position you choose for your light source will determine which characteristic of the subject you emphasize.

True frontlighting occurs when the light source is directly in front of the subject. If the sun is at your back as you're photographing, you're using frontlighting. Since there are no visible shadows, frontlighting shows only the color of the subject, omitting the texture and detail.

At a 45-degree angle from the subject, color, detail, and texture are highlighted; this is called *normal light*. *Sidelighting* encompasses light falling at anywhere from a 45- to 135-degree angle to the subject and can be further broken up into two categories: *sheer lighting* and *rim lighting*. When the light source is any-where from a 45- to 90-degree angle to the subject is called *sheer light*. With sheer lighting, subject texture increases and color decreases.

When the light source moves from a 90- to 135-degree angle to the subject, a broad overexposed rim appears on the edge of the subject, making it appear translucent if its physical nature is translucent, such as with a tulip petal or lamb's ear. Light falling on your subject at this angle is referred to as *rim light*.

The positions of the various types of light.

The subject stood in a shaded area and appeared as a semisilhouette, so I used my pop-up flash to fill in some of the detail. Since the flash is mounted directly on top of the camera, this works well only in frontlighting situations. The flash had no effect on the exposure of the water, because the illumination was only enough to keep the little blue heron from fading into the background. The subtle tonal variations mirror the understated stalking style of this elegant water bird; the image captured the subject's character. A popular tourist spot, the Anhinga trail bustles with wildlife and is handicap-accessible, making it possible for everyone to enjoy. An advantage to shooting in a popular tourist location is that the wildlife have become accustomed to humans. This makes for some stunning close-ups, without having to use a long zoom lens. I crouched only about five feet away, on a paved path, when I shot this.

Little blue heron, Anhinga Trail, Everglades National Park, Florida. Nikon Coolpix 995 with internal flash

True *backlighting* occurs when the light source is 180 degrees behind a subject. The subject will be directly between the camera and the light source. Backlighting produces a thin, overexposed rim around the edge of the subject, and the subject will appear either silhouetted or translucent depending on the subject's physical makeup.

If you can't position yourself around the natural light to capture the essence of the subject, switch the power into your hands by using an artificial light source. With artificial light, the photographer has control over the intensity and direction of the light falling on the subject. Using an external flash is like having your own personal sun to position wherever you need it.

The easiest way to control the direction of light is electronic flash, because all you have to do is move the flash. Natural light, on the other hand, is a fixed light source; therefore, it requires you to accommodate yourself around the subject to take advantage of the available light.

It's critical that you understand where a light source is positioned in relation to the camera and subject, in order to emphasize distinct physical attributes. It doesn't matter what type of light source you use. Whether it's an electronic flash or the sun, it is the *position* of the light source that affects the outcome. Frontlighting eliminates shadows and highlights, revealing only the color of a subject. Normal lighting will result in an equal balance between color and texture. Sheer lighting emphasizes the texture and decreases the color of the subject. Rim lighting shows a broad overexposed highlight with the possibility of translucency in the subject. Backlighting can produce a thin overexposed rim, silhouetting, or subject translucency.

Sunflower, Georgetown, Delaware. Nikon Coolpix 990

One interesting aspect of sunflowers is that they are extremely phototropic, meaning they change their position to face the sun throughout the day. To shoot the face of a sunflower, you'll almost always be shooting in a frontlit situation, with the sun behind you. The frontlighting eliminates shadows and highlights the color contrast between the flower and sky.

Maple leaf, Adirondacks, New York. Nikon Coolpix 990 in close-up mode

Fall foliage is one of the best subjects for practicing your backlighting technique. In this situation, a single beam of light penetrated the hemlock forest, illuminating this maple leaf. Since the background was in shadow, it appeared black, contrasting nicely with the glowing red leaf and balancing green moss. My tripod wouldn't go low enough to capture the angle I wanted, so I placed the camera on the ground and used the timer to avoid photographer shake from the long shutter speed needed to obtain high depth of field.

Snow hills, Unionville, Pennsylvania. Nikon Coolpix 995

If the sun had been any lower on the horizon, this entire scene would
have been in the shade. Light sheering across the hillside emphasized
every snow-covered blade of grass and shallow dip in the landscape.
The texture of this scene vanished within minutes after the sun began
its climb in the sky.

Quill leaf, Big Cypress National Preserve, Florida. Nikon Coolpix 995
in close-up mode

The low angle of the sun highlighted the texture of this flower bud. I
walked around this epiphyte several times before I chose the angle.
This was the only angle from which the cypress swamp reflection wasn't
competing with the subject. Before you set up your tripod, find the best
angle for capturing the essence of your subject.

This is one of my favorite back-
lighting shots. The overexposed
rim of light around the monkey is
a classic backlit effect. I used a
high shutter speed because the
little monkey was scurrying up
and down the acacia tree, and
this meant I had to use a low
f-stop. The low depth of field
separates the sharp monkey from
the dreamlike background, a use-
ful technique for many subjects
and moods.

Vervet monkey, Serengeti National Park, Tanzania. Nikon D1 with Nikkor AF VR 80–400mm lens

DIFFUSED LIGHT

When the sky begins to darken, I grab my camera gear and head out into the field. The available light is diffused because clouds hide the sun. It's like the sun has a giant lampshade over it, which softens highlights and shadows, thereby lowering the contrast in the scene. A cloudy day is not only ideal for highlighting color and subtle detail in a subject; it also enables extended shooting—you can work all day because the light remains consistent.

When I shot this image, I had awoken to a camp smothered in a blanket of mist, which was rising off the frigid glacier-fed Hoh River. I set the white balance (see page 54) to cloudy and chose the highest f-stop to obtain a high depth of field. I used a tripod because of the slow shutter speed; otherwise, I would have broken the hand-held rule. The diffused light from the rising mist saturated the lush green foliage of the temperate rain forest. I bracketed my shots to ensure that I got the exposure I sought.

Hoh Rain Forest, Olympic National Park, Washington. Nikon Coolpix 995

Lion drinking, Ngorongoro National Park, Tanzania. Nikon D1 with Nikkor AF VR 80–400mm lens

The diffused light falling on this young male lion emphasized the luxuriant color of his fur and the surprising pink of his tongue. Lions in this park are conditioned to human presence; some approach the safari vehicles. This one scratched his rump on the door of my vehicle. I used a high shutter speed to capture the motion of his tongue, which meant I had to use a low f-stop.

SILHOUETTING

Perhaps—instead of highlighting color, texture, or translucency—you want to suggest a subject's character. A great way to add some mystery to an image is to silhouette the subject. Silhouettes let the imagination soar, creating countless scenarios to be played out in the viewer's mind.

When you compose a silhouette, be careful to separate your subject from any background objects. If your subject happens to merge with the background, you could end up with an unidentifiable dark blob. Set the camera on autoexposure, and take a meter reading of the subject.

Take the metered shot of what your camera suggests. Are the colors in your subject still visible? Is your background washed out? To underexpose the subject, simply increase your shutter speed or increase your *f*-stop until you find the desired exposure.

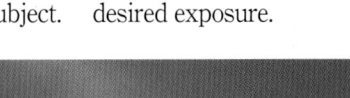

Sand Point, Olympic National Park, Washington. Nikon D1X with Nikkor AF 28–70mm lens

I underexposed this shot by two stops to capture the dark storm clouds. Underexposing caused the sea stacks to be silhouetted, adding mystery to the scene. If I had exposed the scene to capture the true color of the sea stacks, the sky would have been washed out and overexposed.

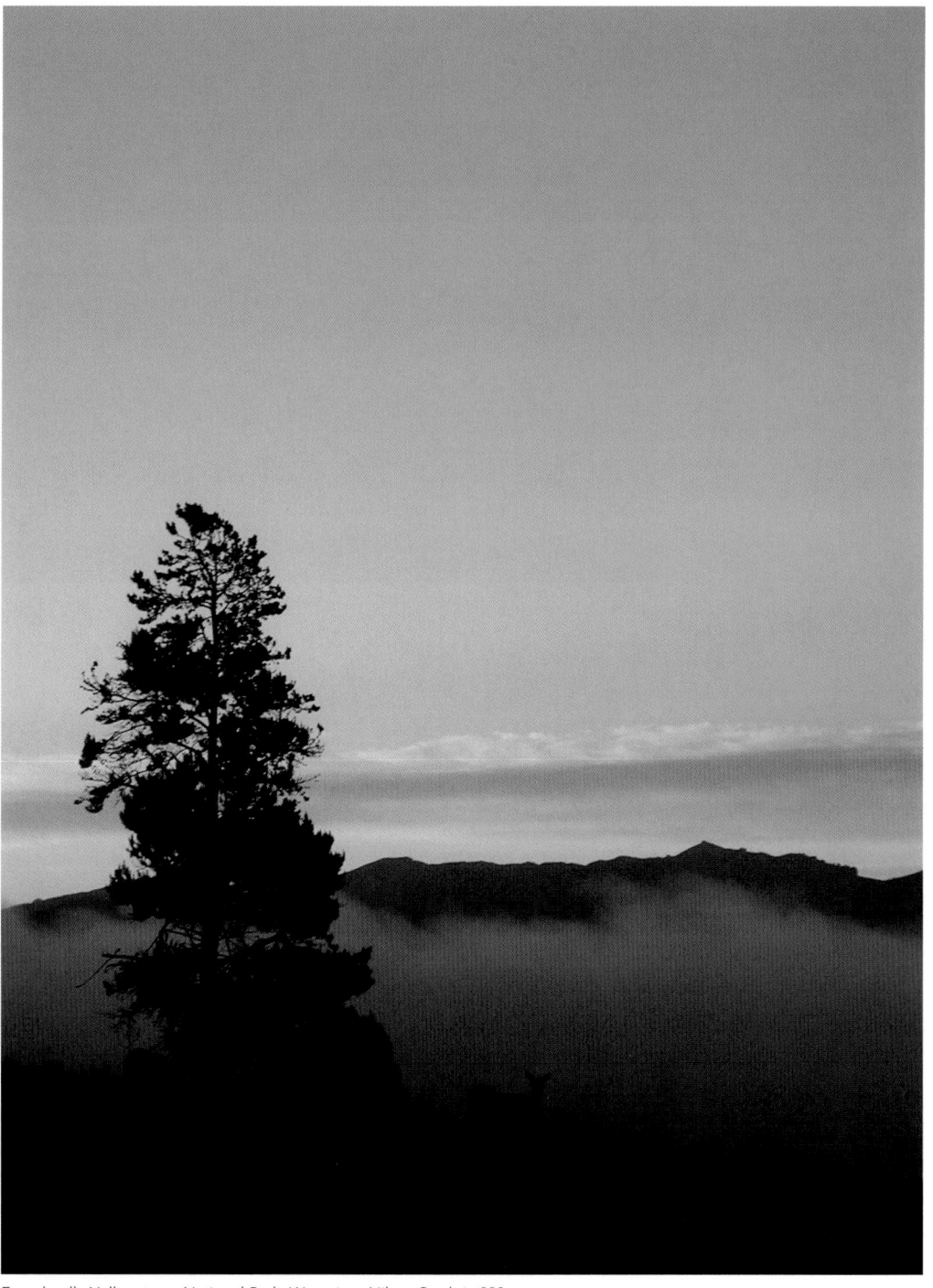

Female elk, Yellowstone National Park, Wyoming. Nikon Coolpix 990

The rising mist separated the elk from the mountains in the background. When composing a silhouette, have some way to separate the subject from the background; otherwise, your subject will become an unidentifiable blob. When visiting a park as crowded as Yellowstone in the summer, get up early to beat the onslaught of people. Most wildlife comes out in the first two hours of the day, which is also the best light in which to get images.

WHITE BALANCE

Just as you can ignore the camera's suggested meter reading when creating a silhouette, you can also deviate from the camera's suggested white-balance settings. White balance is a setting in which the camera measures a scene's color temperature and adjusts it so that white subjects don't take on extreme color casts. Common settings are *auto, cloudy, sunny, fluorescent,* and *incandescent.* When used in the proper situation, each setting will most likely produce an image the way you actually see it. However, if you change the white balance to a setting for which it is not recommended, the results can be interesting.

I use the white-balance settings as I would a set of filters—and I don't have to carry along extra gear! To add more blue and violet to lend a cooler feel to an image, I set the white balance to *fluorescent.* To introduce more red and orange, I set it to *cloudy* or *incandescent.* The best way to learn about these settings is to try them out yourself. Since you can erase as many images as you like, it costs nothing to experiment. With your camera on a tripod, try the different white-balance settings on the exact same scene to see what the camera can do.

Experimenting with the white-balance setting was worth the time for this shot. I set the white balance to fluorescent, *which caused the warm reds and yellows of the scene to turn blue and violet. Changing the white-balance setting can alter the mood of an image just as adding a filter can. Try it out to see how you can transform a scene with the press of a button.*

Badlands National Park, South Dakota. Nikon Coolpix 990 with cloudy white-balance setting

When I made this image, I had never seen the Badlands before. I climbed up a trail to the top of a formation to get a higher vantage point on the valley below. I knew exposure was crucial to capturing this mystical scene. If I overexposed, I would lose subtle shadows to a brighter haze. But underexposing would force the variable shadows to disappear into a solid silhouette. Bracketing in half-stop increments saved this image. I used the cloudy white-balance setting to capture the warm orange color of the scene without having to add a warming filter.

Badlands National Park, South Dakota. Nikon Coolpix 990 with fluorescent white-balance setting

FLARE

As with white balance, creative experimentation is also the best way to incorporate flare into your growing portfolio of digital images. Lens flare occurs when direct sunlight hits the glass of the camera lens. Changing the angle of the lens just a few degrees can create an interesting spotting or streaking effect in the image.

Capturing flare isn't easy. You must point your camera directly into the sun. Fortunately, digital cameras, unlike film cameras, have an LCD screen in addition to a viewfinder. Always look at the LCD screen instead of through the viewfinder when shooting into the sun. You don't want to cause eye damage. Adjusting the settings manually is the best way to capture the exposure you want. Autoexposure is fine if you want to silhouette your subject; however, using the auto settings will most likely cause the image of the subject to turn black. Opening up a couple of stops will overexpose the sky but keep the subject's exposure true.

April snow, Unionville, Pennsylvania. Nikon Coolpix 995

▲ *I mowed my grass on a Friday afternoon. The following morning I awoke to a winter wonderland. I jumped out of bed, grabbed my camera, and headed into the backyard. The birds were singing just as they would on a typical spring morning; the robins were even searching for worms under the light snow coating. The scene was surreal. Shooting directly into the sun resulted in some interesting pink and green flare spots, adding to the otherworldliness of a late April snow.*

◄ *I had to use a relatively fast shutter speed for this shot because the wind was blowing the poppies all over. Of the twenty shots I took, I was happy with only one, so I erased the other nineteen, leaving plenty of room on my compact flash card for the rest of the day's photo opportunities. I always have a camera with me just in case a great photo opportunity arises such as this one.*

Poppies along Route 301, Maryland. Nikon D1X with 28–70mm 1:4.5 macro lens

CHAPTER FOUR

Mount Rainier, Washington. Nikon D1X with Nikkor AF VR 80–400mm lens

COMPOSITION

Today's DIGITAL CAMERAS are capable of capturing a perfect exposure, and setting the f-stop and shutter speed. Some lenses can even cut down on photographer shake with vibration-reduction technology. What a digital camera can't do is compose an image to capture the attention of the viewer. Creative composition rests in the hands of you, the photographer.

While the basics of exposure, shutter speed, and depth of field are relatively easy to grasp, an "eye" for photography can take a while to develop. Having an eye entails seeing how a subject reacts to light then finding the perfect angle from which to capture that reaction. Of all the aspects of digital nature photography, composition is the most important. Even if your exposure, focus, and depth of field are flawless, the shot will be mediocre if your composition does not captivate. With guidelines, however, you can compose an image that excites and involves the viewer.

AVOIDING THE FOUL ZONE

Visualize an X in your viewing frame. The dead center, where the two lines of the X intersect, is what I call the "foul zone." Avoid placing your subject in this spot in the center of the frame. This dead-center composition leaves no place for the viewer's eyes to travel. Shooting in the foul zone is the most common mistake beginners make. Too often, beginners are so busy trying to get the right exposure, and fiddling with the *f*-stop and shutter speed, that they ignore the composition.

THE RULE OF THIRDS
One way to avoid placing the subject in the foul zone of the frame is to use the rule of thirds. To do this, visualize a grid of two evenly spaced horizontal and two evenly spaced vertical lines over your image that break the scene into nine rectangles. The spots where the lines intersect are the four "target zones." These zones are where you want the viewer's eye to eventually settle in the image. Placing the subject, or the subject's main point of interest, on one of these target zones will engage the viewer in the image. A main point of interest could be anything you choose: the subject's eye or the rising sun, for example.

COMPOSITION AND TRIPOD USE
Before I start snapping photos, I back up to determine the reason I'm drawn to the subject. Once I decide, I choose the best angle from which to accentuate that aspect. This may mean taking a small step to the left, holding the camera above my head, or getting down on my elbows. Once I choose the angle that I feel will best "reveal" the subject, I use either my body or my tripod as a tool to position the camera to get the photograph that I envision.

One of the benefits of using a tripod (aside from steadying the camera) is the advantage it gives me in composing a scene. With a tripod, I can hone in on the precise area of the subject that attracted me. I can maneuver fractions of an inch to avoid a blade of grass in the foreground, or change the angle a few degrees to crop out unwanted shadows and highlights in the background. Using a tripod also enables me to bracket my shots to ensure a correct exposure without changing the composition of the image.

Using the rule of thirds and breaking down a scene into a nine-rectangle grid pattern is a great way to learn how to compose an image. Steer clear of the foul zone by placing the subject's main area of interest in one of the four target zones. Placing the horizon line of an image on one of the two horizontal lines guides a viewer through the image to see it as the photographer did.

Bumblebee on a dandelion, Unionville,
Pennsylvania. Nikon D1X with Nikkor 28–70mm
1:4.5 macro lens

*Can it get any blander than this shot? A
viewer would pause at this image for about
one second before losing interest and turning
away. I deliberately placed the bumblebee
dead center in the frame to illustrate how the
viewer's eyes start and stop in the foul zone
with a composition like this. When looking
through the viewfinder or at the LCD screen
to compose an image, force yourself to move
the subject out of the center of the frame.*

Cropped bumblebee on dandelion, Unionville,
Pennsylvania. Nikon D1X with Nikkor 28–70mm
1:4.5 macro lens

*When I cropped in on the bumblebee and
placed it in the upper left target zone, I
drastically increased the appeal of the image.
The viewer's eyes begin in the lower right
corner, travel up the dandelion stem, and
land on the bumblebee. So, why not just
crop all of your images to get the
composition you want? As you crop an
image, you take away information, thus
reducing the size of the print.*

FORMAT: DRAWING THE VIEWER INTO THE IMAGE

Look at the shape of your subject. Will it look better in a horizontal or vertical format? A vertical subject, such as a towering tree, looks better if you emphasize the shape by shooting in a vertical format. A herd of wildebeest on the Serengeti plains look majestic when composed horizontally, which emphasizes the endless herd on the vast grasslands. You also must consider the intended use of the image. A horizontal calendar, for example, dictates a horizontal framing, whereas a magazine cover requires a vertical image. If you're not sure how the image will be used, shoot both formats and pick out the best one later.

Once you decide on a vertical or horizontal format, use the rule of thirds to compose the scene. Fill most of the frame with the aspect you like most. For example, if you're drawn to an ominous sky in the Everglades, fill most of the frame with that sky, leaving only the bottom third for the water. On the other hand, if drip castle formations of the Badlands is what inspires you, include two thirds of the formations and only one third of the sky in your shot.

Keep in mind that the compositional guidelines I've set are just that—guidelines. There are no cut-and-dried rules when approaching composition. Don't become so tied to the rules that all of your images look the same compositionally. Vary your angle; try new positions. And, digital photography affords you the advantage of viewing the image immediately on your LCD screen and reshooting until you achieve the image you wanted when first you saw the subject.

Sunflowers, Chief Timothy State Park, Washington. Nikon Coolpix

◄ *I was drawn to this scene by the train of sunflowers traveling across the grassland plains. While the sky didn't interest me, I thought it crucial to include some of it in the top third of the frame. I chose a horizontal format to emphasize the sprawling grasslands and the sunflowers that cross the frame.*

Yellowstone National Park, Wyoming. Nikon D1X with Nikkor AF 28–70mm lens

I was shooting a waterfall in shade late one afternoon when I walked around a bend to be stopped in my tracks by a rich gold canyon. The sky didn't add anything to the scene, so I left it out of the image. I framed the landscape horizontally to include as much of the golden cliff side as possible. Using an f-stop of f/22 also allowed me to use a slow shutter speed of 1/15 sec. to capture the motion of the rushing water.

Lubber grasshopper, Biscayne National Park, Florida. Nikon Coolpix 995

Whether you're photographing a majestic mountain range or an ant, rules of composition still apply. To make the image above, I lay on the ground, composing at a grasshopper's eye level to connect the viewer to the subject. I was careful to position the camera so that the grasshopper's eye landed in the upper right target zone, which leads the viewer through the image.

Indian pipes, Washington. Nikon Coolpix 995

The upright nature of these Indian pipes looked best in a vertical format. I used a poncho to protect my camera from the pouring rain while shooting this image. If you're heading into the rain forest of the Pacific Northwest, take along plenty of rain gear for yourself and also for your camera equipment.

Wildflowers, Grand Teton National Park, Wyoming. Nikon D1X with Nikkor AF 28–70mm lens

A vertical format was the only option for this image. Five different layers draw the viewer into the scene. The eye begins at the close-up flowers, moving onto the open meadow, stopping briefly at the evergreen trees, then onto the alpine peak, and finally the looming sky.

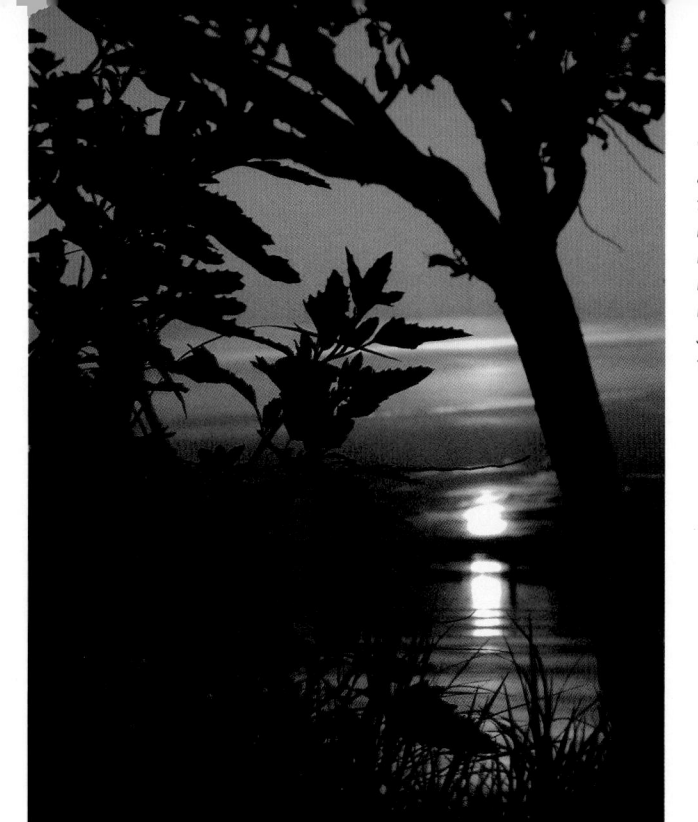

Water and sunsets are like peanut butter and chocolate: good by themselves but fantastic when put together. I used the natural vegetation to frame the sun in the lower right target zone so that the viewer is compelled to see nothing else in the image. Even a place as crowded as the Jersey shore has its quiet places. Just find the solitude and lose yourself in the scene.

New Jersey shore. Nikon Coolpix 990

The lioness led her young cubs away from the local watering hole to a softer, safer resting place. As the five cubs clumsily loped along, I fired off a series of shots. I liked this shot best, with the mother's head in the lower left target zone while the cubs draw the eye up to the right corner of the frame.

Lioness with cubs, Ngorongoro Crater, Tanzania. Nikon D1X with Nikkor AF VR 80–400mm lens

CHAPTER FIVE

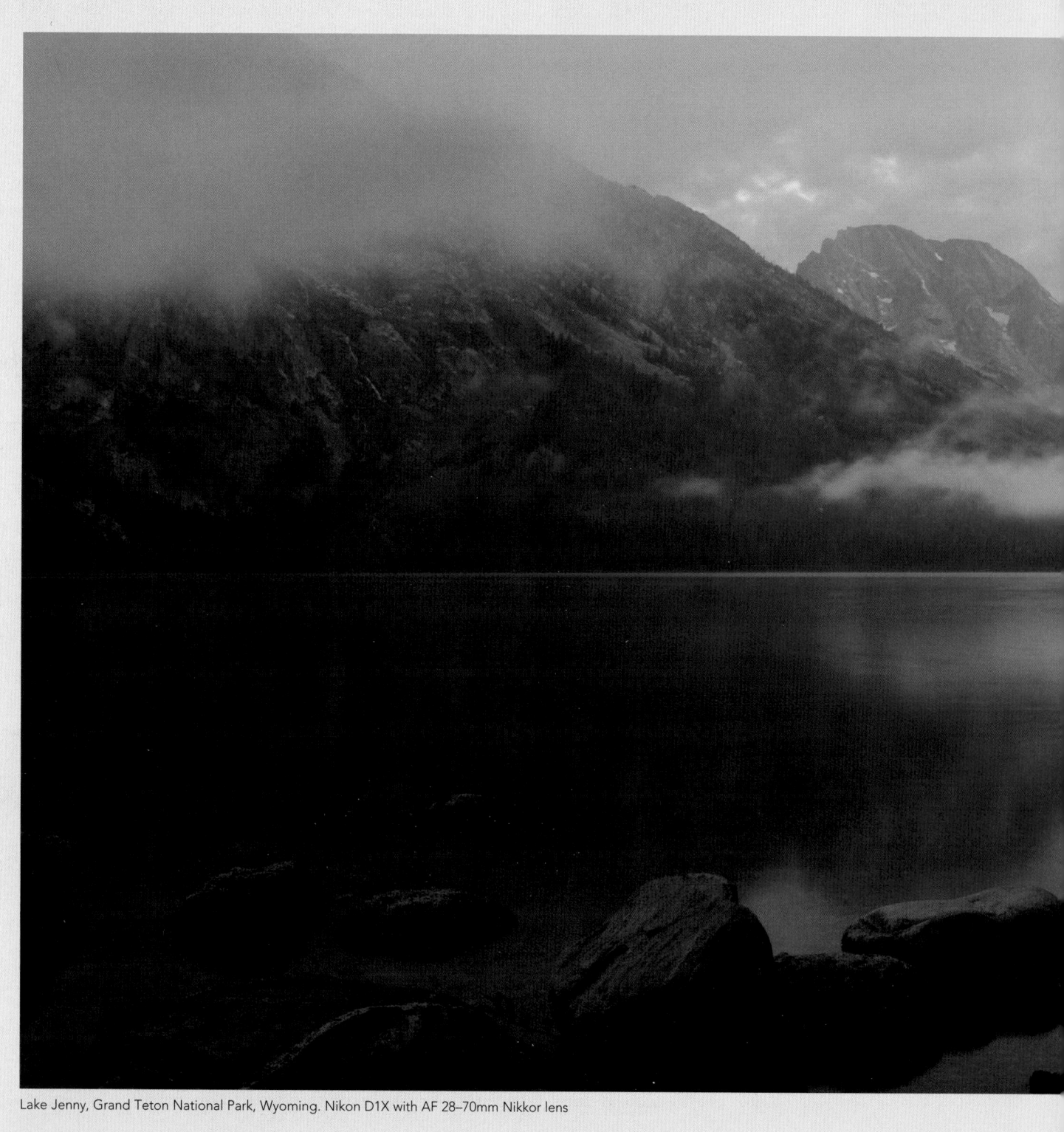

Lake Jenny, Grand Teton National Park, Wyoming. Nikon D1X with AF 28–70mm Nikkor lens

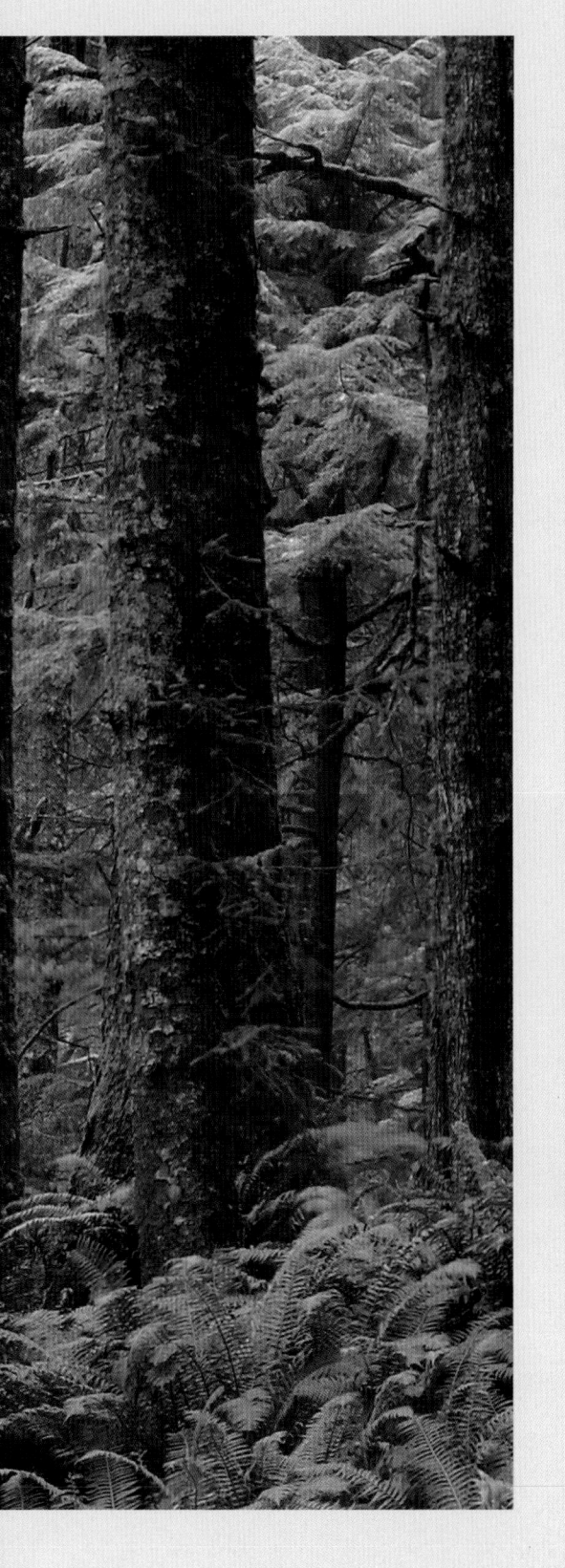

BASIC PHOTO TECHNIQUES

THE FOUNDATION of a digital image originates with a photographer's vision, built up with an understanding of the basic photography principles and techniques. You can visualize a breathtaking image, but if you can't use your equipment to capture what you see, your vision doesn't mean anything. If you're building a house and the foundation isn't sturdy or the walls aren't stable, the entire structure will crumble. The same problem occurs if your f-stop or shutter speed is off. The image simply won't hold up visually, because the exposure isn't what you anticipated. It's crucial to become proficient with the basics of digital photography to the point where your technique becomes second nature, allowing you to tap into your creative side and concentrate on the other aspects of creating an image.

ISO

Before shooting an image, select an ISO setting, which determines the image's clarity or graininess. Digital cameras use the same ISO equivalencies as film cameras. The only difference is that in changing the ISO on a digital camera, you don't have to change the film or switch cameras—just press a button. It is possible to make images with different ISO settings on the same digital media. Take a shot using ISO 100, then on the very next shot, use an ISO of 800.

A low ISO setting, typically 100 on many digital cameras, yields the smoothest image possible. So ISO 100 produces a much smoother, crisper image, whereas ISO 800 produces a rough-textured image. Increasing the ISO number will increase the graininess and of the image. If you were able to touch an ISO of 100 it would feel like silk pajamas, while touching an ISO of 800 would feel like a burlap potato sack.

Each doubling or halving of the ISO number is equivalent to one stop of light. Changing from ISO 100 to ISO 200 moves one stop up to a more light-sensitive setting. From ISO 100 to ISO 800 is three stops up, making the setting even more sensitive to light and resulting in a grainy texture. You would adjust the ISO to a more light-sensitive setting if there isn't enough light available for the low ISO setting. For example, if you are heading into a dense, dark, temperate rain forest in search of a spotted owl, you may want to set your ISO to 800 to increase the chances of getting the shot under a low-lighting situation. Most of the time, I shoot using the lowest ISO setting my camera has, in order to capture the sharpest and smoothest image possible. I only switch to a higher ISO setting when all my other tricks have failed.

MEASURING LIGHT & DIGITAL'S EXPOSURE ADVANTAGE

In photographic terminology, *stops* are used to measure light. A stop is a universal measurement of the amount of light that's interchangeable with shutter speed, aperture (known as *f*-stop), and ISO (International Standards Organization or, more correctly, International Organization for Standardization) settings. This concept is a little hard to grasp initially. Think of a stop in traveling terms: If you travel a mile by car, foot, or bike, the mode of transportation doesn't matter; the result is still one mile. The same holds true for a stop of light. You can "travel" one stop of light using your shutter speed, your *f*-stop, or your ISO setting. No matter what setting you choose, you still have traveled one stop of light.

The amount of light affects the image's exposure. There's no right or wrong exposure; it's how you envision the image. When shooting with a digital camera, catching the exposure you want with the first few shots isn't nearly as crucial as it was when using film. You immediately can view the LCD screen (on the camera) to make sure the image appears the way you imagined. If you're unsuccessful, just keep shooting until you capture the exposure you want. While you still must understand how exposure works, it's easier with an LCD screen than it is with film to see the result and correct your mistakes.

Covered bridge. Nikon D1X with Nikkor 28–70mm lens at ISO 125 (left) and ISO 800 (right)

I shot two images of the exact same scene using ISO 125, then ISO 800. Using an identical f-stop, I increased shutter speed when using the ISO 800 setting to achieve the exact exposure as the ISO 125 setting.

LANDSCAPES

PEOPLE ARE DRAWN to a landscape because they can imagine themselves being in a meadow of wildflowers or surrounded by morning mist rising off a mountain lake. Try to combine all these senses on a two dimensional surface using only the sense of vision to convey your message. Does the image conjure up different senses? The sweet fragrance of a lily? The feel of humidity? The roar of crashing waves? Ask yourself: Will the viewer of the image long to be here? If so, you have successfully captured your subject.

COMPOSITION

As I leaf through family vacation photo albums, the landscape images seem to be the most neglected. A common disclaimer is, Well I guess you had to be there; it looked better in person. Of course it did. The photographer labored up a jagged granite face, reached the peak—exhausted—to be hit in the face with a forty-mph gust of wind. The adrenaline rush took over and everything looked magnificent. At this point it was easy to simply lift the camera and take a shot of the extending mountain range with the horizon and sky meeting in the middle, completely ignoring the rule of thirds.

Always catch your breath before photographing, taking a few minutes to compose the beautiful scene. Look around for something in the foreground to add depth to the image. Wildflowers, rocks, trees, and even people help to add depth. And, using multiple subjects at varying distances will add levels of interest.

Ask yourself what drew you to the scene you're about to shoot. Look at the shapes and positions in the landscape, and emphasize the natural structures with vertical or horizontal framing. A vertically standing spruce tree will look best in a vertical format, whereas a broad sprawling acacia tree will look best in a horizontal format. Remember the rule of thirds and position the subject in one of the target zones so that you can lead the viewer through your image.

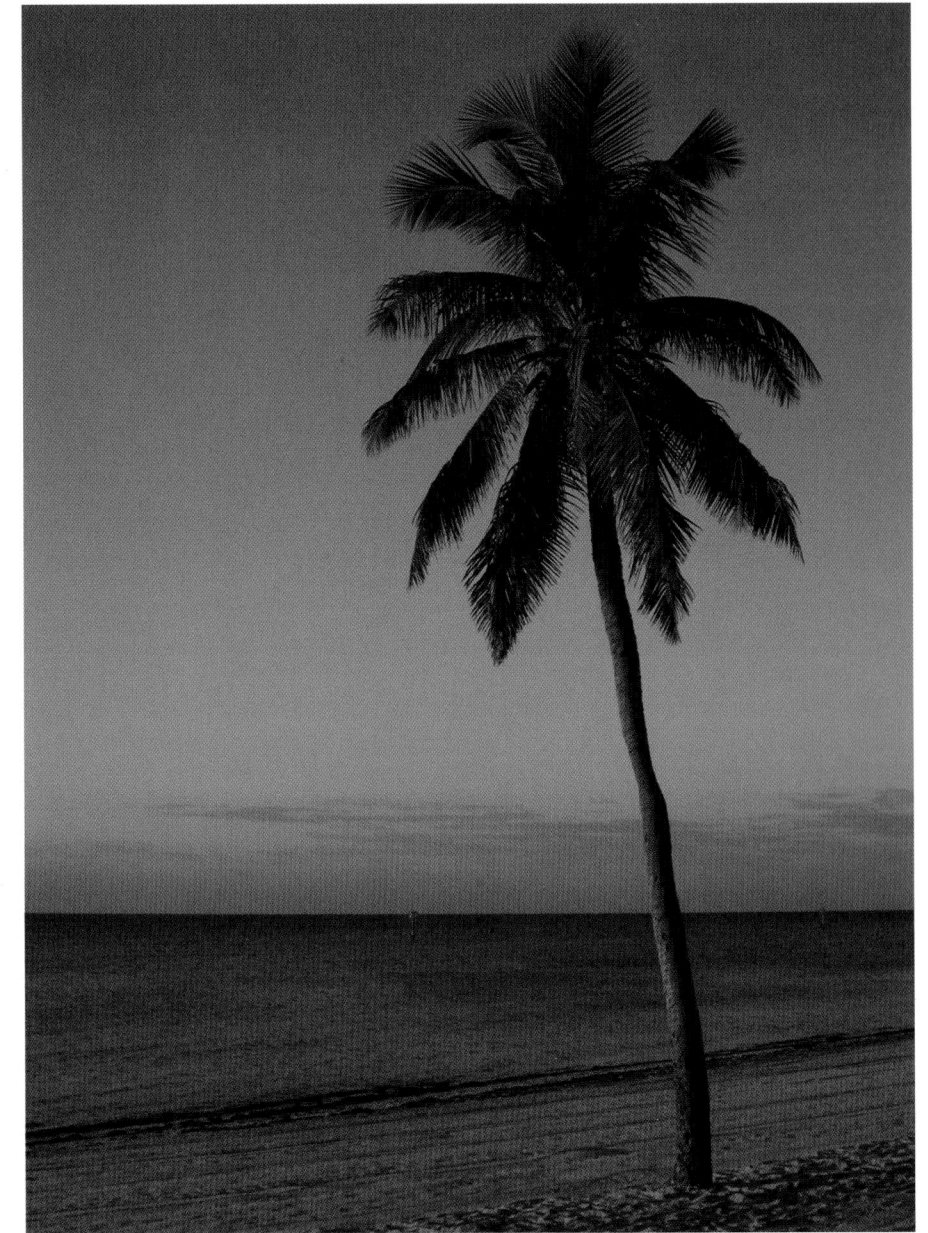

Coconut palm, Key West, Florida. Nikon Coolpix 995

About twenty minutes after the sun lost its morning flush, I was drawn to a solo standing palm. I shot this image vertically to emphasize the towering tree. I positioned the top of the palm on the upper right target zone, placing the horizon and sand in the bottom third of the image. To capture this, I handheld the camera at the highest possible angle to keep the horizon low. A cherry picker would have helped me out here because my tripod did not extend high enough.

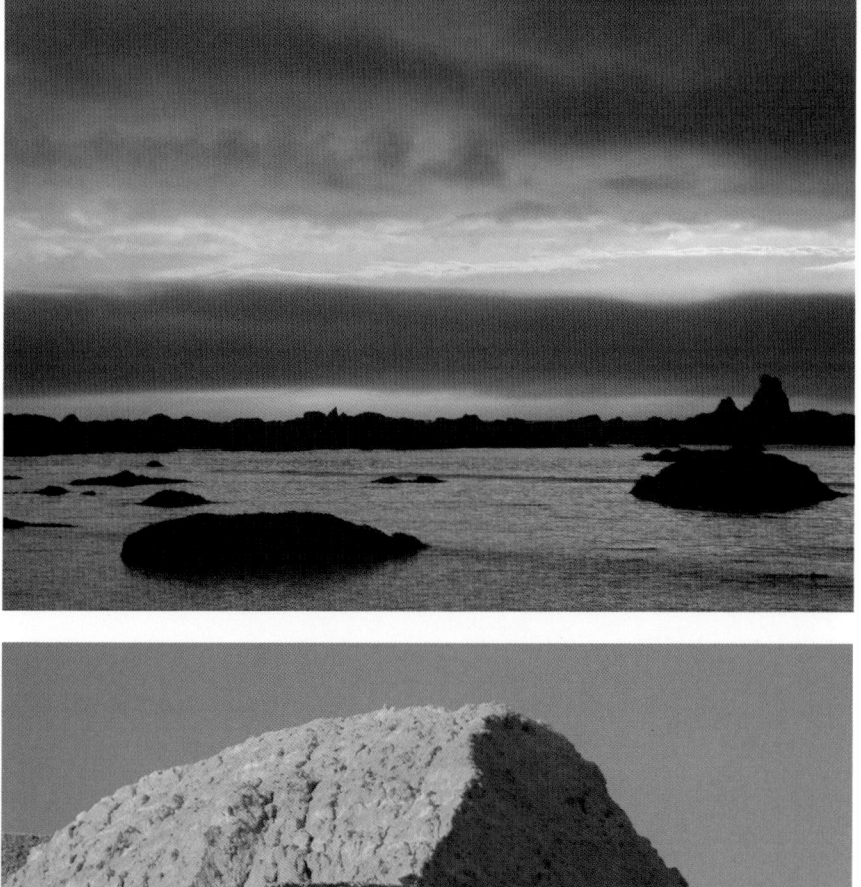

Pacific coast, Olympic National Park, Washington. Nikon Coolpix 995

The horizontal front of clouds immediately drew me to this scene. To emphasize it, I used the rule of thirds while composing and placed the horizon line just above the bottom third of the frame.

Sunflowers, Chief Timothy State Park, Washington. Nikon Coolpix 995

I positioned myself low enough to the ground to position one of the sunflowers against the blue sky. The complementary colors of the yellow against the blue invite maximum contrast, causing the subject to stand out.

Formations, Badlands National Park, South Dakota. Nikon Coolpix 995

The first and last hour of light in the day saturates color and elongates shadows, which emphasize the structure of a subject. The long curved shadow cast by this formation draws the viewer's eye from the bottom right to the top of the frame.

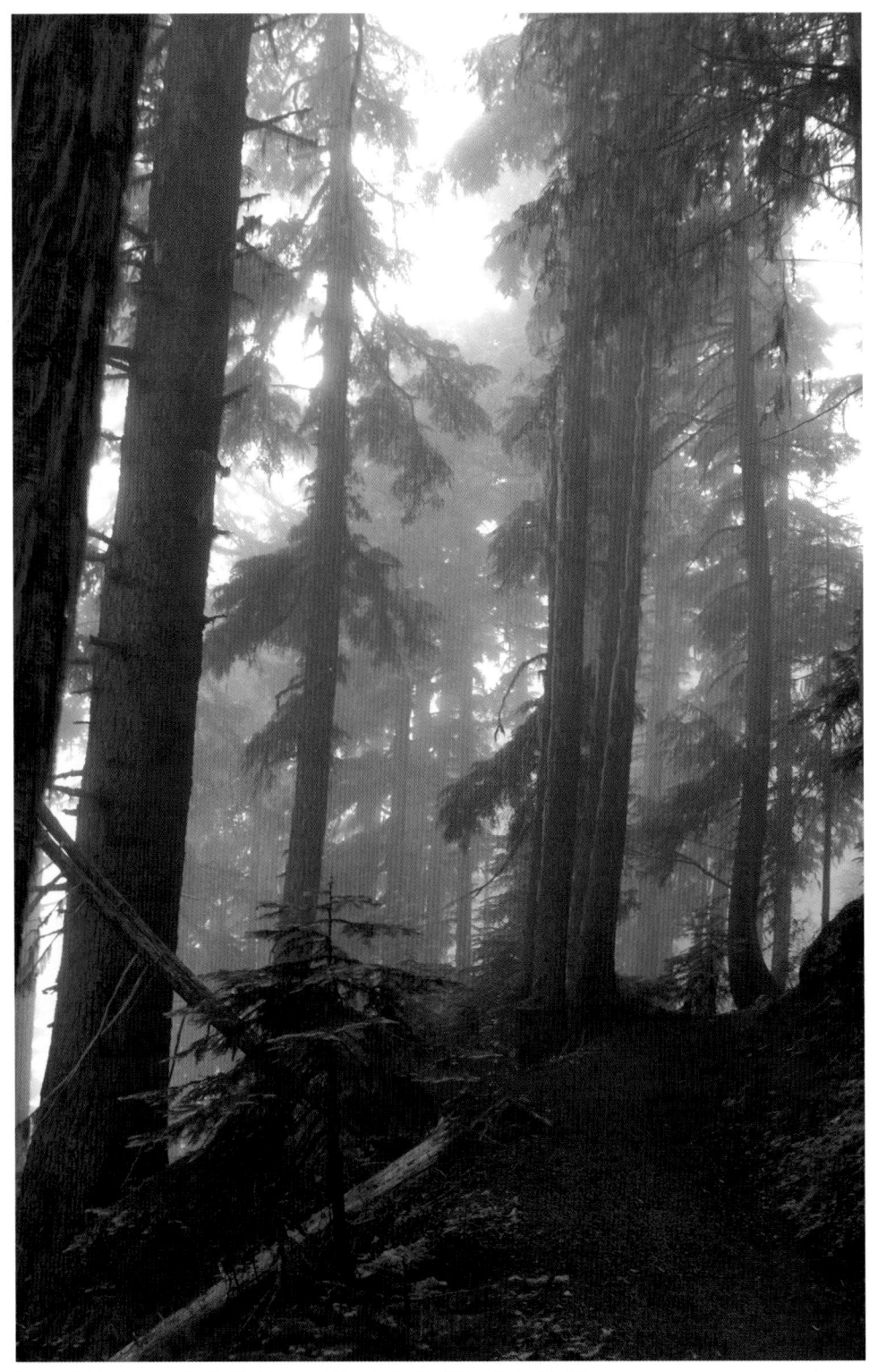

Mount Rainier National Park, Washington. Nikon D1X with Nikkor AF VR 80–400mm lens

I used a vertical format to emphasize the trees soaring into the clouds. I included the trail to lead the viewer's eye into the image. My tripod wouldn't extend high enough for the angle I wanted, so I used a nearby tree to brace the camera.

SUNNY DAYS

Landscape photographs taken on bright sunny days are often washed out and bland. Unfortunately, between the hours of 10:00 A.M. and 2:00 P.M.—when the most light is falling on the landscape—is the worst time to take a photograph. This is because the sun is nearing a 90-degree angle to the ground, flooding the scene with hard light and harsh contrast. How do you turn the harsh lighting into an interesting image?

By being aware of the location of the sun, you can avoid a washed-out sky. Due to the rotation of the Earth, the sun "travels" from east to west; however, the arch of this path is closer to the Southern Hemisphere. This is why moss typically grows on the north side of trees; the sun never hits the north side. This is also why the north end of the sky—with less direct, harsh light—always has the deepest blue color, and the south end is much lighter and washed out.

The key to capturing a deep blue sky is to position yourself in the landscape so that the scene you're shooting is facing the south and your camera is facing north. I use the white-balance *sunny day* setting available on many digital cameras. Even under this setting, a metered shot might not give you the result you desire. If your sky is still too washed out, simply increase your *f*-stop or shutter speed to allow less light to be recorded. This will result in a darker sky and fewer overexposed highlights. Your digital camera may also have a contrast-adjust setting that you can use to either increase or decrease the contrast in the image.

You may not always want a blue sky in your image. If you want a lighter sky and a backlit subject, face the south side of the sky. Even though some of the image will be washed out, it doesn't mean the photograph won't captivate the viewer. An overexposed sky is ideal for highlighting the feeling of a lazy, hot, humid summer day.

Yellowstone National Park, Wyoming. Nikon Coolpix 990

I was getting soaked as I took this shot. The storm had broken behind me, flooding the foreground with light while the rain kept pouring down. I always keep a plastic bag close at hand for situations when my camera is in jeopardy of getting wet. The dead trees were the result of the forest fire of 1988 that devastated our nation's first national park.

It's obvious how the carbon glacier (right) in Mount Rainier National Park gets its name, but it's not as obvious how to shoot it. My metered shot was over-exposed, because the meter was trying to bring the black up to a mid tone. To correctly expose the glacier and have it appear black, I increased my shutter speed one stop, which also saturated the color of the blue sky.

For this alternate view below, also in Mount Rainier National Park, I used the close-up setting and manual focus to capture the wildflowers in detail while using a high f-stop to get as much of the background in focus as possible. I positioned my camera directly in front of wildflowers with some spruce trees filling the middle tier before the ominous snow-capped Mount Rainer. The three layers give the image depth, capturing various ecological niches.

Atlantic coast, Acadia National Park, Maine. Nikon Coolpix 995

A sunny fall day is spectacular on the New England coastline. Even though I was having a lazy day, I needed a fast shutter speed to stop the action of the waves crashing on the rocky shore. Using the excuse of being on vacation, I had not brought my tripod, so I positioned the camera on my shoe to keep my composition consistent. Imagine the different angles I could have taken if I had brought my tripod along.

▼ Setting my white balance to sunny day, I positioned myself so that the formation was facing the south side of the sky and I was facing north. My meter reading was a bit off, so I underexposed the scene by 1/2 stop to saturate the color of the sky and lower the highlights.

Badlands National Park, South Dakota. Nikon Coolpix 995

CLOUDY DAYS: DIFFUSED LIGHT

Early-morning diffused light is one of the best possible shooting situations. No matter where I am, a foggy morning captivates my imagination, lending an air of mystery and wonder to any photograph. Not knowing what is behind the haze—a long-lost city, a grizzled cabin, a lurking vulture—intrigues and invites viewers to create their own story.

I often hear my beginning photography students say, What a crappy day to take pictures. Then, I let them in on a well-kept secret. A cloudy day gives off a soft light crucial for color saturation in an image, allowing the viewer to mosey through the image without being distracted by harsh contrast and shadows.

When working in this light, decide how much information you want to record. Completely silhouetting objects eliminates soft shadows, which are vital details to the unknown region of an image. However, overexposing an overcast scene can sometimes reveal too much information, thereby diluting the mystical suggestion of the unknown. Exposure of a hazy image elicits the emotional outcome from the viewer.

Taking a meter reading from an overcast scene is often difficult. I take the shot my meter suggests, then I bracket a half and then a full stop either way of the meter reading to increase my chances of getting the photograph I want. The results and moods will vary drastically; however, you don't have to record the image the way you see it. The exposure can be mysterious, too. In the scant early-morning light, you'll need a tripod and some lens tissue. Mist and rain droplets often find their way onto your lens, so check it periodically and wipe it dry.

Mount Sheridan, Yellowstone National Park, Wyoming. Nikon Coolpix 995

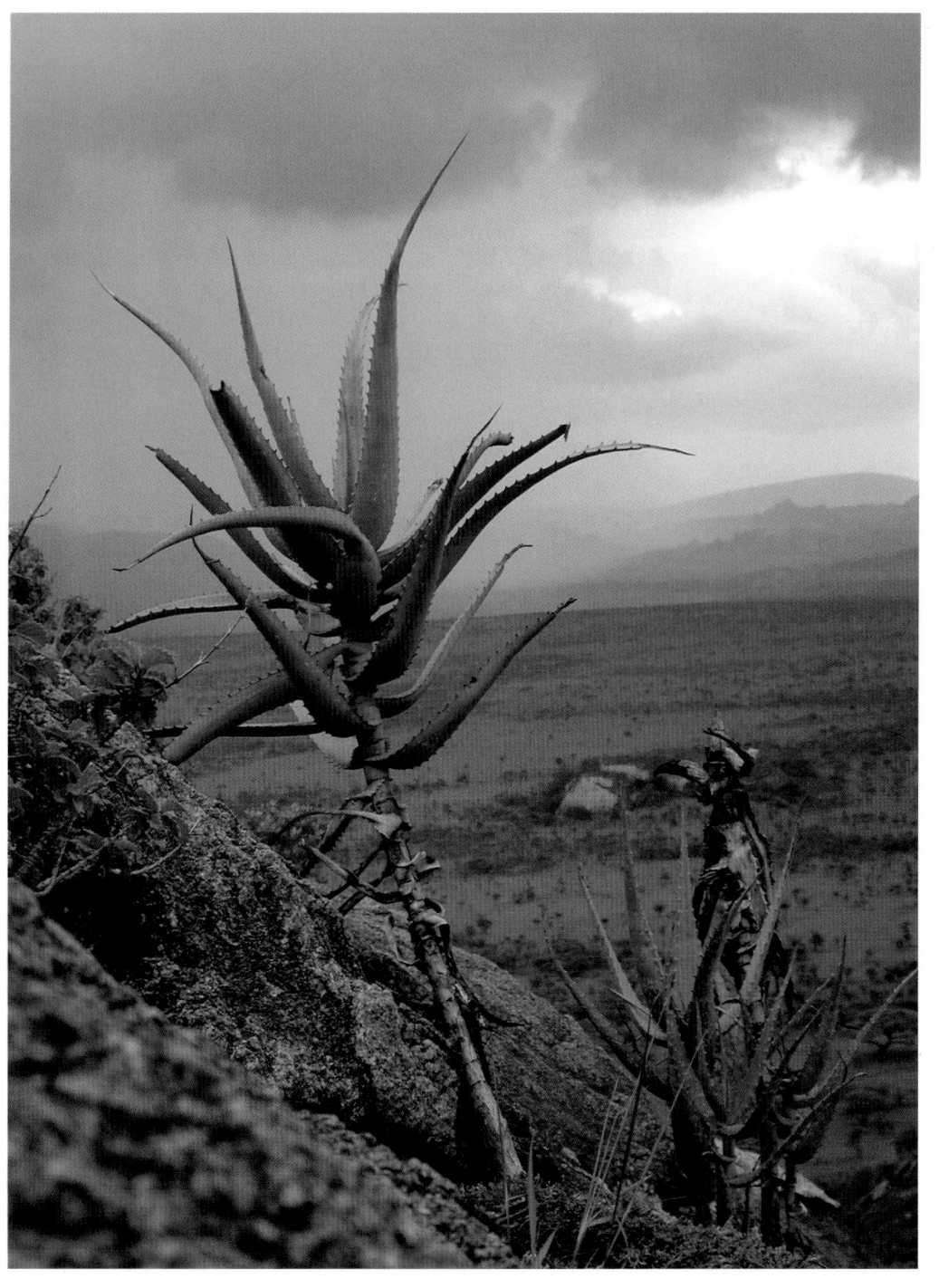

Aloe tree, Soitergoss Wilderness area, Tanzania. Nikon Coolpix 990

The low ƒ-stop I used to capture this image caused the lower left corner to be out of focus. I opted for a low ƒ-stop in order to use the handheld rule; I had to do a little rock climbing to reach the top of this kopje and I wasn't able to drag my tripod along.

◀ *The dark clouds filtered the sunlight, saturating both the grass and the mountains. I took this shot right before one of the most spectacular lightning storms I've ever witnessed. It lasted for hours while nine students and I huddled in our tents twenty miles from the nearest road.*

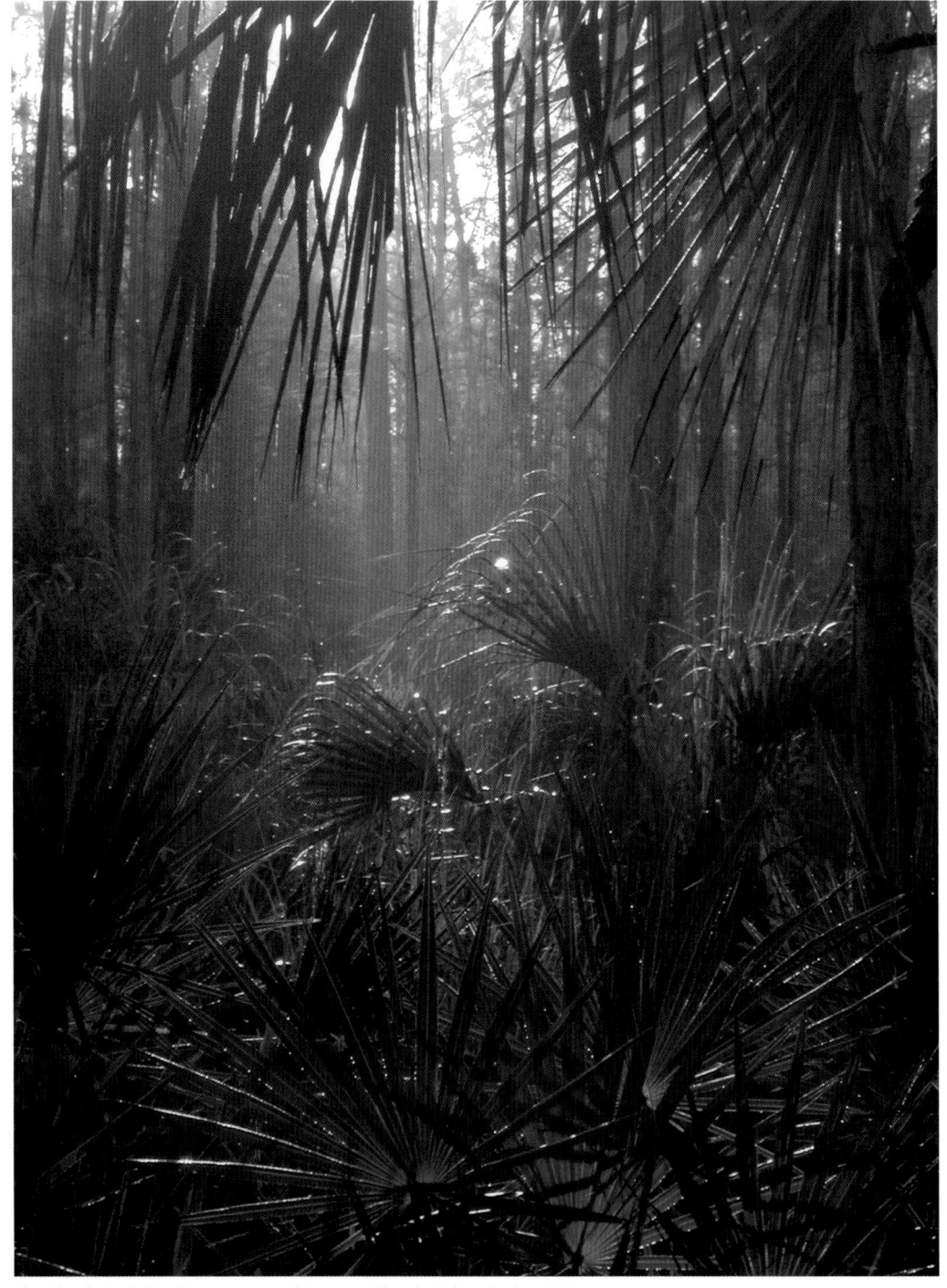

The Florida Trail, Big Cypress National Preserve, Florida. Nikon Coolpix 995

You won't find a better fog producer than the humid climate of southern Florida. Use of a tripod enabled me to use a slow shutter speed so that I could select a high f-stop to capture the greatest possible depth of field. The mist didn't last long; as soon as the sun crept above the last slash pine, the fog disappeared.

Thermal vents in Yellowstone consistently fill the valleys with morning fog. I handheld my camera to get this shot, using a shutter speed of 1/250 sec. The image is actually much darker than the scene was at the time. Use your camera settings creatively to summon up some magnificent images.

I could have pulled a little more color out of this scene if I had underexposed from the meter reading; however, I wanted to keep detail in the boardwalk. If I had underexposed for more color, I would have lost that subtle detail.

Yellowstone National Park, Wyoming. Nikon Coolpix 995

Black mangrove, Elliot Key, Biscayne National Park, Florida. Nikon Coolpix 995

REFLECTIONS

Reflections are the ultimate camera, momentarily capturing a three-dimensional scene on a single plane. The calmer the water, the clearer the reflection. Morning is the best time to capture a crisp reflection—while the water is still. However, the reflection doesn't have to be crisp to work aesthetically. A rippling creek or a choppy coastline still reflects light, just in a different way. You'll see only fractions of the scene and, most likely, high contrast between the lit areas and the areas in shadow.

Reflections are everywhere; your awareness of them will be heightened as you begin to photograph them. Puddles, ponds, lakes, oceans, streams, and even dew droplets all produce reflections. The key is finding the angle that works best for the scene.

Grasses, Big Bend Preserve, Florida. Nikon Coolpix 995

Note that the colors in the reflection are richer than those of the actual grasses. A reflection saturates color. Keep in mind, also, that you don't have to travel into the backcountry to get amazing shots. Look around. I took this photograph from the side of the road. With your digital camera you can reveal the extraordinary in ordinary places.

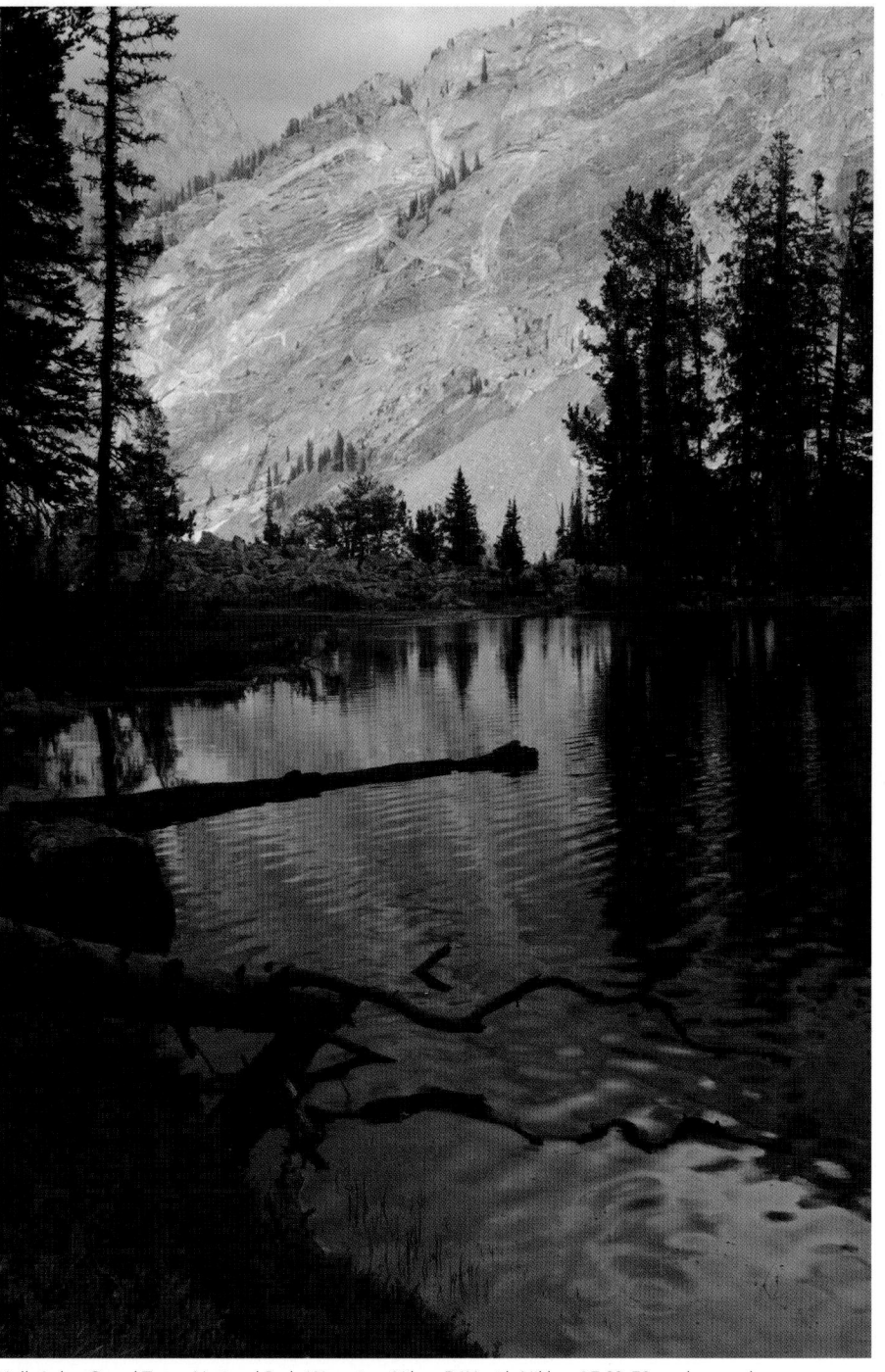

Holly Lake, Grand Teton National Park, Wyoming. Nikon D1X with Nikkor AF 28–70mm lens and Nikon SB-28 flash

I was instantly drawn to this scene; however, I didn't like the foreground as a silhouette. To combat the dark foreground, I used fill flash to cast light onto the grass and lighten the logs hanging over the water. By using fill flash, I added depth to the image. Note that a reflection doesn't have to be smooth or crystal clear to work, as the ripples on the surface of the lake show.

Morning mist, Lake Colden, Adirondacks, New York.
Nikon Coolpix 990

The first time people see this image, they have
an urge to turn it upside down because the
reflection is clearer than the reality. To capture a
reflection this clear, the water must be completely
still, which requires rising early before the wind
starts. Since I had a tripod, I could use a slow
shutter speed and high f-stop.

I did not have to rise early to capture this
image, however, as I was awake all night chasing
bears from our campsite. Five years ago, when I
started camping in this region I was lucky to see a
bear print. As more people come into the area,
bears find camping food as an easy meal, even
being fed by some people. Almost 100 percent of
campers in the High Peaks region in the summer
of 2001 were losing their food to bears. This is
not a bear problem; it's a people problem. Please
don't ever feed wild animals to attract them for a
photo; it's not worth the picture. If you're
camping in bear country, learn how to hang a
bear bag; or better yet, bring a bear canister not
only to protect your food but also to help the
survival of the bear.

Shell, New Jersey shore. Nikon Coolpix 990

As the wave receded, I spotted a clamshell with a hole in the middle. The soft morning
fog diffused the sunlight enough to produce a soft reflection on the thin layer of sea
water still clinging to the sand. One quick shot and the next wave came crashing in,
transforming the tiny seascape once again.

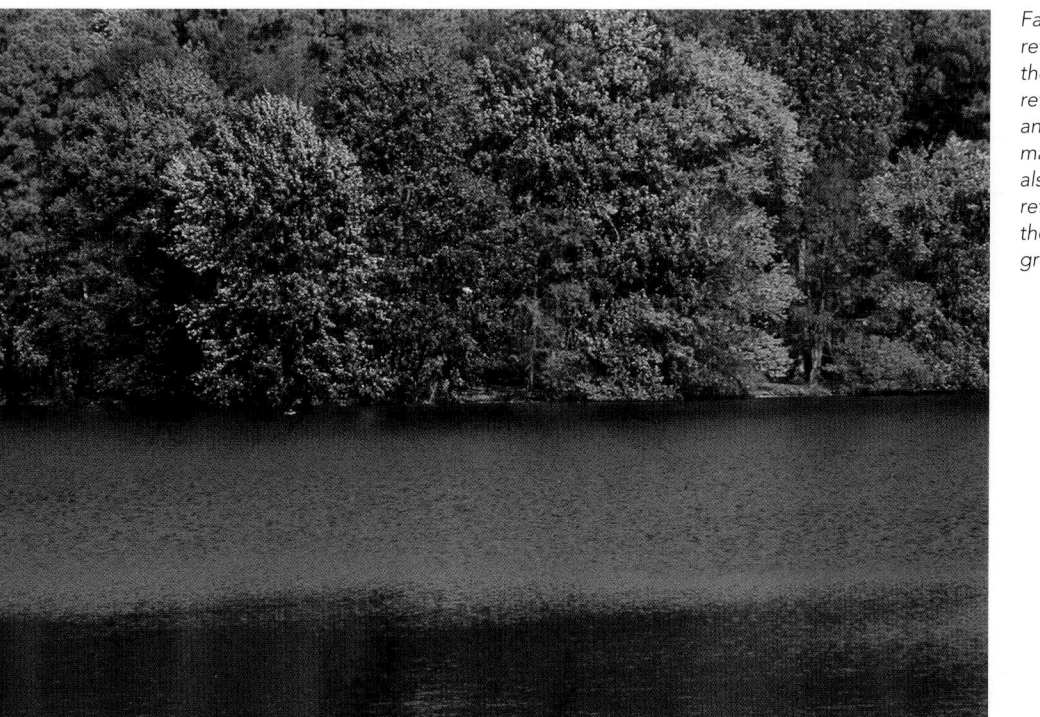

Fall colors are perfect for reflections. Facing my camera to the north, I was able to catch the reflection of the deep blue sky, and the trees were frontlit for maximum color saturation. Note also how the colors in the reflection are richer than those of the actual foliage; a reflection is a great saturator of color.

Hopes Reservoir, Delaware. Nikon Coolpix 950

This shot is like a naturally occurring double exposure: the lily pads and the reflected grasses occur on the same focal plain. I shot this late in the opulent afternoon light, which caused the grasses to look like glowing strands of gold.

Lily pads with reflected grasses, Anhinga Trail, Everglades National Park, Florida. Nikon Coolpix 995

Maasai warrior, Tanzania. Nikon Coolpix 990

Peering over the grazing plains of Maasai land, I spotted the reflection of this warrior in a small puddle atop a rock outcropping. The higher I climbed up the rock outcropping, the more visible the warrior's reflection became in the puddle. Reflections are everywhere—you just have to be observant.

Epiphyte, Big Cypress National Preserve, Florida. Nikon Coolpix 995

Hiking waist deep through a cypress grove with seventy pounds on my back is one of the most interesting experiences I've had venturing into the backcountry. I wanted to capture an epiphyte (a plant that usually grows on another plant) and the environment, but the sky was cloudy and would have resulted in overexposure had I included it in the image. The reflection of the sky (serving as the background in this image) is at least one stop darker than the sky itself. This way, I not only captured the environment but added interest to the image.

PATTERNS IN NATURE

If a system works, nature repeats it. From a single frozen water crystal to millions of cells combined to create entire organisms, pattern is appealing. Nature often follows a predetermined map. Take, for example, the formation of clouds: Each water droplet comes together to form a certain type of cloud—cirrus, cumulous, stratus; the environmental conditions dictate the outcome. Another example is the honeycomb of a beehive: Each honeycomb cell constructed by worker bees is the same size and holds the same volume as the next. The position and shape of the cells maximize the space to its full extent.

Patterns are everywhere. Keep your eyes open to find them. Scales on a butterfly, gills on a mushroom, waves in the ocean, and branches on a tree are illustrations of nature's patterns. The question is, How do you shoot a pattern?

Photographing the patterns of nature will help you with your composition technique. The key to capturing a pattern in the natural world is to ignore all the previous rules of composition—focus on nothing. No foul zone to avoid, no rule of thirds. A true pattern has no end and no beginning; it simply repeats itself to form a more substantial image. Shooting patterns enables you to see the entire scene in the frame, which, ultimately, is what you strive for when composing any photograph. If you can see the entire frame, you are aware of any subtle distractions in an image.

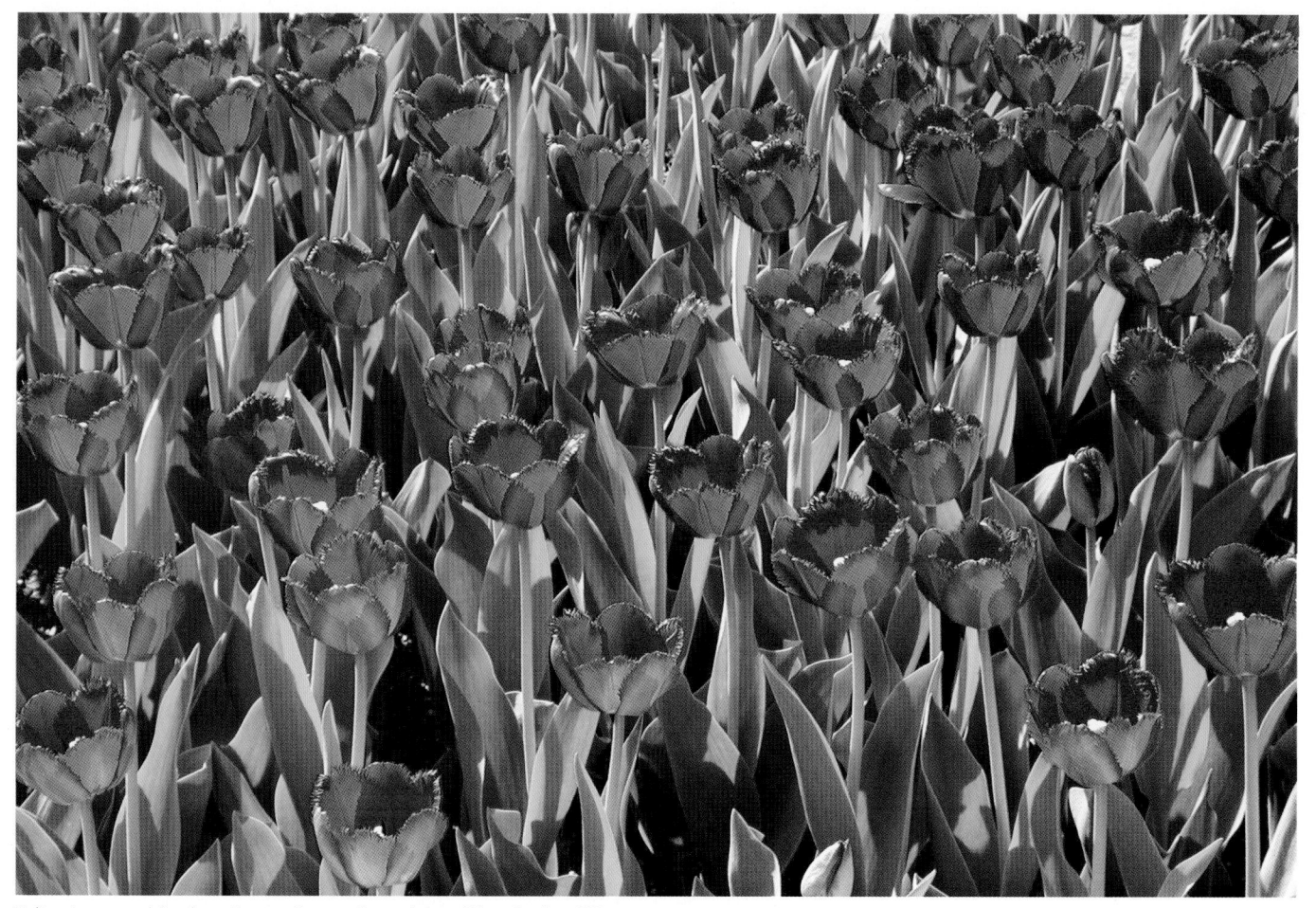

Tulips, Longwood Gardens, Kennett Square, Pennsylvania. Nikon Coolpix 995

We recognize the beauty of patterns, often using them in our gardens to create a dramatic effect. I shot this just as the sun peeked above the tree line. The backlighting caused the petals and leaves to appear translucent, increasing the spectacular effect of the pattern.

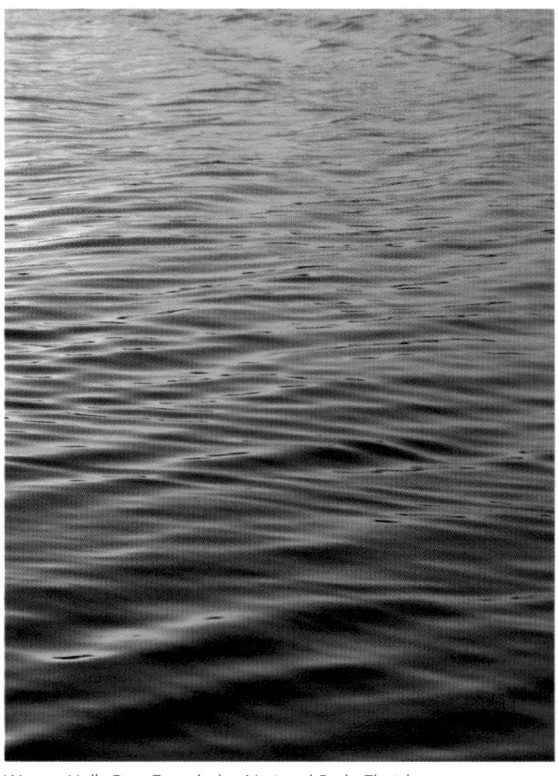

Waves, Hells Bay, Everglades National Park, Florida.
Nikon Coolpix 995

Waves form one of the most repetitious phenomena in nature. I wanted to freeze the motion, so I used a high shutter speed, which forced me to use a low f-stop. I was in a canoe with my tripod securely fastened to one of the support beams.

Rippled sand, Elliot Key, Biscayne National Park, Florida.
Nikon Coolpix 995

As the tide rolls out, it leaves behind miniature dunes resembling the waves that created them. I took this shot late in the afternoon when the sun was low enough to cast light shadows in the low sections of the little dunes. Notice how they seem to have no beginning or end.

Green cactus, Longwood Gardens, Kennett Square, Pennsylvania. Nikon Coolpix 950

Repetition draws the viewer to this shot. Each cactus has repeating spiral whorls; the more than 30 cacti in the shot make this an intriguing pattern.

A sky filled with giant puffy clouds is irresistible. An abundance of light allowed me to handhold the camera for this shot. I used the highest possible f-stop and increased the shutter speed one stop from the meter reading to saturate the color of the blue sky, thus setting off the clouds.

Clouds, Everglades National Park, Florida. Nikon Coolpix 950

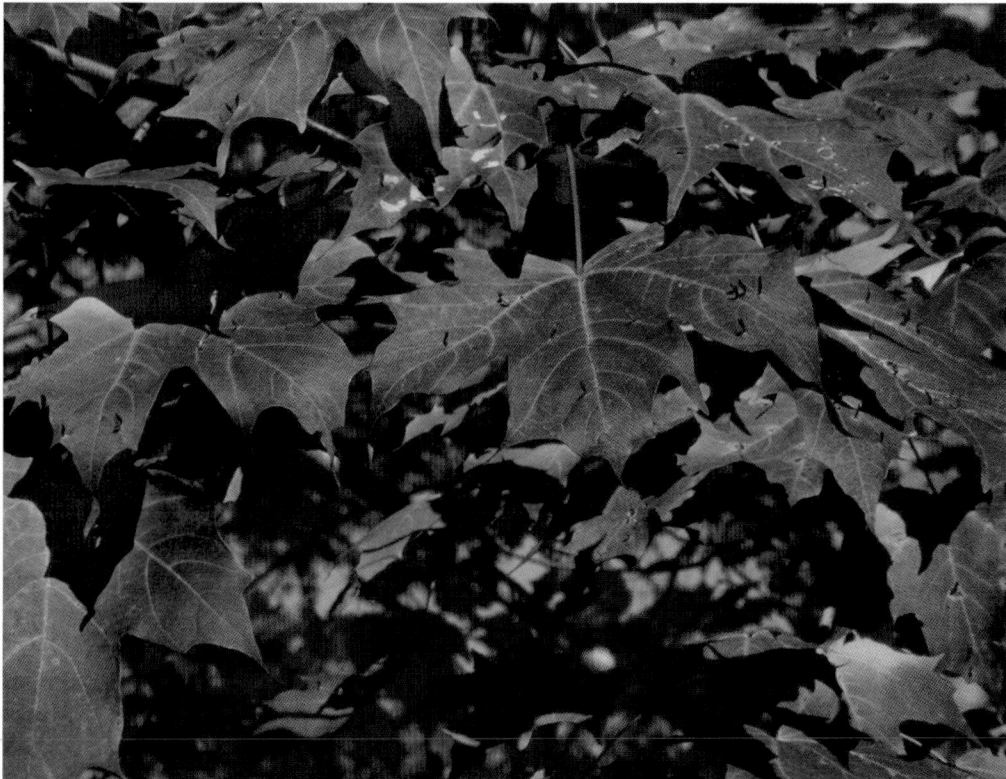

Each fall I look forward to the millions of colored leaves that transform the landscape into a masterpiece painted by Mother Nature. The cooler the nights, the better the color. To shoot this image, I faced north, which enhanced the deep blue fall sky.

Maple leaves, Newark, Delaware. Nikon Coolpix 995

SNOW

My first time shooting in snow with a digital camera gave me the confidence I needed to switch to digital completely. As I hit the Calamity Brook Trail in the Adirondacks in late January of 2000, I thought I was fully equipped, with snowshoes, bivy sack, fleece liner for the sleeping bag, and an ample food supply. I strapped on my snowshoes and started my trek in the chilly but tolerable 10-degree Adirondack mountain air.

At this point in my photography career, I was still seesawing between 35mm film cameras and digital cameras. I packed an arsenal of equipment: my old faithful Pentax K-1000, my Nikon 6006, and my Nikon Coolpix 950. After about a 3-mile hike into the snow-blanketed winter wilderness, I set up camp, scarfed down some Lipton instant noodles, and settled into my sleeping bag for what I thought was going to be a warm, comfortable sleep.

I awoke at 11:00 P.M. shivering. I felt a cold so intense I was immobilized. I tossed and turned for the next six hours trying to force blood into my extremities. The silence was pure, broken every so often by a cracking sound piercing the stillness as the tree sap froze and expanded in the arctic Canadian-driven temperatures—which split the trees wide open! It sounded like gunshots echoing through the frigid hemlock forest. Finally, at 5:00 A.M. I emerged to check the thermometer. Over the course of the night, the temperature had plunged below minus 20 degrees Fahrenheit, which is as low as my thermometer registers. My breath froze into minute crystals on every exposed hair and fiber.

The stars were still out, and since I had managed to warm up a little, I reached for my Pentax K-1000 and focused on the constellation Orion and the hemlocks silhouetting the horizon. I depressed the shutter. Nothing happened. This totally manual

Mount Washington, New Hampshire. Nikon Coolpix 950

While skiing at Wildcat Ski resort late in the season, I noticed a spring snowstorm hovering above Mount Washington's peak before it moved in and deposited a couple of inches of fresh snow on the slopes. If I'm out enjoying a day of skiing, I don't lug around my Nikon D1X and risk falling on it or getting it wet. It's much easier for me to put my Nikon Coolpix in a plastic bag and slip it into my coat pocket, where it's at the ready if a photo opportunity arises. This storm blew over Wildcat in just minutes, which meant that if I had not had my camera with me, I would have missed the shot. I overexposed from my meter reading to capture the snow as white, not gray, which is what my camera wanted to record it as.

workhorse of 35 mm SLR cameras had frozen up. I tried again with the Nikon 6006. It, too, was rendered useless by the deep freeze. My headlamp was also seized up. I had traveled six hours and trekked three miles through three feet of snow to capture some winter images, and nothing was working. Even my zippers were stuck because of the arctic weather conditions. At this point, even though I had no faith in anything man-made, I decided to try the Nikon Coolpix 950.

As I turned the switch to manual, a twinkle of light appeared on the LCD screen. After about five seconds, a faint image appeared. I couldn't believe it! The digital camera worked! It was slow, but working. I shot until I couldn't feel my hands, took off my boots and socks, and got back into my bivy sack, realizing my big toe and half my right foot were turning white in the early stages of frostbite. I returned home with a newfound respect for the rugged Nikon Coolpix 950, the only thing—man or equipment—that truly survived the arctic blast without malfunctioning.

Since my frozen-north adventure, I keep the camera batteries in an inside pocket. That way, they stay warm and ready, I put them in the camera only when I plan to use it, and the camera turns on immediately. This also extends the life of the battery. If you have a pocket-size digital camera, keep that in an inside pocket, as well. Then the only thing you have to look out for is condensation on your lens.

EXPOSING FOR SNOW

Capturing the exposure you want in snow requires that you make camera adjustments to photograph the scene the way you see it. Set the white-balance feature to *white present* to keep the snow from being underexposed by the camera's meter. When white is present in an image, the meter tries to make it a mid tone, causing the image to be underexposed and the snow to appear gray. If you don't have a *white present* setting, manually increase the amount of light being recorded, which will counteract the meter's underexposure.

Cardinals, Unionville, Pennsylvania. Nikon D1 with Nikkor AF VR 80–400mm lens

This is one of my best-selling shots, especially during the holiday season. I wouldn't say it's one of best shots, photographically. It does, however, seem to evoke an emotional response from many people. Husbands buy it for their wives, girlfriends buy it for their boyfriends, and some people buy it because it reminds them of a snowy day when they just sat back and watched the birds. Even though it's not mating season, this pair of cardinals stays together the entire year, visiting my feeder every morning and late afternoon. They have become accustomed to my opening my kitchen window to snap a few shots. Using a long zoom enabled me to crop in on them. Don't overlook your backyard as a subject in various lighting and weather/seasonal situations.

Mount Rainier National Park, Washington. Nikon D1X with Nikkor AF 28–70mm lens

Mountain weather changes quickly, and so do the lighting conditions. I started shooting as a cloud moved in front of the sun, which silhouetted the evergreen trees. The snowfields in the background remained in direct sunlight, which added interesting contrast in the image.

TRIPOD USE IN COLD WEATHER

When using a metal tripod under cold conditions, use duct tape and pipe insulation to cover the legs. This keeps your hands from touching metal and freezing. When using my carbon-fiber tripod, I don't bother with the pipe insulation because carbon fiber doesn't get as cold as metal.

ANIMALS IN THE LANDSCAPE

I once stalked a bull elk all morning to get close enough for a portrait. As the wind shifted against me, so did my chances of capturing a close-up of the colossal creature. Instead of packing up my gear and heading back to camp, I photographed the bull elk as part of the scene and not just as the single focus of the image (below). If your zooming capabilities aren't enough for a portrait, tap into your creative side to allow the animal to interact, completely undisturbed, with its environment. Use the distance to incorporate the creature's uninhibited natural behavior into the shot.

A classic compositional mistake photographers make is, despite being too far away to make a portrait, taking a photo of the animal when it's directly in the foul zone—just to prove they saw it. They figure, No matter, I'm lucky to have the opportunity to photograph any wildlife. Instead of composing with the animal in the foul zone, try another approach, making the most of the situation. Remember the rule of thirds and compose the image with the animal heading into the frame. Try to guide the viewer through the image by use of a creative composition.

One way to evaluate the success of a landscape shot that includes wildlife is to visually remove the animal from the shot. Ask yourself, Does the landscape still capture your attention? Look again. Does the animal add to the aesthetic quality of the image?

Bull elk, Yellowstone National Park, Wyoming. Nikon Coolpix 990

Not able to attain a close-up portrait, I made the majestic elk part of the landscape. Since I was facing directly into the sun, the sky took on a washed-out look. Yet facing the sun created some interesting backlighting effects and rim light on the elk's velvet antlers.

Elephants, Ngorongoro National Park, Tanzania.
Nikon D1 with Nikkor 17–35mm lens

Elephants that took refuge in this park during the ivory poaching era escaped unharmed and, consequently, have some of the largest tusks in the world. Elephants' tusks grow their entire life, so a 70-year-old male can have tusks that seem to scrape the ground. I used a wide-angle lens to capture this train of elephants trekking across the open grasslands.

Canadian geese with goslings, Brandywine State Park, Wilmington, Delaware.
Nikon Coolpix 990

If I were to take the geese out of this image it would still work. However, since I composed the geese swimming into the frame, they give the scene life; you can feel the movement as the geese meander up the Brandywine River leisurely enjoying the same spring day you are.

Gull, Elliot Key, Biscayne National Park, Florida. Nikon Coolpix 995

A semisilhouetted pier against a reflected sunset is a classic shot, but doesn't it work much better with the addition of a perching gull? Note the use of the rule of thirds: pier in the lower third, horizon in the upper third, and gull in the upper right target zone.

Vervet monkey, Ngorongoro National Park, Tanzania.
Nikon D1 with Nikkor AF VR 80–400mm lens

Wanting to make the vervet monkey stand out as much as possible, I used a low f-stop for a small depth of field; this blurred out the yellow-fever acacia tree forest in the background, which emphasized the downed tree and vervet monkey.

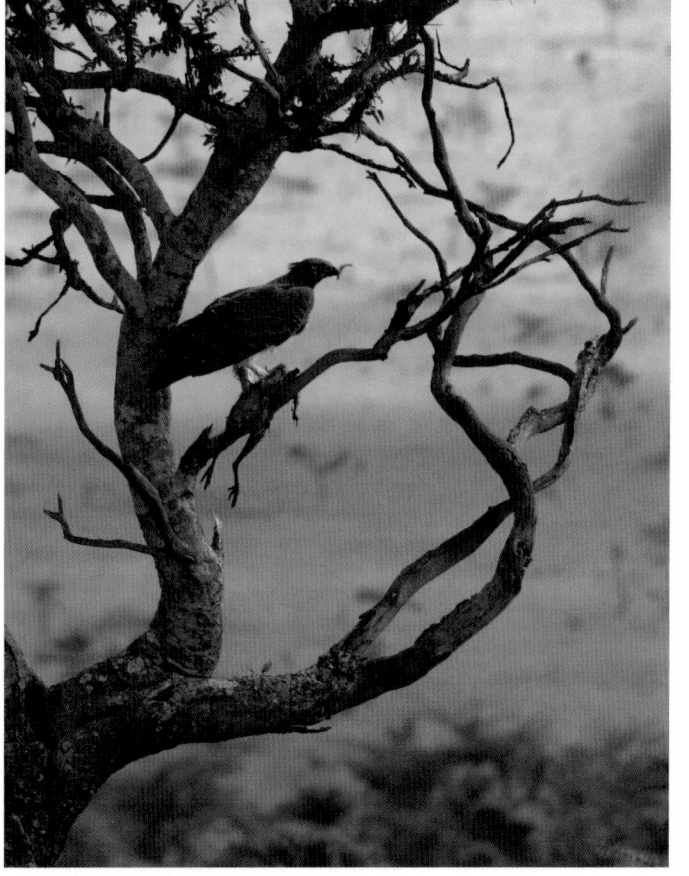

Eagle with prey, Serengeti National Park, Tanzania.
Nikon D1 with Nikkor AF VR 80–400mm lens

I disobeyed the handheld rule on this shot, with the zoom extended to 400mm and a shutter speed of 1/125 sec. I was able to get a sharp image because the lens, with its vibration-reduction technology, counteracted my shake.

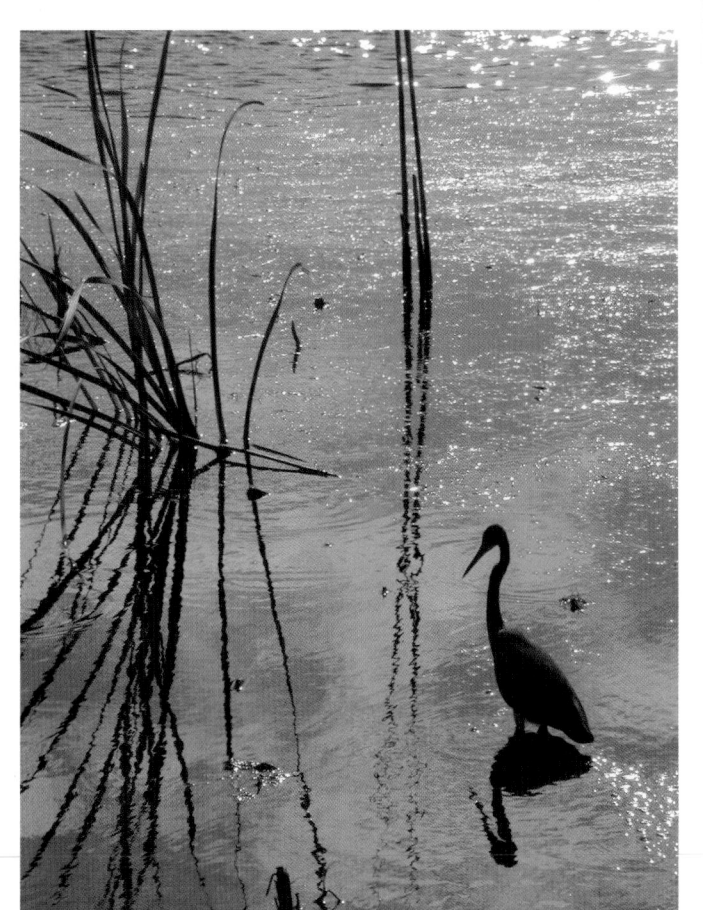

Heron, Eco Pond, Everglades National Park, Florida. Nikon Coolpix 995

With all the interesting backlighting and reflections that are occurring in the scene, I didn't need the heron in this image to capture the viewer's attention. However, the heron adds to the shot. I positioned the bird in the lower right target zone, and to silhouette it and the grasses, I increased the shutter speed one stop from my meter reading to limit the light recorded.

Badlands National Park, South Dakota. Nikon Coolpix 990

SUNRISE
& SUNSET

A S WITH ANY SUBJECT, before you shoot ask yourself why you are drawn to the scene. And, as a photographer, emphasize those characteristics that attracted you. In the case of a sunrise or sunset, most likely it is the color and shape of the landscape.

EXPOSURE

Accentuating the essence of a sunrise or sunset is simple if you follow a few easy steps. You can meter this type of scene many ways. Some photographers meter the brightest part of the sky. I use matrix metering to measure the light in the entire scene, including the brightest and darkest parts of the landscape. Metering the entire scene usually gives me an overexposed image. A slight overexposure can be crucial when including subtle detail. However, most often I underexpose the image to saturate the color and silhouette shapes, which is exactly what you want to do in sunrise or sunset images. You can underexpose the image two different ways: either increase shutter speed or increase f-stop. Both limit the light recorded on the CCD.

Meribu stork, Ngorongoro Crater, Tanzania. Nikon D1 with Nikkor AF VR 80–400mm lens

I watched and photographed this stork for about an hour while I waited for him to take flight. Knowing animal behavior is crucial to capturing consistently good animal shots. I knew that the storks roost in acacia trees at night, so it was inevitable that the stork would take off just before darkness fell. Since I wanted to stop the action of the stork, I used a high shutter speed. I underexposed the scene one stop to silhouette the bird and saturate the color of the orange sky.

CROPPING OUT THE SUN IN CAMERA

Many of my sunrise or sunset shots don't actually include the sun. I either get up before it rises, or I wait a few minutes after it sets. These two times of the day are some of my most peaceful moments. I just sit back and enjoy the colors while waiting for the perfect moment to snap a shot. Leaving the sun out of the image lends an overall softer feel, inviting the viewer to travel throughout the image, not just focus on an overexposed area.

Pearl Bay, Everglades National Park, Florida. Nikon Coolpix 995

I shot this fifteen minutes before the sun peeked over the red mangroves. I wanted to include subtle detail in the canoes to maintain the tranquil mood of the scene. I took about eight bracketed shots before I was happy with the detail and color in the image. The perfectly still water allowed me to use a long shutter speed and catch a sharp reflection. This is one time I ignored the rule of thirds, placing the horizon in the middle of the frame; it works because the canoes break up the bottom half of the scene.

Hells Bay, Everglades National Park, Florida. Nikon Coolpix 995

▲ Even after the colors of the sunrise fade, great photo opportunities still abound. To capture the menacing clouds lingering above, I under-exposed to make the clouds appear darker than they were, thus intensifying the drama in the shot.

▶ Luckily, a pair of ravens woke me up just in time to capture the sun rising above Holly Lake. I underexposed by two stops from my meter reading to saturate the color. Using a tripod enabled me to use a low shutter speed and an f-stop of f/22 to obtain the highest depth of field possible.

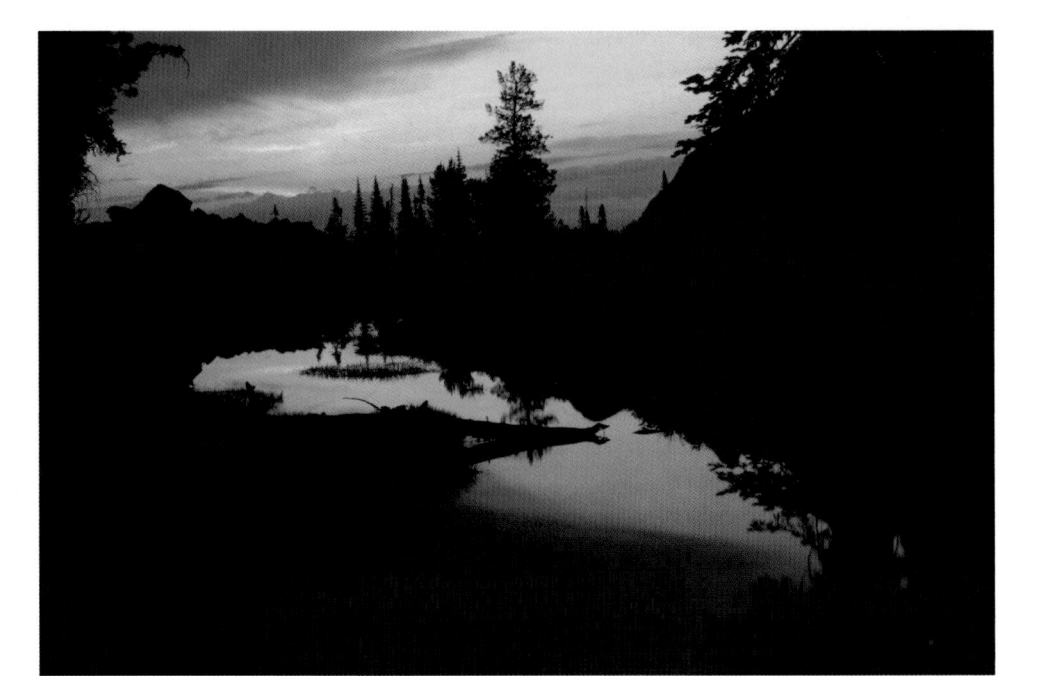

Holly Lake, Grand Teton National Park, Wyoming. Nikon D1X with Nikkor AF 28–70mm lens

SUNSETS

Patience is paramount to capturing a brilliant sunset. The first time I set out to photograph a sunset, it was a complete failure, but I did learn a valuable lesson. After carrying all of my camera gear up a steep hill in the middle of winter, I set up an hour before the last warming ray disappeared for the night. I snapped off a couple shots until the glowing orb fell below the horizon. Unsatisfied with way the winter scene looked, I packed up my gear and tossed it in the back of my pickup. As I was driving away, I saw the best shot in my rearview mirror. I had left too early to capture the brilliant colors of a blazing sky, postsunset—something I vowed never to do again!

When I'm on a sunset photo shoot, I scout out the scene ahead of time. This way, I can anticipate the location at which the sun will drop, thus increasing my chances of a fantastic shot. I search for subjects to include in the foreground to add depth to the image and lead the viewer through the frame. Trees, people, and birds are excellent silhouette subjects that make an ordinary sunrise or sunset shot extraordinary.

My recipe for a savory sunset lies in the bracketing. Take a meter reading of the entire scene and shoot the image. Now underexpose by half-stop increments until you've taken a total of five shots. Your last shot in the bracketed sequence will be two stops underexposed from the meter reading. Each shot will have a slightly different emotional feel, allowing you to pick the one that best reflects your feelings. When you bracket with a digital camera, don't feel guilty about taking too many shots. Bracketing and viewing the images on the LCD screen can save an image. I'll say it again: Digital cameras have the advantage. Take as many shots as needed to get your "vision"—you can always erase the ones you don't like and it doesn't cost anything.

Acacia tree, Tanzania. Nikon Coolpix 990

I framed the tree horizontally to accentuate the sprawling branches. Using the rule of thirds, I composed so that the underbrush was in the bottom third of the image. I underexposed from my meter reading to saturate the color of the sky.

AFTER DARK

When other photographers are packing up their gear and turning in, it's time to go on the prowl for some night shots. The sun isn't the only light source you can harness for digital images. You can shoot by the light of a fire, the moon, a flash, or other artificial lights.

Early digital cameras weren't good at making long exposures. The longer the shutter speed, the more "noise" appeared in the image—in the form of overexposed random pixels. Today's digital cameras are improving to the point that I feel comfortable taking exposures of more than a second. Some digicam models even have a noise-reduction setting to cut down on the overexposed pixels in an image. The technology of long exposures hasn't advanced to the point, however, that you could shoot a star trail; you can capture stars, but a five-hour exposure is still out of the question for digital technology.

To shoot long exposures, use a tripod or some type of camera support. Without camera support, results will be blurry. With nothing visible on the LCD screen (due to the darkness), you'll have to use the viewfinder to compose your shot. Take a meter reading, shoot, and see what it looks like. If the shot is a little blurry, camera shake from depressing the shutter may be the cause. One way to get around this is to use the timer, thus reducing photographer shake as long as the camera is properly supported. Your camera model may also have a shutter-release cable, which also will eliminate photographer shake—and you won't have to use the timer.

At night the meter may tell you that you don't have enough light to take a shot. If your camera has a bulb setting, this is the time to use it. A bulb setting means that the shutter will stay open as long as you hold down the shutter-release button. The longest exposure I've taken with acceptable results is thirty seconds; even so, I rarely shoot anything over four seconds long.

Silhouetted trees, Yellowstone National Park, Wyoming. Nikon Coolpix 990

You can see that at a shutter speed of one minute, noise appears in the image. The longer the shutter speed, the more noise will appear.

Illuminated tent, Yellowstone National Park, Wyoming. Nikon Coolpix 995

I used a few techniques to capture this shot. Having composed the shot using a tripod, I set up a flash with a slave trigger attached to it in the tent. (A slave trigger causes the flash to fire when another flash of light hits it.) I positioned someone with another flash to the left of the tent about forty feet away, making sure she was out of the frame. Then, I started my long exposure. At about ten seconds into the exposure, I signaled my helper to fire off her flash, which in turn caused the flash in the tent to go off. I continued the exposure for another twenty seconds. The flash can be fired off at any time and produce the same result. The long exposure made it possible to capture the blue color of the sky and silhouette the dead evergreen trees.

With a group of eleven students, I hiked over six miles to an open meadow with a clear view of the towering mountain. We got there by 4:00 A.M., and the moon was so bright, most of the time we didn't even need our headlamps. To capture this magical scene, I used a shutter speed of twenty seconds with an ISO of 125 and an f-stop of f/4.5. At 4:15 A.M. clouds rolled in completely blanketing the mountain. Nature photography requires being at the right place at the right time, but you also have to know how to use your equipment effectively.

Moonlit Mount Rainier, Washington. Nikon D1X with Nikkor AF 28–70mm lens

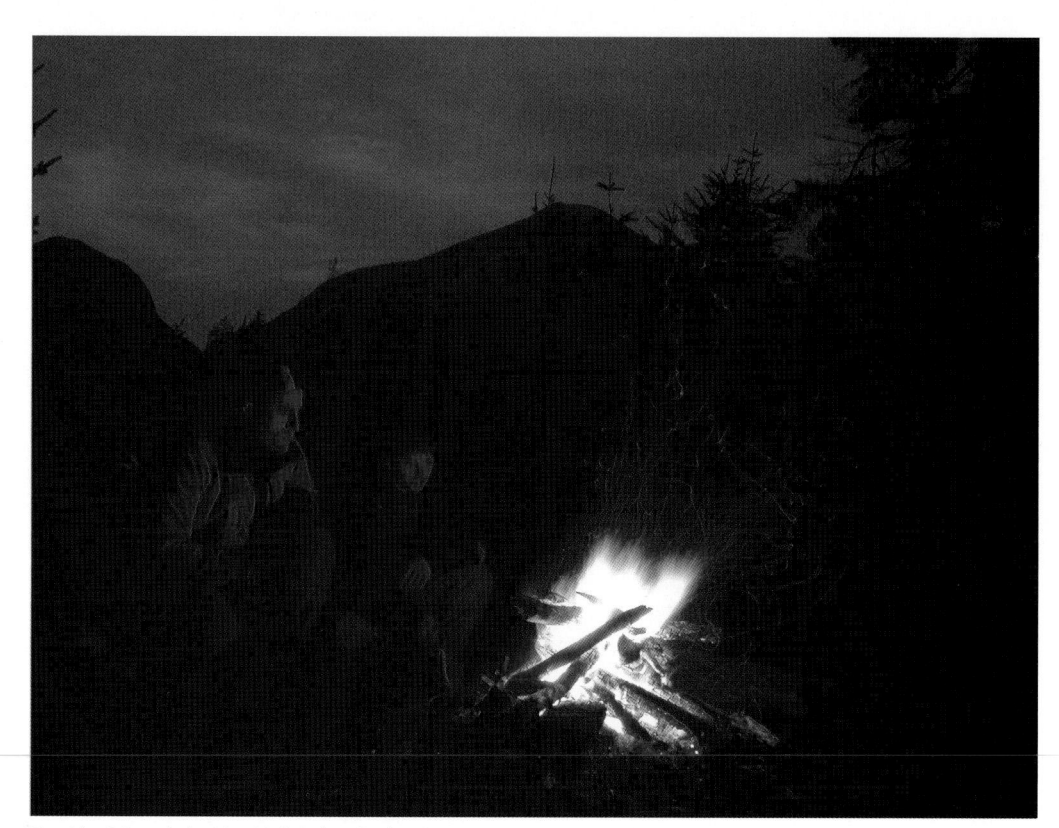

Using a tripod for this four-second exposure was essential to capturing a sharp shot. I asked my two friends to sit completely still while the shutter was open. Even though the sun had already set, there was just enough light to illuminate the sky and silhouette the mountains in the background.

Fireside, Adirondacks, New York. Nikon Coolpix 990

CHAPTER SEVEN

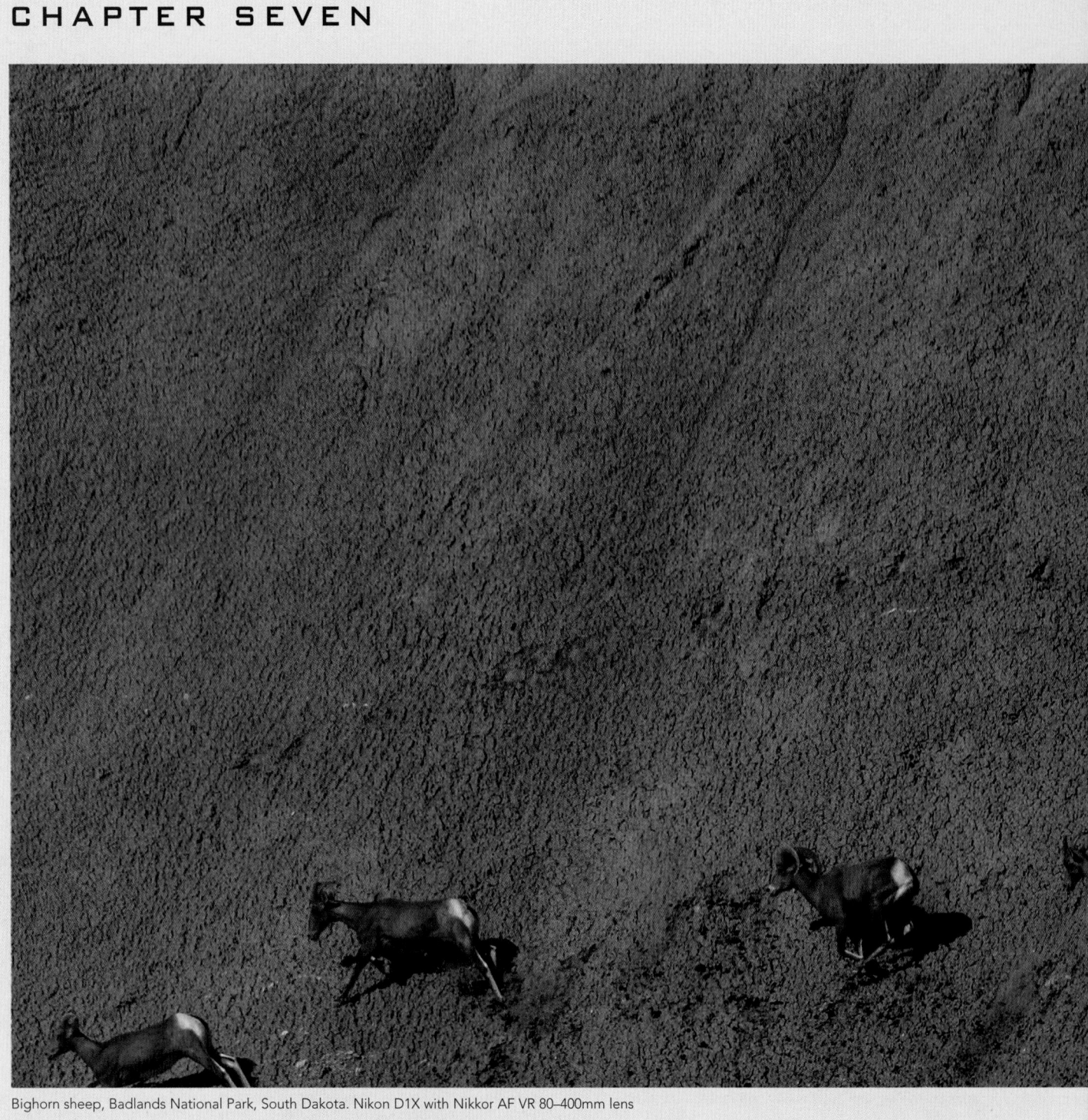

Bighorn sheep, Badlands National Park, South Dakota. Nikon D1X with Nikkor AF VR 80–400mm lens

ANIMAL PORTRAITS

ANIMAL PORTRAITS are quite possibly the most captivating images. As humans, we're drawn to them because we can relate to other animals. We feel the subject's excitement, sadness, or concern. As a photographer, aspire to capture the essence of the animal you're shooting. A great animal portrait not only captures physical attributes, but gives the viewer a sense of the animal's character. This may seem a daunting task; yet a good portrait shot is well worth the effort.

GETTING CLOSE

How close do you have to be to call an image an animal portrait? There's no definite answer. If you crop in, filling the frame with the animal, it's a definite portrait. Yet, if you zoom in too close, you may be cropping out the information that allows the viewer to get to know the subject. If your subject doesn't fill the entire frame, what you are doing is including an interesting element in a landscape shot. When the animal in the image engages most of the attention and elicits an emotional response, I consider the photograph a portrait.

The best way to get close to your subject is to use a long zoom lens. A zoom lens enables you to photograph your subject without disturbing its environment and disrupting its natural behavior. No matter what size zoom you use, chances are the animal already knows you're there because its senses are much better than yours. The goal is to stay far enough away that the animal doesn't feel threatened. If you keep your distance, your chances of capturing the animal's natural behavior are much better.

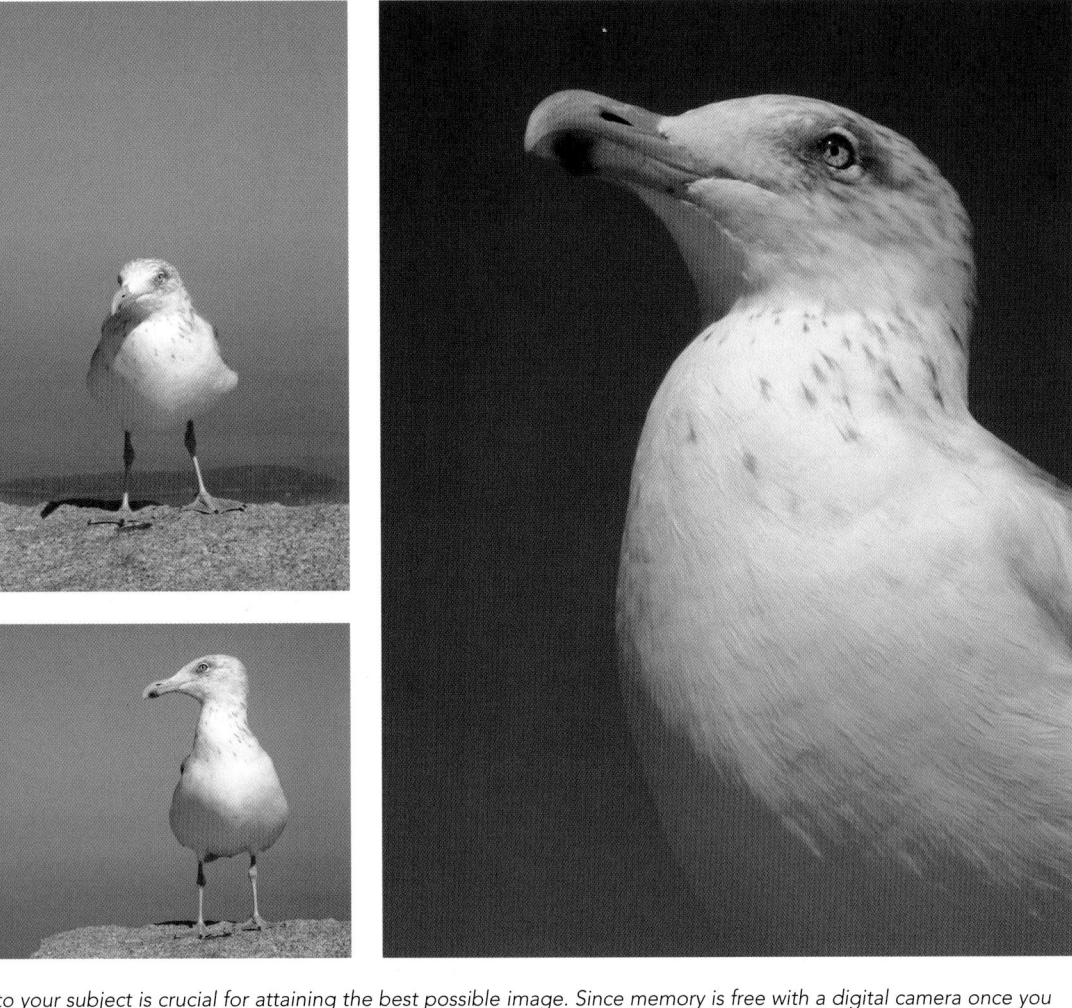

Gull on Cadillac Mountain, Acadia National Park, Maine. Nikon Coolpix 995

Sticking to your subject is crucial for attaining the best possible image. Since memory is free with a digital camera once you make the initial investment, take as many shots as you must to get the image you envision. In just a few minutes time, I photographed this gull using three different compositions. As I approached this perching gull, it hunched down, preparing to fly. I stopped, composing a shot of the gull with its beak pointing directly into the camera at my eye level. This straight-on angle immediately connects the viewer to the gull. When the gull bobbed its head up and looked to its right, I immediately switched to horizontal framing, catching the gull looking directly into the camera. By composing in this way, I gave the gull room to either fly off or simply hop along the granite wall, and the viewer's eye room to move throughout the image.

As the gull became more comfortable with my presence, I inched closer, positioning myself below it to make it seem significantly larger than it was. I was facing north to capture a deep blue sky, and my exposure had to be dead-on to catch the detail in the white feathers. One problem with photographing white subjects is that a slight overexposure will eliminate detail. Since the gull was facing south, I was able to capture a highlight in the eye from a reflection of the sun.

American crocodiles, Flamingo Marina, Everglades National Park, Florida. Nikon Coolpix 995

There are fewer than 500 of these endangered prehistoric reptiles left in the saltwater coastal areas of southern Florida. These two resident crocodiles of Flamingo Marina are an easy subject to capture, because they don't move much. However, after seeing my first shot, I realized that a bridge was being reflected in the water, adding a human reminder that I didn't want in the image. Capturing the crocodiles in their natural environment required my eliminating the human influence of the bridge. Moving a few steps to the right, I was able to avoid that reflection. This is a case in which seeing the image immediately on the LCD screen helped me get the image I wanted. Had I been using film, I wouldn't have noticed the reflection until I was back at my light table in Unionville, Pennsylvania, 1,300 miles from the nearest wild crocodile.

Squirrel tree frog, Big Cypress National Preserve, Florida. Nikon Coolpix 995

Every saw palmetto in Big Cypress National Preserve seems to have a resident population of tree frogs. This particular frog was a model subject, letting me set up my tripod within four inches of it. The tripod allowed the use of a long shutter speed and a high f-stop. Since the sun was at a low angle to the frog, the light sheered across it, producing a shadow that emphasized its shape. I used the close-up mode and manually focused the pocket-sized digital camera to capture the subtle green tones of the scene.

KEY ELEMENTS

Composition and lighting are the key elements of a good portrait. If you want to make the animal appear larger or more powerful, position the camera below the animal's eye level, which will increase the dramatic effect caused by the low camera angle. A low angle will actually make the viewer feel vulnerable. However, if you position yourself above the animal, the animal will appear nonthreatening. Viewers will feel as though they are more dominant than the animal in the image. If you want the viewer to be on the same playing field as the animal, photograph the animal at its eye level. An eye-to-eye angle works best if you want the viewer to make an immediate connection with the animal.

No matter what angle you chose for a portrait, include an eyespot whenever possible. An eyespot is an overexposed highlight in an animal's eye. It gives a subject life. If your subject is facing away from the sun, you can still include a highlight in the eye by using the camera's internal flash or by adding a highlight in an imaging program after you download the shot.

The lighting and composition will change the effect of the image. A soft, diffused light works best to give the animal portrait a warm, calming feel. A hard, contrasting light lends drama to an image and can make an animal look intimidating.

Choosing a format for this shot was easy: I emphasized the long neck by using vertical framing. Watching this giraffe run away from the safari vehicle was hilarious, his long legs flaring about as he sped across the scrubby landscape.

In popular parks, such as Yellowstone or Ngorongoro Crater, animals have become habituated to vehicles and aren't scared by human presence. However, when you're in remote areas, as I was when I took this shot, the animals aren't accustomed to vehicles and they have a much larger comfort zone. It is important to always be aware of an animal's comfort zone and avoid it, not only for the animal's safety but also for your own.

Giraffe, Tanzania.
Nikon D1 with Nikkor
AF VR 80–400mm lens

Late in the afternoon, as the sun neared the horizon, a stork stood between my camera and the sun, which resulted in a perfect backlighting situation. The sparse feathers on its head appear translucent. By composing the image with the stork headed into the frame, I left room for it to move.

Meribu stork, Ngorogoro Crater, Tanzania. Nikon D1 with Nikkor AF VR 80–400mm lens

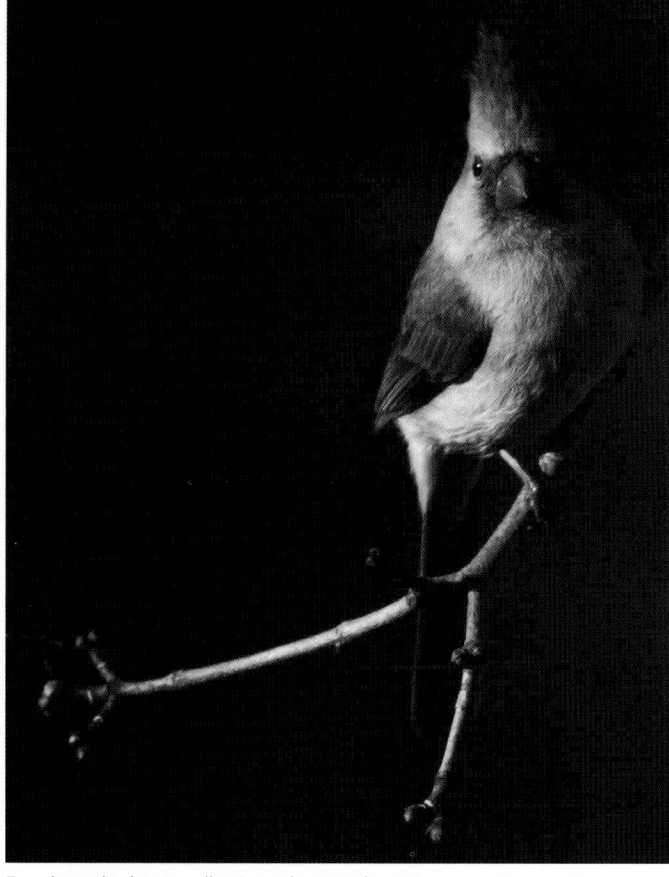

Cuban tree frog, Everglades National Park, Florida.
Nikon Coolpix 995 with fill flash

Female cardinal, Unionville, Pennsylvania. Nikon D1
with Nikkor AF VR 80–400mm lens

I used my camera's pop-up fill flash to create a highlight in the frog's eye. Without the highlight, the frog would have seem disengaged from the viewer. Notice how most of the image is out of focus; as long as the eye remains in focus, the image can work using low depth of field.

I took this early in the morning, just as the sun hit the treetops yet hadn't touched my backyard. From an open window in my attic I was at eye level with the cardinal. The rich morning light saturated the color of the cardinal, which I emphasized further with the underexposed, blurry background. I placed the cardinal's eye—which also includes the crucial eyespot—in the upper right target zone of the composition.

Even though these shots were taken months apart, they're similar in nature. And, they gave me the idea for an article on nursing mammals. Keeping track of your images is essential if you're going to make connections among images in your portfolio.

Nursing lamb (captive), University of Delaware, Newark, Delaware. Nikon D1X with Nikkor AF VR 80–400mm lens

Nursing foal (captive), University of Delaware, Newark, Delaware. Nikon D1X with Nikkor AF VR 80–400mm lens

◀ This box turtle is part of a study being conducted by the University of Delaware to ensure the species' survival. Using an external flash with a diffuser softened the glare of the turtle's shell. The flash enabled me to use a high ƒ-stop to get adequate depth of field. Even when subjects are radio-collared, they can be hard to find in the field. Check with your local university or natural resources department to see what kind of field studies are going on. You may find some excellent wildlife photo opportunities.

Box turtle (radio-collared), University of Delaware wood lot, Newark, Delaware. Nikon Coolpix 990

▼ I was on assignment in the swine farrowing facility at the University of Delaware. Just three days old, the piglets were beginning to explore their environment. I climbed halfway into their pen to let them become accustomed to me. This particular pig had just finished nursing and, with belly full, was all tuckered out. He was near the solid aluminum side of the cage, so it was difficult to use flash at the typical 45-degree angle. I slid out the diffuser on the flash and aimed it directly at the aluminum cage wall. The result is a diffused light source bouncing off a shinny object, giving the pig's hair a very silky appearance.

Piglet (captive), University of Delaware, Newark, Delaware. Nikon Coolpix 950 with Nikon SB-28 flash

◄ If you've ever seen a wolf in the wild, you'll understand why captive animals make such great subjects. While camping in Yellowstone a wolf ran through our campsite, but by the time I reached for my camera, the stealthy animal was gone. Captive animals offer a photographer time to set up, and if you're willing to wait awhile, you can capture some interesting images. And, even in a captive situation, wolves continue to exhibit instinctual behavior. Local wildlife rehabilitation centers are havens for subjects. Before visiting a rehabilitation center, check to see if there is any way you can get an unobstructed view through the fences or cages. If you do have the opportunity to take shoot in a rehab center make sure you give the center a CD with a few of your best shots as a thank you.

Wolves (captive), Bear, Delaware. Nikon D1X with Nikkor AF VR 80–400mm lens

Bull elk, Heart Lake Trail, Yellowstone National Park, Wyoming. Nikon Coolpix 990

▶ While shooting wildflowers, I looked up about fifteen feet and saw this gigantic bull elk. The sun was behind it, and I wanted to capture an eyespot, so I used the internal flash. I knew it wouldn't change my exposure, but it was just enough to put a small highlight in the eye, giving my subject life. The bull elk seemed comfortable in my presence, so I stayed where I was, shooting well over a hundred images. I even watched it chase a male mule deer out of its territory. And, it was his territory—I saw this same elk in the same spot when I led another group of students along the same trail one month later!

I always tell my students to keep their long zoom lens on their camera body when photographing animals. A landscape shot will wait for you to change lenses; however, an animal may not. Following my own advice, I did have my long zoom on my camera, and I was quick enough to capture this marmot before it retreated into a bolder field.

Capturing one of these timid and fast-moving creatures isn't easy. When you walk up a rock face in Tanzania, lizards scatter, sliding quickly into the cracks and crevices. Spotting this male, I crept within shooting range, careful not to make quick moves. If you stay at one of the game lodges in Tanzania, your chances of photographing one of these creatures is much better because they're accustomed to people in those locations.

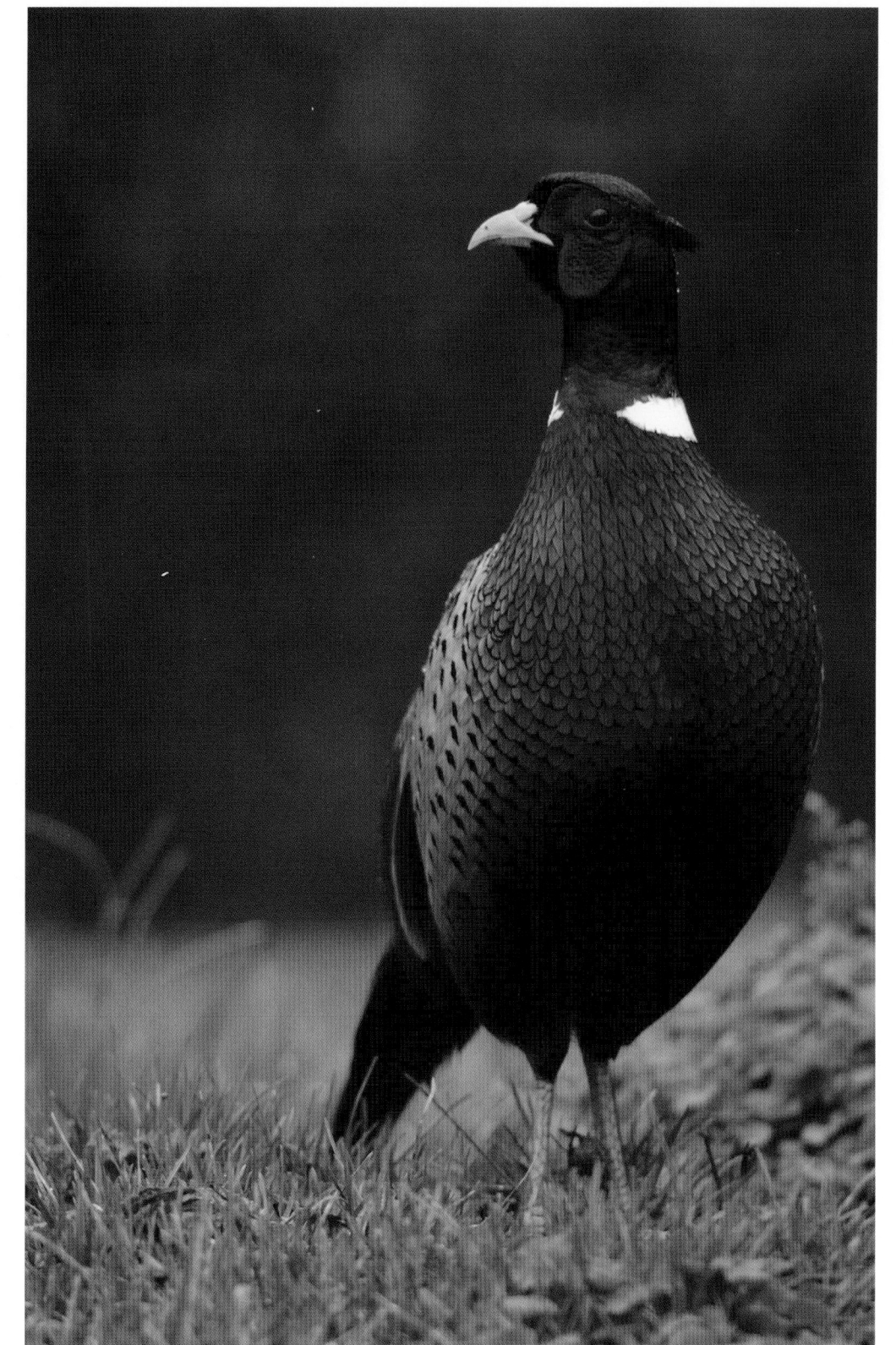

During the winter and spring months this striking male pheasant roams my neighborhood in search of an easy meal. One morning, it spotted me through the kitchen window and honked unceasingly on my back doorstep until I tossed out some cracked corn. A cloudy morning was an ideal lighting situation to saturate the color of this handsome bird. Conditioned to people, this pheasant allowed me to take my time and compose the perfect shot.

Pheasant, Unionville, Pennsylvania. Nikon D1X with Nikkor AF VR 80–400mm lens

PEOPLE ARE PART OF NATURE, TOO

Mandy Tolino, Badlands National Park, South Dakota. Nikon Coolpix 995

Since you can see the image immediately, digital cameras are a great way to goof around with your friends. After being in 100+ degree heat all day while hiking in the backcountry of Badlands National Park, we were a little sun-stupid. We decided to take some "fashion shots" on the formations, trying different poses and using different shutter speeds. What a cool way to learn about photography, trying new techniques and seeing the results immediately!

This was day thirty-seven of a backcountry trek in southern Florida, teaching a wildlife photography course for the University of Delaware. Explaining to one of my students how to make yourself look intimidating by using harsh light and a low angle, I used a little fill flash to capture a highlight in my eye without losing any of the menacing shadows in my face.

Self portrait, Eliot Key, Biscayne National Park, Florida. Nikon Coolpix 995

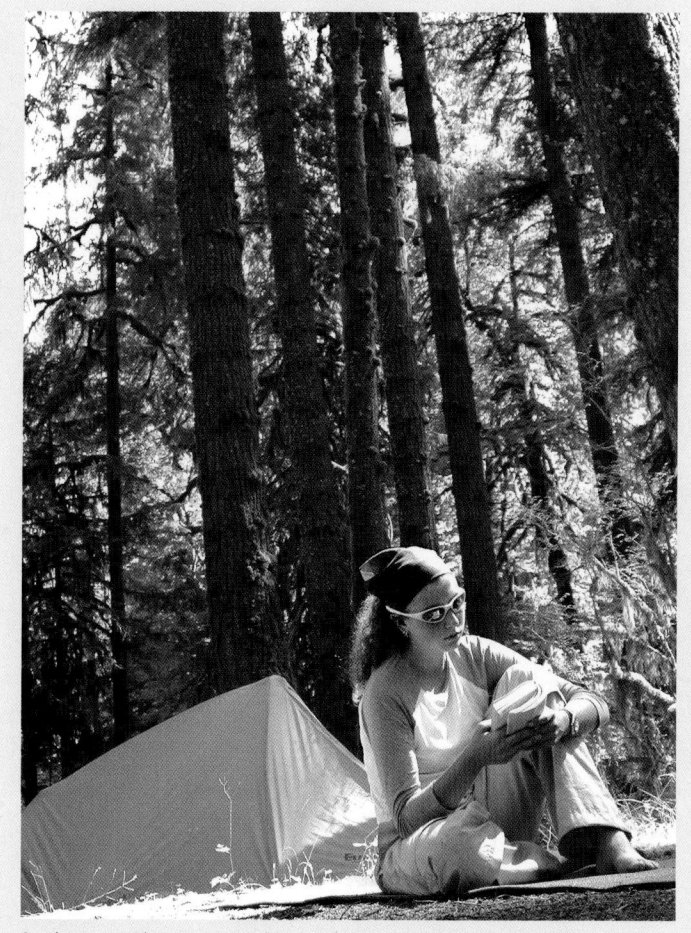

Sarah Amon, Olympic National Park, Washington. Nikon Coolpix 990

Our twenty-two-day wildlife photography trek across the national parks of the United States was coming to a close. This one of those shots that I wish I could jump into and relive, listening to the wind chatter through the spruce trees.

Hadza boy, Tanzania. Nikon Coolpix 990

I was in the heart of Tanzania hanging out with a small group of Hadza, a group of people who sustain themselves as humans did 10,000 years ago—strictly by hunting and gathering. Their knowledge of the land and interaction with one another was awe inspiring. This young boy was making an arrow by using fire to straighten the shaft and tying feathers on the end. The grass hut in the background is his home. I've never met a group of happier or freer people, and I consider myself lucky to have spent three days with them.

Spiderweb in frost, Unionville, Pennsylvania. Nikon D1X with Nikkor 28–70mm 1:4.5 macro lens

CLOSE-UPS

AS I BEND ON ONE KNEE, a miniature landscape appears. Toadstools turn into a forest canopy, moss becomes the scrubby under-brush, and tiger beetles take the place of lions. Sometimes all it takes is dropping your lens cap and kneeling to pick it up to realize what magnificent macro photo opportunities await beneath your feet.

CLOSE-UP COMPOSITION

How close must you be to call an image a close-up? This depends on the subject. A close-up of a rattlesnake might take up an actual area of 4 x 5 inches, while a portrait of a bumblebee might only take up a 1 x 1.5-inch area. You determine how intimate you want to get with your subject.

Whether I'm shooting a six-ton charging bull elephant or a two-ounce clinging sea star, the method I use to compose an image is the same. If the subject allows, I always use a tripod. Keeping the camera steady enables me to hone in on the aspect of the subject that originally caught my eye. Then I consider whether the subject looks best in a horizontal or vertical framing position. In the chapter 4, I wrote about the rule of thirds as a way to avoid placing your subject in the center of the frame. When shooting close-ups, I still follow the rule of thirds; however, in some instances, placing the subject in the center (the foul zone) is the best possible choice for adding pizzazz to an image. An exotic creature or a gleaming eye placed in the center of the frame will immediately grab the viewer's attention.

Note that a single blade of grass or a stick protruding into the frame can be an unwanted distraction in a close-up image. Take a test shot and view it on the LCD screen to search for undesirable aspects of the image. It's much easier to fix these in the field instead of digitally eliminating them from the photograph later in an imaging program.

To capture the translucent glow of tulip petals, I shot from underneath the tulips, eliminating frontal lighting and using only backlighting to expose the image. I got there early, before the crowds came, so I had plenty of space to set up my tripod.

Tulips on display at the Philadelphia Flower Show 2001. Nikon Coolpix 990

Clematis, Unionville, Pennsylvania. Nikon D1X with 28–70mm 1:4.5 macro lens

I was drawn to this particular clematis because of the complementary colors of yellow and violet. I placed the flower head in the upper right target zone and used a low f-stop to give the image a soft quality.

MACRO & DIGITAL

For decades, macro (close-up) photography has been limited to those people who have deep enough pockets to purchase close-up lenses, extension tubes, bellows, and a slew of other gadgets and gizmos. With the advent of digital cameras, any photographer can capture picture-perfect close-ups without purchasing additional equipment. Many of today's digital cameras have built-in macro capabilities. The challenge is to test how close you can get with your digital camera. If you already have all of those gizmos and gadgets for your 35mm SLR camera, you may be able to use them with a SLR digital camera model. I have a set of twenty-five-year-old extension tubes that work well with my Nikon D1X. Before purchasing your next digital camera, check to see if you can put some of that old equipment to use.

The early days of fall bring on a flush of new color. Blending in with the asters, this mantis was awaiting its next unsuspecting meal. Even though the mantis is camouflaged, I capture the attention of the viewer by placing it in the direct center of the composition—the foul zone. I usually avoid composing in the foul zone, but sometimes it is clearly the best choice.

Praying mantis on woodland asters. Nikon Coolpix 950

Bumblebee on zinnia. Nikon Coolpix 990

Toadstools with moss. Nikon Coolpix 990

The composition of this image required that the camera angle be lower than a tripod would allow, so I placed my camera on the ground. Since the toadstools weren't going anywhere, I used a long shutter speed and a high depth of field. Using the timer eliminated the possibility of photographer shake, thus ensuring a sharp image.

◄ *Certain plants, such as zinnias, are notorious for attracting wildlife. Knowing where to find these plants or how to cultivate them can increase your chance of photographing wild subjects. When you find your flower of choice, set up your tripod, compose the scene, and wait for your subject to fly into the frame. You may be surprised how quickly you attract your subject when you relax. Early on in my venture into nature photography, I was guilty of taking a pinned butterfly out of my insect collection and placing it on a flower. Can you guess what the photograph looked like? It looked like a dead butterfly on a flower. If you're patient with your subjects, you'll be much happier with the results.*

AVAILABLE-LIGHT CLOSE-UPS

Nature and wildlife close-ups are especially difficult to make when shooting under natural lighting conditions. The depth of field is limited; available light is often scarce; and the subjects have a tendency to fly, slither, jump, or blow away. However, with a little patience and ingenuity, you can capitalize on available light for shooting close-ups.

Begin your journey into the realm of the digital close-up by photographing something easy, such as an orchid or a mushroom. These subjects will stay stationary all day, so time is of no importance. With your subject immobile, you can experiment with fast and slow shutter speeds, large and small apertures, and a variety of compositions and lighting techniques. Learning close-up photography with a digital camera is easy because results are immediate, and you can make changes to your f-stop and shutter speed on the spot until you achieve the result you desire.

When shooting close-ups, use a high enough f-stop to attain adequate depth of field to ensure the sharpness of the image. This means you must find a way to steady the camera. Using a tripod is the best and most versatile way to do this; unfortunately, many shots are close to the ground, requiring an odd angle. In these situations, a tripod may not work. Positioning the camera on the ground, your shoe, a log, or a nearby rock may then be the only solution.

When shooting a close-up, ask yourself a few questions. Why am I drawn to this subject? What qualities does this subject possess? What do I want the viewer of my image to see? Is the texture of the subject captivating? Is it the color? Or a combination of the two? If you know what draws you to a subject, you can make decisions on how to expose and photograph it to capture its essence. Take, for example, an orchid—a species that has evolved to thrive in low light conditions. I would not strip its identity by using hard light on it. Instead, I would accentuate the orchid's striking color and soft texture by diffusing the available light.

To minimize shadows and contrast, you can use a variety of tricks to bend the light to your plan. Simply reposition yourself around the subject, or place a bounce card on the opposite side of the light source to fill in shadows. An index card, a hand, or even a candy bar wrapper works well in this situation. Using colored paper and foil can also result in some interesting effects.

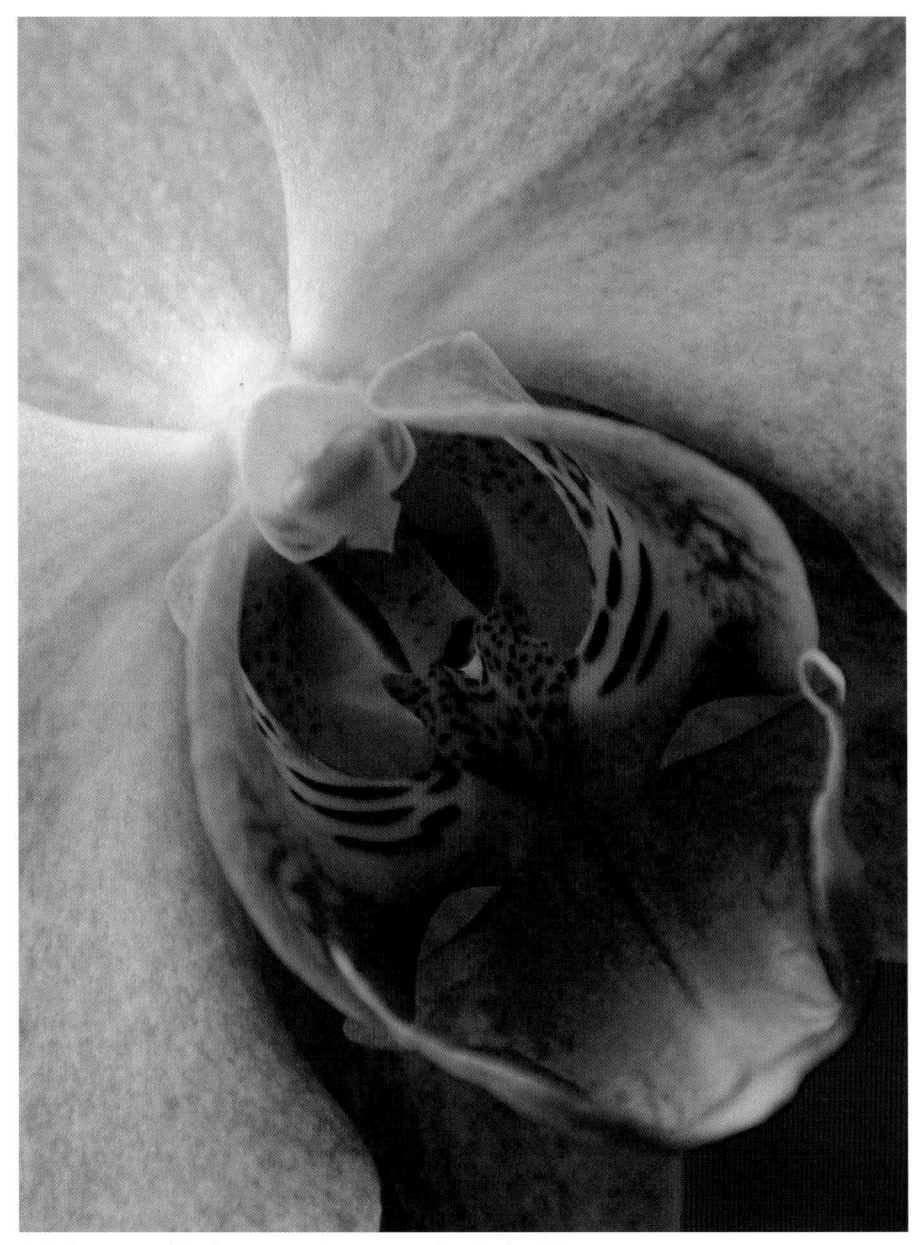

Orchid, Longwood Gardens, Kennett Square, PA. Nikon Coolpix 950

I was drawn to this orchid because of the beautiful color, soft texture and fascinating reproductive structure. Since my subject was immobile, I had ample time to set up, capture the image, and relay to the viewer what drew me to the subject in the first place. I simply held my hat above the orchid to block out direct light, which left a soft diffused light to accentuate the soft color and texture of the blossom.

Shooting these backlit spring tulips, I positioned my camera on the ground, so I could see the LCD screen. I took a metered shot with the sun directly in the frame, which turned the tulip completely black. Not my intended result. When I slowed down the shutter speed two stops, I captured the exposure I wanted: glowing tulips streaked with rays of sunlight, foreshadowing the sunny days of summer.

▼ Early morning fog rising off Lake Colden diffused the sun on this chilly fall morning. There's no better diffuser than the natural conditions of a foggy day. By shooting directly above the subject, everything lies on the same focal plane, which resulted in this entire scene being sharp in focus.

Tulips, Unionville, Pennsylvania. Nikon Coolpix 990

Maple leaf on gravel bed. Nikon Coolpix 990

I was following a trail of grizzly bear tracks while hiking along the shore of Heart Lake, however what caught my eye was the brilliant backlighting of a feather tangled up in a spruce limb. Positioning myself so that the spruce branch was cropped out of the image, I drew upon the deep blue, contrasting lake as a background. I manually set the focus, moving the tripod and camera back and forth until the feather was sharp.

Feather on Heart Lake, Yellowstone National Park, Wyoming. Nikon Coolpix 995

I spotted this sea star against a barnacle-covered rock waiting for the next tide to roll in. I couldn't have created a better light to capture this subject than the naturally occurring diffused light of the cloudy day. Diffused light accentuates the different textures of the scene. I placed the camera on the ground to get the angle I wanted and used the timer to avoid photographer shake.

Ochre sea star, Olympic National Park, Washington. Nikon Coolpix 990

I positioned the camera on a tripod directly over the cactus, being careful not to single in on one particular tuft since this shot falls into the category of a pattern. The overcast day was ideal for exaggerating the soft texture, but don't let the image fool you—the hairs will imbed themselves into your skin if you touch the plant.

Cactus houseplant, Unionville, Pennsylvania. Nikon Coolpix 950

When alarmed, the camouflaged scorpion gets into a stinging position and stays very still, so I was able to use a slow shutter speed and a high f-stop. I got the depth of field needed to capture the tiny hairs and body segments without a flash. Whenever possible, I use natural light to photograph my subjects.

Scorpion, Soitergoss Wilderness area, Tanzania. Nikon Coolpix 990

INTERNAL-FLASH CLOSE-UPS

If given the option, I will always choose to photograph with natural light; however, some situations just don't work under natural-lighting conditions. An internal flash is ideal for those situations when you need light and have no time to set up. Most internal flashes are mounted directly above or next to the lens of the camera.

As mentioned in chapter 3, this type of frontlighting is best for color saturation and poor for texture. If you want to light your subject in any way other than frontally, you'll have to use a light source other than your internal flash.

If you're photographing a person or an animal and you have a red-eye-reduction setting on your camera, use it. The red-eye-reduction setting emits a series of flashes, which causes the pupils of the subject's eyes to constrict before the photograph is actually taken. This, in turn, reduces the plague of red-eye in an image, thus saving you the time and effort of manipulating the image later.

Mating ladybugs, Unionville, Pennsylvania. Nikon Coolpix 995 with internal flash

I was mowing the grass when I spotted these two ladybugs mating. I ran into the house and grabbed my pocket-sized digital camera. I didn't think I had time to set up my close-up bracket, so I used the internal flash to illuminate my subjects. Looks pretty good for being such a quick shot.

Toad, Brandywine Creek State Park, Wilmington, Delaware. Nikon Coolpix 990 with internal flash

WHEN INTERNAL FLASH HELPS

As I meandered through the eroded formations of Badlands National Park, South Dakota, an abrupt rattle froze my pace. A young prairie rattlesnake warned me off. I couldn't pass up this photo opportunity, yet I knew I didn't have much time until the rattler continued on its nightly hunt. The sun had fallen below the horizon, so the available light was too scarce to make the shot work. I decided my best chance of capturing this creature was to use the internal flash because of the speed and ease of operation.

Young or immature rattlers also have no control over the amount of venom they release; a single bite can kill. To avoid deadly fangs, I fasten my camera to a tripod, turn on the internal flash, and set the close-up mode to autoexposure. After setting the timer, I position the tripod. After taking the shot, I check the LCD screen to make sure I got it, and the rattlesnake and I part unharmed.

This toad was laying eggs, so I knew it wasn't about to leave until all of the eggs were deposited into the shallow puddle. I took the time to set up a tripod with the legs fully stretched out in the lowest possible position to the ground. Even though I had enough available light, I used the internal slow-flash setting to create a highlight in the toad's eye. Capturing a highlight in the eye of a creature can make the image; on the other hand, not having one can mean an ordinary image.

EXTERNAL-FLASH CLOSE-UPS

If you want ultimate control over your close-up lighting, you'll want to purchase an external flash. Using external flash with digital cameras couldn't be easier. In the past, with SLR cameras, figuring out guide numbers, taking bracketed test shots, using light sticks, and watching your hair turn gray were aspects of striving for the perfect close-up shot. If you are serious about close-ups, buy a dedicated external flash for your camera system.

A dedicated through-the-lens (TTL) flash, which eliminates the need to figure out a guide number, will give you a much better success rate with close-ups. A dedicated external flash works directly with your camera's metering system. You set the f-stop and shutter speed, and the camera will tell the flash how intense the light should be. If you aren't content with the results, you can always turn the flash to manual and set the intensity yourself.

Handholding a flash for close-ups is fine; however, it can be cumbersome in the field. This is a situation in which a flash bracket comes in handy. Unfortunately, close-ups require the flash to be positioned at an odd angle to the camera, which is the reason that many flash brackets used for portraits won't work for close-ups. For a flash bracket to be useful for close-ups, you need the option of adjusting the flash-to-subject distance. You also must be able to quickly switch from horizontal to vertical framing. Since no bracket on the market that fit my camera fulfilled my purpose, I designed my own. It holds the flash in a sturdy position without giving up the 360-degree movement. I can also tilt the flash on a 45-degree angle, which is helpful when taking extreme close-ups.

Bumblebee on golden rod, Yellowstone National Park, Wyoming. Nikon Coolpix 995

Stopping the action of this predatory insect required a fast shutter speed. To get adequate depth of field, I used an external electronic flash. An internal flash simply wouldn't do because the shiny exoskeleton would have caused reflected glare in the image. Using a close-up bracket with my flash at a 45-degree angle, I crawled toward the predator until I was within photo range. Two clicks and the beetle was gone, fleeing with its prey behind a nearby rock. Making adjustments ahead of time is essential when shooting action close-ups; you never know when your subject is going to head for cover.

Tiger beetle, White Clay Creek State Park, Delaware. Nikon Coolpix 950 with Nikon SB-28 flash

Taken during a heavy breeze, photographing this lily required a fast shutter speed. Also, I wanted high depth of field so that the stamens appeared sharp. This only left one option—using a flash, which also highlighted the water droplets.

◀ To capture a busy bumblebee, you need a fast shutter speed. To get high depth of field, I used an external flash held at a 45-degree angle to the subject to get an equal balance of color and texture.

Lily, Stone Harbor, New Jersey. Nikon Coolpix 990

CLOSE-UPS THROUGH GLASS

Shooting through aquarium glass is a great way to capture close-ups without worrying about poisonous bites or emptying your pockets buying loads of underwater camera equipment and scuba gear. Another bonus to shooting through an aquarium is that you have plenty of time for setting up.

Before picking up your camera, make sure the aquarium glass is clean. The last thing you want in a near-perfect image is a dirty finger smudge, so always keep paper towels and cleaner nearby. Another problem when shooting through glass is unwanted glare caused by light reflecting off the glass. To avoid glare, place the lens of your camera directly against the aquarium glass, which allows the least amount of space between your camera and the glass. Another solution is to use a polarizing filter, which aids in reducing the amount of glare.

For close-ups of coiled snakes or resting tree frogs, natural light or aquarium lighting and a tripod may suffice. If your target is a moving clown fish or moray eel, an external electronic flash could be useful. You may wonder, Why not just use the internal flash on the camera? All of my tests with the internal flash have resulted in a huge overexposed glare spot in the photograph. I use the same external flash techniques for aquarium close-up photography as I do for field close-up photography. The only difference is how I hold the flash. With the camera directly against the glass of the aquarium, I position the external flash directly over the top of the aquarium and I add a diffuser. The diffuser softens the light being cast on the subject. The diffuser also helps to reduce the glare bouncing off the sides of the aquarium.

I've found that most pet-store owners will allow you to set up and shoot images in their stores, as long as it doesn't interfere with their business. Of course, it's nice to follow up your photo shoot with a color printout of your best photographs. And who knows? You might even sell a few images.

I positioned the external flash directly over the top of the tank and waited for the eel to emerge from its hiding place. As soon as it opened its mouth I took a shot.

Moray eel (captive), Wilmington, Delaware. Nikon Coolpix 990 with Nikon SB-28 flash

Sea horse (captive), Wilmington, Delaware. Nikon Coolpix 990 with Nikon SB-28 flash

To amplify the texture of the sea horse, I held the external flash over the top of the aquarium. I made sure the aquarium glass was extra clean because I didn't use a diffuser on the flash.

Sea anemone (captive), Wilmington, Delaware.
Nikon Coolpix 990 with Nikon SB-28 flash

I used a diffused external flash held over the top of the aquarium to soften the texture of this creature. The diffuser eliminated the harsh shadows often caused by a direct flash.

Dwarf camin (captive), Baltimore Aquarium, Maryland. Nikon Coolpix 4500 with Nikon SB-28 external flash

Getting an angle such as this in the wild would require me to be positioned in the water with the dwarf camin. It's a lot safer for you and your equipment to photograph a subject like this one through glass.

Emerald tree boa (captive), Baltimore Aquarium, Maryland.
Nikon Coolpix 4500 with Nikon SB-28 external flash

By photographing through glass, I didn't have to worry about the boa trying to bite me.

Various saltwater fish (captive), Baltimore Aquarium, Maryland. Nikon Coolpix 4500 with Nikon SB-28 external flash

In a public aquarium like the one in Baltimore, you don't have the option of using your flash above the tank. I placed my camera lens directly against the aquarium glass. I also placed the flash against the glass and held it about a foot above the camera to reduce glare.

Pelicans, Tanzania. Nikon D1 with Nikkor AF 80–400mm lens

ACTION PHOTOGRAPHY

CAPTURING MOTION IN NATURE with a digital camera is exhilarating. Whether the subject is a striking snake or a drifting dandelion seed, the concepts of action photography remain consistent. Two methods make it possible to show motion in a still image: use of a long shutter speed to blur the moving subject in the frame, and use of a fast shutter speed to stop motion in the image.

BLURRING MOTION

You'll want to consider a few things before choosing a shutter speed. What aspect of motion are you after—the speed of a cheetah streaking across the grasslands or the slow rhythm of waves lapping the shore? Once you decide on the type of motion you want to illustrate, choose a shutter speed. Start simply: Look for a subject that's always moving and won't be spooked by your actions. A waterfall is a good starting place.

As mist collects on your eyelashes, you decide to blur the motion of the cascading waterfall. Find a sturdy way to support your camera. A tripod works best, but a fallen log or flat rock is a good substitute. To blur motion, use a slow shutter speed. Without camera support you risk blurring the entire shot; all you want to blur is the motion of the moving water, thus keeping the rest of the photograph sharp.

After testing various shutter speeds on waterfalls, I have concluded that 1/125 sec. will stop most of the action of moving water, whereas 1/30 sec. will begin to blur the motion. Yet, 1/30 sec. is only the starting point; the longer the shutter speed, the more motion you will see in the photograph. When setting up for a slow shutter speed waterfall shot, you should always use the highest possible f-stop your lens will allow, capturing the greatest depth of field and recording the least amount of light by the CCD.

One obstacle when shooting with long shutter speeds is having too much light falling on the scene to successfully blur the motion. For example, your highest f-stop is f/11, and your meter suggests taking the shot at f/11 with a shutter speed of 1/60 sec. This shutter speed is not long enough to blur the motion of the water because there's too much available light, granted not a typical problem in photography. If there's too much light, make sure your ISO dial is set to the lowest setting; ISO 100 is the most common. You may also have an image-adjust setting that will allow you to make the image darker. This would let you use a slower shutter speed.

The next best way around too much light is to recompose. Find a section of the waterfall that's not directly illuminated by the sun. Since water is highly reflective, it can be grossly overexposed in sunlight. If you can't find a shady spot and you have a neutral-density filter, this is the time to use it. The filter cuts down on the ambient light without jeopardizing the tonality of the image.

If you have a shutter-release cable. you should use it when you're trying to blur motion with a slow shutter speed. An alternative is to set the timer to shoot the image. These two techniques eliminate the possibility of photographer shake in your image.

Running baboon, Lake Manyara National Park, Tanzania. Nikon D1 with Nikkor AF VR 80–400mm lens

Surrounded by a baboon troop in the dark, humid groundwater forest, I crouched down and began to shoot the scene playing out before me. After five minutes, a large male baboon spotted me and bellowed an alarm. Chaos broke the midday calmness, and baboons scattered, screamed, jumped, and ripped past me. I locked onto a female carrying a baby on her back and fired off twenty-five exposures in sequence in a matter of seconds as she scrambled to reach the nearest towering fig tree. Using the vibration reduction setting of the 80–400mm lens, with a shutter speed of 1/30 sec., I panned the baboon with focus tracking locked onto her and her baby. Since the focus was locked on the moving subject, everything in front of and behind her blurred. This shot is a true testament to technology; I was using every advanced feature my camera and lens had to offer. The autofocus and focus tracking kept the baboon in focus, and the vibration reduction lessened photographer shake. An image that seems to be the result of a fast shutter speed is actually a product of a slow shutter speed using advanced technology.

The heavily shaded temperate rain forest was an ideal situation in which to use a long shutter speed to blur the motion of the water, giving it a silky look. The high f-stop created a depth of field large enough to keep both the foreground and background of the scene in focus.

Waterfall, Hoh Rain Forest, Olympic National Park, Wyoming. Nikon Coolpix 990

A gusty fall day created the ideal condition to show the motion of seeds being carried by the wind. After setting up a tripod and composing the shot so that the wind blew seeds into the frame, I set the f-stop to f/11 and the shutter speed to 1/125 sec., which was slow enough to blur the seeds. My shutter speed didn't have to be very slow, because the wind was moving swiftly across the wetland.

Milkweed seed pod, Unionville, Pennsylvania. Nikon Coolpix 995

STOPPING ACTION

Lions roaring, animals clashing horns, and birds in flight all require a fast shutter speed to stop action and give viewers a feel for what it would be like were they able to jump into the image. Stopping action is more difficult than blurring motion. If you are stopping action, you subject must be moving, so you may have to move, as well. You have no control over where your subject goes; you can only try to anticipate its next move. One way to do this is to use a tripod and hope your subject moves into the frame. If you move with the subject, use the handheld rule to avoid photographer shake.

While I have captured many action shots with my pocket-sized Nikon Coolpix digital cameras, I prefer using my 80–400mm VR lens on my Nikon D1 or D1X to shoot moving subjects. When I know I'm in a location in which action shots are possible, I always have my 80–400mm lens attached to the camera. A wide-angle lens is fine for landscapes—the landscape will wait for you to switch lenses. A charging elephant will not. Having a long zoom on the camera increases your chances for getting the action shot.

To capture action shots with a pocket-sized digital camera, hold the shutter down half way. Many digital cameras have a delay when the shutter is depressed, which makes it easy to miss the action. Keeping the shutter depressed half way while you wait for the action, and then fully depressing it, will cut down on the delay.

Elephants defending their young, Tanzania. Nikon D1 with Nikkor AF VR 80–400mm lens

When elephants fear for the safety of their offspring, they form a protective circle around the young. The large bull in the center of this image was in musth, indicated by a dripping gland on his forehead. An elephant in musth can become aggressive and dangerous because of increased sexual activity and excitement. This over five-ton bull was swinging his head back and forth, and stamping his feet to try to scare us away. The earth shook beneath his feet, and he was successful in his efforts; I took a few quick shots and drove off before the bluff charges turned treacherous. With plenty of available light, I used the handheld rule and a shutter speed of 1/500 sec., and still attained adequate depth of field.

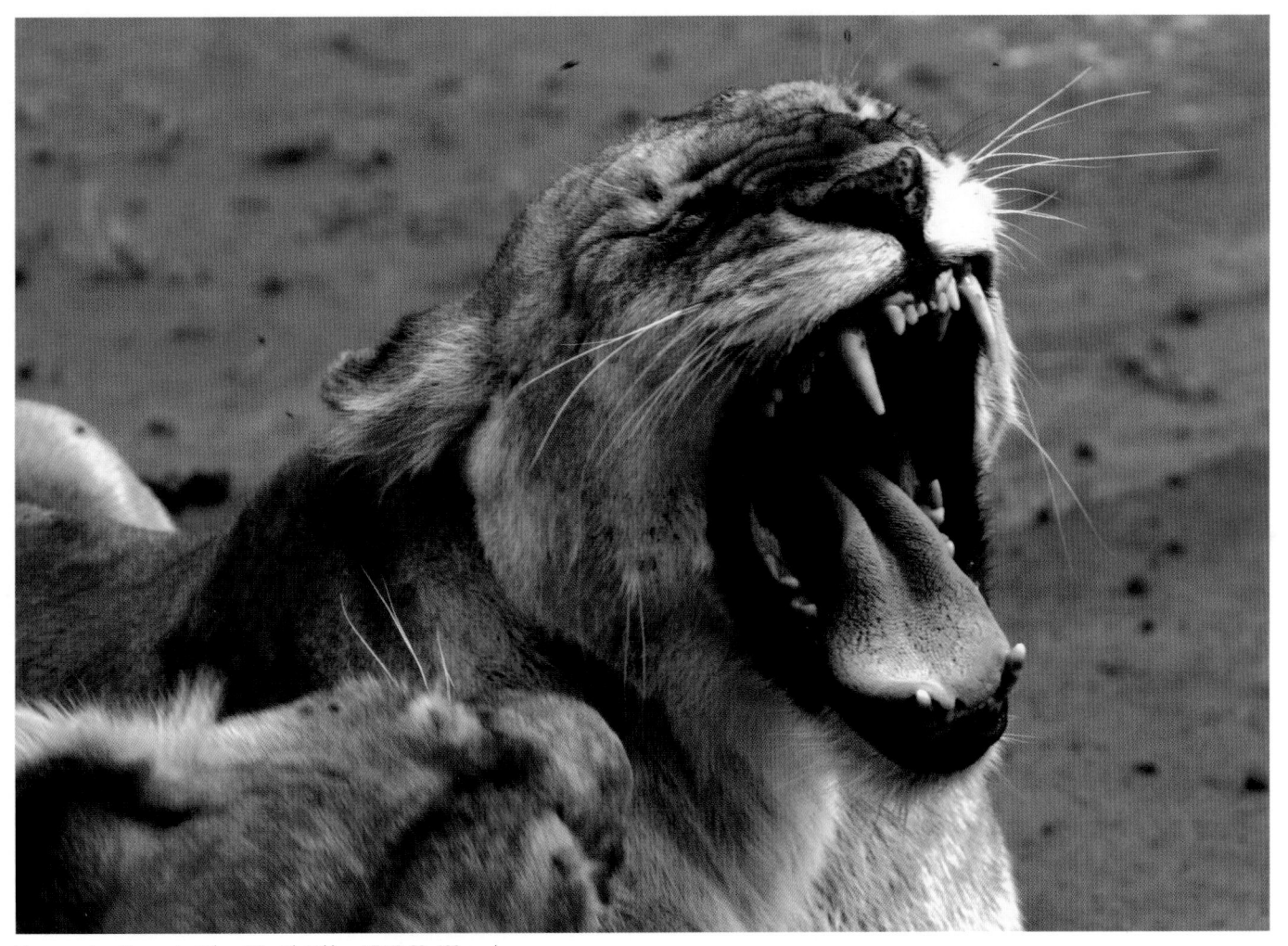

Lion yawning, Tanzania. Nikon D1 with Nikkor AF VR 80–400mm lens

While it may look as though this lion was roaring, it was actually just waking up from an afternoon catnap. Without any accompanying sound, the scene can be a little frightening. I photographed the sequence of the entire yawn. To capture the action, I used a shutter speed of 1/500 sec.

The faster the shutter speed, the more action you can stop. I used a low f-stop so that I could use a fast shutter speed to freeze the motion of the water. When I downloaded the shot, I noticed it was almost a black-and-white image with just a hint of green. I thought the green hint detracted from the image, so I used the gray mode in Photoshop to eliminate the color.

If you've ever walked along the shore in the Pacific Northwest, you've most likely seen one of these creatures. They scurry back and forth along the coast and are always ready to defend themselves with their menacing claws. I used the shutter-priority setting to set a fast shutter speed of 1/250 sec. to capture the action. The camera then set the f-stop to f/4 because of the low available light, which gave me a low depth of field.

Waterfall, Brandywine State Park, Delaware. Nikon Coolpix 990

Purple shore crab, Olympic National Park, Washington. Nikon Coolpix 990

Danielle Murray, Tanzania. Nikon D1 with Nikkor AF VR 80–400mm lens

To capture a series of action-stopping images, you need a camera that allows you to take multiple shots, storing the data in a buffer zone before the images are saved onto the digital media. I took ten images in a row of this African kite swooping down to steal Danielle's cookie off her camera bag. Shooting a series of images increases the odds of capturing one you like.

Ben was jumping directly over me, soaring about six feet in the air. I set the camera on a tripod, composed the scene, then yelled for Ben to start pedaling. I depressed the shutter halfway, and as he entered the frame, I fully depressed the shutter to avoid a shutter delay. It took a couple of takes—eleven to be exact—to get the shot the way I envisioned. Practicing your actions photography on humans is a good way to test your equipment and technique before you go out in the field to capture the action of wildlife. It's much easier to ask your friend to pedal over the jump again than it is to ask a leopard to take down another gazelle.

Benjamin Kuprevich mountain biking, Delaware. Nikon Coolpix 990

CHAPTER TEN

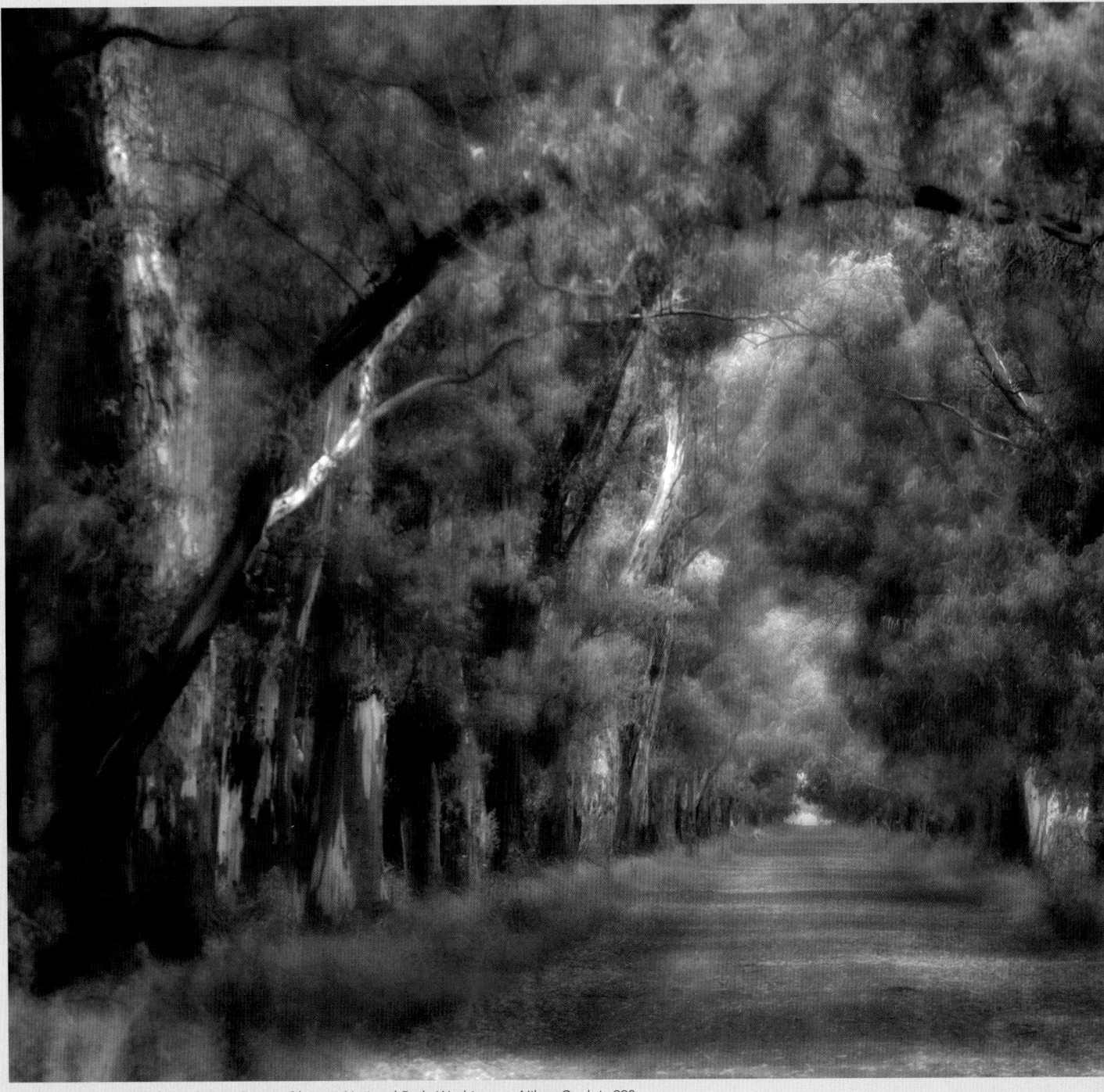

Moss-covered trees in the Hoh Rain Forest, Olympic National Park, Washington. Nikon Coolpix 990

MANIPULATION

ASIDE FROM ACTUALLY CAPTURING nature scenes on your digital camera, manipulating your images can be one of the most enjoyable and creative aspects of digital nature photography. Sometimes, your image may not turn out exactly as you planned. If this is the case, put on your favorite pair of slippers, grab a cup of coffee, and take your image to the digital darkroom to perform some digital magic. I'm not saying to not worry about your technique in the field because you can always fix it later in Photoshop. A good shooting technique is irreplaceable. Starting out with a good photograph will make your digital darkroom session go much smoother.

IMAGE MANIPULATION

For over a century, photographers have used darkroom techniques to fix what they couldn't capture on film. They've burned highlights, dodged dark regions, and cropped out what they don't like. The end result of all their hard work in the darkroom reflects the image they envisioned while shooting in the field.

An Adobe Photoshop session in the digital darkroom isn't any different from a session in a conventional darkroom, except for the number of choices. I have used a conventional darkroom plenty of times developing film, printing contact sheets, and developing my own prints. However, I far prefer the freedom of Adobe Photoshop for all of my darkroom needs. I don't need a separate room or chemicals, and I can work in my digital darkroom on a plane, train, or while relaxing under an old oak tree at my favorite getaway spot in the woods.

Make a short list of considerations and steps before you begin your digital darkroom session to give you some guidance.

For example:

1. What images are you going to use? (Once you decide on your images, save them to the desktop so that they are easily accessible.)

2. What are you trying to accomplish in your digital darkroom session?

3. What imaging tools are you going to need? Are these the best tools for the job?

4. List the steps you need to go through and which tools you need for each step. (If you're still in the learning stage, make sure you try at least one new tool each time you work.)

5. Did the image turn out the way you wanted? (Take note of what was successful and what wasn't.)

Be aware of digital darkroom dilemmas; while you can do a lot to an image, you can't perform miracles. An image taken on a bright sunny day combined with an image taken on a cloudy day won't look natural. The light, perspective, and color have to be believable for an image to work. When you think you're finished manipulating an image, ask someone what he or she thinks. Don't reveal that you manipulated the image until you get a response. Then explain what you did and talk about the image again.

Actually using the different available tools is by far the best way to learn about Adobe Photoshop. You can read dozens of books on the subject, but until you actually try it, you won't know how to manipulate an image. After a few months of hard work, you'll look like a pro, wowing your friends and relatives with your magnificent images. As noted in the list, I suggest trying out one different tool in the program every time you use your digital darkroom. In this section, I'll go through the basic techniques to get you started and also list the tools I used to create each of the following images with Adobe Photoshop 6.0 and 7.0.

THE MANIPULATION DEBATE

Manipulation of images has become much easier with the advent of Adobe Photoshop; however, it does not have to originate in the computer. I once saw a magazine photograph of a luna moth with a caption that stated it was feeding on the nectar of a thistle plant. If the photographer and editor knew anything about luna moths, they would have known that members of the giant silk moth family Saturniidae don't have mouth parts; they feed only in the larval stage. This image was a setup; the photographer probably caught the moth one summer night and waited until morning to put it on a pretty flower for a photograph. The photographer didn't identify it as captive or manipulated, and even decided to lie and say the moth was feeding, losing all credibility.

There's nothing wrong with digitally enhancing your images or using captive subjects, as long as you aren't trying to trick the viewer into believing an untrue situation. After I manipulate an image, I ask people to see if they notice anything odd about an image. If they don't, I know I've successfully manipulated the image, and then I explain what I did.

Whether you use captive animals or studio setups, or manipulate your image in Adobe Photoshop, you must be truthful and caption the image accordingly. If you fail to do so, you misrepresent not only yourself but your subject, as well.

At what point should an image be captioned as "manipulated"? There's no definite answer to this question. I don't caption an image as being manipulated if I slightly change only the contrast or brightness. However, if I change a midday scene into a sunset, or add elements to an image that weren't in the original, I always caption the photos as such. If you think you should caption an image as being manipulated, then do so. It's crucial to be honest, not only for yourself but for the nature photography industry.

Image: *Everglades sunrise (enhanced)*

Goal: *Change yellow and orange colors to blue and violet.*

Tools: *Image/Adjust/Curves*

Steps: *Under Image/Adjust/Curves, I switched the RGB setting to blue and increased it until I had the result I wanted. This transformation took about five seconds from start to finish.*

Comment: *I achieved the same result by switching the camera white-balance setting to fluorescent when I was shooting the image in the field.*

Original image

Manipulated image

Original image

Manipulated image

Image: *Palm trees in the afternoon (manipulated)*

Goal: *I was at the right place but at the wrong time, so I wanted to change this afternoon shot into a sunset shot. I wanted to silhouette the grass and palm trees and change the color of the blue sky to orange and yellow.*

Tools: *Magic Wand, Image/Adjust/Brightness/Contrast, and Image/Adjust/Curves*

Steps: *I used the Magic Wand tool to select the grass and trees, setting the tolerance to 40 and holding down the Shift key until I selected everything I wanted. Using Image/Adjust/Brightness/Contrast and setting the Brightness as low as it would go, I completely silhouetted the grass and trees. I then used the Magic Wand tool to select the entire sky and used the Image/Adjust/Curves tool to increase the red and decrease the blue and green. My final step was to darken the entire image using Image/Adjust/Brightness/Contrast.*

Comment: *I accomplished my goal in under ten minutes.*

Original image

Image: *Male lion, Serengeti Plains, Tanzania (enhanced)*

Goal: *Change the dull image into one that visually "pops."*

Tools: *Image/Adjust/Selective Color*

Steps: *Under the Image/Adjust/Selective Color tool, I checked the Absolute method and selected the red color, decreasing the cyan by 100 percent and increasing the magenta, yellow, and black by 100 percent. Then I selected the yellow color and decreased the cyan by 23 percent, increasing the magenta by 24 percent, the yellow by 18 percent, and the black by 8 percent.*

Comment: *It was a year and a half before I changed this bland image into one that pops. Always save your images if you think they have promise, even if you don't start working on them right away. Some of your digital images may be like blocks of wood just waiting to be carved into beautiful sculptures. When you combine your digital data with the skills you learn in Adobe Photoshop, you can create brilliant images. This technique works on a variety of photos. Try different percentages of color until you achieve the desired result.*

Manipulated image

Image: *Grand Teton National Park in clouds (enhanced)*

Goal: *Change the color image to black and white.*

Tools: *Image/Mode/Gray Scale and Image/Adjust/Brightness/Contrast*

Steps: *I used the Image/Mode/Gray Scale to turn the color image into a black-and-white one. Using the Image/Adjust/Brightness/Contrast tool, I increased the contrast and decreased the brightness until I achieved the result I wanted.*

Comment: *I don't usually use the black-and-white mode on the camera. It's much easier to change a color image to a black-and-white image than the other way around in an imaging program. However, black and white captures a completely different mood than a color image can invoke.*

Original image

Manipulated image

Image: *Path in Hoh Rain Forest*

Goal: *Change a color image into an old fashioned-looking sepia-toned image.*

Tools: *Image/Adjust/Hue/Saturation and Image/Adjust/Curves*

Steps: *I used the Image/Adjust/Hue/Saturation tool to set the saturation to -100, which took all the color out of the image, changing it to black and white. I then used the Image/Adjust/Curves tool to increase the red and decrease the blue until I achieved the result I wanted.*

Comment: *Some printers have a sepia setting, eliminating the need to go through these steps to create an old-fashioned image; all you have to do is hit Sepia Print.*

Original image

Image: *Pond (manipulated)*

Goal: *I wanted to give this lush, green spring scene a timeless quality by converting it into a monochromatic image.*

Tools: *Layer/Duplicate Layer, Filter/Gaussian Blur30, Layer/Opacity80, Eraser30, Layer/Flatten Image, Image/Adjust/Hue/Saturation, and Image/Adjust/Curves*

Steps: *I used the Layer/Duplicate Layer tool to create an exact replica of the image. Using the new layer, I selected Filter/Gaussian Blur, setting the radius to 30 pixels. I then chose Layer/Opacity and set the opacity to 80 percent. Using Eraser set to 30 percent, I erased the layer to the background just along the grasses at the edge of the pond, to draw the viewer through the image. I used Layer/Flatten Image to combine the two images. With Image/Adjust/Hue/Saturation, I changed the color image into a sepia-toned one by colorizing the image and setting both the hue and the saturation to -30. Using the Image/Adjust Curves tool, I set the input to 130 and the output to 124 to slightly darken the image.*

Comment: *Learning to build on and combine the skills you learn in Adobe Photoshop is essential if the quality of your work is going to improve. I used several techniques to accomplish my objective of a completely different mood and timeless quality.*

Original image

Manipulated image

Manipulated image

Original image

Image: *Vervet monkey with baby (manipulated)*

Goal: *Blend the overexposed sky into a green background, suggesting a soft feel to the entire image. Also, brighten the mother's face.*

Tools: *Magic Wand, Eyedropper, Dodge, and Airbrush*

Steps: *To photograph this scene at the baby's eye level, I had laid on my stomach and shot upward; at this angle, the sky appeared in the background, causing unwanted highlights that distracted from the overall soft feel. I used the Magic Wand to select everything that was over-exposed in the background, and then used the Eyedropper tool to select a green color in the background. I used the Airbrush tool to fill in the overexposed areas with the color I had selected. I repeated the Eyedropper selection and Airbrush to vary the colors in the back-ground, giving the scene a natural appearance. The last step was to use the Dodge tool to lighten up the face of the mother.*

Comment: *Notice how the top of the image is lighter than the rest of it to suggest a sky without having the highlights that distract the viewer. I spent about an hour on this image.*

Manipulated image

Original image

Image: *Badlands National Park (manipulated)*

Goal: *To illustrate how unbelievable an image can look using unrealistic lighting.*

Tools: *Edit/Crop, Select/All, Edit/Copy, Image/Canvas Size, Edit/Paste, Edit/Transform/Flip Horizontal, Move, and Layer/Flatten*

Steps: *Using the Edit/Crop tool, I cropped the original image, cutting the highest peak in half vertically. I selected the entire image using Select/All and then used the Edit/Copy tool. Under Image/Canvas Size, I tripled the width of the canvas. I used the Edit/Paste tool to add the new layer and the Edit/Transform/Flip tool to flip the new layer horizontally. I used the Move tool to line up the new layer directly next to the background layer. Once the two layers fit together, I used the Layer/Flatten tool, then cropped the canvas to fill the frame with the new image.*

Comment: *This scene would have to be taken on a planet with two suns to be believable. However, the method used to create this image is worth learning and can be used for many other applications. This image would work for a CD cover or an outer-space movie advertisement.*

Manipulated image

Image: *Elephant (manipulated)*

Goal: *Change a half-headshot into a full front-on elephant portrait.*

Tools: *Crop, Select/All, Edit/Copy, Edit/Paste, Image/Canvas Size, Magic Wand, Edit/Transform/Flip Horizontal, Move, Lasso, Edit/Transform/Perspective, and Layer/Flatten*

Steps: *I cropped the image as closely as possible down the center of the elephant's head. I used Select/All to outline the image, then I used the Edit/Copy tool. Using the Image/Canvas size tool, I tripled the horizontal size of the canvas. I then used the Edit/Paste tool with the Edit/Transform/Flip Horizontal tool to line up the two halves meeting in the middle to create an entire elephant. Everything looked pretty good except for the shrunken trunk (below left). I used the Magic Wand and the Lasso tool to select the trunk below the tusks, and I used the Edit/Transform/Perspective tool to widen the trunk, making it appear normal size. Finally, I flattened the image and saved the new version.*

Comment: *The approximately five-ton giant literally dwarfed the Land Rover I was traveling in. As shocked as I was with its size, I was even more attracted by the intricate texture of its skin in the diffused light. Every crease and wrinkle seemed to tell a tale of an animal that has witnessed a lifetime of stories. Even though nature may seem to produce symmetrical organisms, there are usually slight variations. Try these techniques on a self portrait and see how different you look. This technique works on a variety of subjects.*

Original image

Manipulated image (first stage)

Manipulated image (final)

Images: *Andrew Olson and alligator (manipulated composite)*

Goal: *Combine two images to make one*

Tools: *Lasso, Edit/Copy, Edit/Paste, Eraser, Layer/Flatten, and Move*

Steps: *I started using the Lasso to draw a wide circle around Andrew. I used the Edit/Copy tool and then clicked on the image with the alligator. Using the Edit/Paste tool, I layered Andrew onto the image.*

I then used the Move tool to position Andrew where I wanted him in the frame. I used the Eraser tool to eliminate the edge of Andrew until he blended into the background.

Comment: *The lighting is believable; however, not many people would believe Andrew is swimming with a gator. As I've said before, manipulating your images is fun; you don't always have to create a beautiful masterpiece to learn manipulation techniques.*

Original image

Original image

Manipulated image

Images: *Hoh Rain Forest and Everglades National Park (manipulated composite)*

Goal: *Combine the soft silhouettes of the Hoh Rain Forest with the spectacular sky of the Everglades.*

Tools: *Magic Wand, Edit/Copy, Edit/Paste, Eraser, Layer/Flatten, and Image Adjust/Hue/Saturation*

Steps: *I used the Magic Wand tool with a tolerance of 50 to select the Everglades sky. I held down the Shift key to add more to the selection until I had selected everything I wanted. Using the Edit/Copy tool, I copied the selection, then used the Edit/Paste tool to layer the selection onto the Hoh Rain Forest image. I used the Eraser tool with an opacity of 20 to blend the Everglades sky into the Hoh Rain Forest. When I had achieved my desired blend, I flattened the image using the Layer/Flatten command. I then used the Image/Adjust/Hue/Saturation tool to increase the saturation 10 percent to heighten the color saturation of the combined image.*

Comment: *Changing the sky in an image is a valuable skill to master. Too often, a sky is washed out, dull, or just doesn't have the pizzazz you envisioned. Even though these images were taken at opposite ends of the continental United States, they were taken during the same time of day, so it was easy to combine them and make the image appear natural. This is an image that must be labeled "manipulated" if I ever submit it for publication.*

Original image

Original image

Manipulated image

THE NATURE OF NATURE

When you photograph nature, you may witness some scenes that will change you forever. While tracking radio-collared lions with a friend in South Africa, we encountered five lions surrounding a female giraffe. We watched for five hours as the giraffe defended her calf. Relentlessly, the lions moved closer, jumping on the giraffe's back until she gave in to the hungry pride, fleeing and leaving her calf behind. We returned that evening to find not the lions but the giraffe, licking the only remains of her calf, the hooves.

One of the greatest aspects of being a nature photographer is witnessing powerful moments such as this. Nature makes you laugh, it makes you cry, and it always gives you something new to discover and photograph.

Image: Male bluebird (manipulated)

Goal: Separate the bird more from the background, boost color, and increase eyespot. Even though I used a low f-stop of f/5.6, I captured too much detail in the background to completely separate the bluebird from it. The diffused light of the cloudy day saturated the color of the bluebird but not enough to add zest to the image. I also didn't get a bright enough eyespot to give the subject life. I wanted to change what I couldn't capture in the field to portray the bluebird as the regal creature that it is.

Tools: Magic Wand, Lasso, Select/Feather, Filter/Blur/Gaussian Blur, Image/Adjust/Hue/Saturation, and Dodge

Steps: I used the Magic Wand tool set to a tolerance of 35 to select as much of the background as possible. I then used the Lasso tool while holding down the Shift key to select what the Magic Wand wouldn't. I used Select/Feather set to 4 pixels to make the selection blend better. Using Filter/Blur/Gaussian Blur, I set the radius to 200 pixels to completely blur the background. I then selected the bluebird using the Magic Wand and Lasso tools. Using Image/Adjust/Hue/Saturation, I increased the saturation to 14. My final step was to select a brush size of 13 and use the Dodge tool with the Range set to Highlights and the Exposure to 20 percent. I dodged the eye until I achieved the eyespot I wanted.

Comment: If I had used a little fill flash and an f-stop of f/2, I could have achieved this outcome in the field without spending so much time on the computer.

Original image

Manipulated image

Original image

Original image

Manipulated image

Images: *Male bluebird and female bluebird (manipulated composite)*

Goal: *Combine the two images to make one image that looks natural.*

Tools: *Lasso and Eraser*

Steps: *I decided it would look more natural to import the male bluebird into the image of the female bluebird. I used the Lasso tool to select the male bluebird. Using the Edit/Copy tool, I copied the selection, then clicked onto the female bluebird image and used the Edit/Paste tool. Using the Move tool, I positioned the male bluebird where I wanted it. I used the Eraser tool to blend the male into the background by erasing the edges with an opacity set to 20 percent so that I could blend him in gradually. I then flattened the layer when I was happy with the results.*

Comment: *I built a bluebird house in hopes of attracting these beautiful creatures to my backyard. It worked. The bluebirds built a nest in the new house, and I was eagerly awaiting their first clutch of nestlings. I periodically took shots when the light was good, but my objective was to capture the male and female together. I thought the birds would be around all summer to give me ample photographic opportunities. One early Sunday morning in the middle of May, a pair of tree swallows staged a coup and seized the nest, tossing three sky-blue eggs to the ground below. I was so upset. I know this is part of nature, but nature is hard to take sometimes and is rarely fair. I picked up the three shattered blue eggs, but I never saw the bluebirds again. I did accomplish my goal of having the male and female in the same image—but not through the camera. This is an image that must be labeled as "manipulated" if I were to use it in a publication.*

CONCLUSION:
SOMETHING TO SHOOT FOR

The process of digital nature photography can be learned by just about anyone. Not everyone can be an Ansel Adams, but you can enjoy being part of nature and capturing its wonder. Now that you've read about various lighting conditions and photo techniques, and have an understanding of how your digital camera works, it's time to get your feet wet and go out on a photo shoot.

One of the hardest aspects of embarking on a photo shoot is deciding what to photograph—not for a lack of subjects but rather an abundance of them. So, I've included a list of photography assignments (in the box opposite) to give you a something to aim for. These will give you direction and encourage you to try different techniques, which will increase the variety of images in your growing portfolio. Pick a technique, read the corresponding section, then trek into the field to practice that technique.

As in sports, if you don't practice before the big game, you won't be at your best. Say you're hiking in Yellowstone National Park and you witness a pack of the reintroduced wolves taking down an elk, you don't want to have to take out your instruction manual to determine what shutter speed and f-stop to use. Confidence in your technique will ensure your success in getting the astonishing scene playing out before you.

On your initial photo shoots, take along a little notebook and write down exactly what you wanted to accomplish as well as what settings you used. Once you get accustomed to different lighting situations, you will no longer need to retrace your steps. Shooting will become second nature. Try different techniques, use various lenses, climb a wall or tree to capture a bird's-eye view, or lie on your back to capture a "turtle's-eye" view. Consider making short-term goals for your-

self, such as photographing a cardinal in the early-morning light. Then consider more substantial goals, such as creating an entire cardinal calendar highlighting all seasons of the year.

Remember that you don't have to travel to the far ends of our planet to capture superb nature shots. Your backyard and local park are briming with action. Please also remember to leave only footprints in your wake and take only digital images. We live in a fragile world. Every little thing you can do to preserve our Earth is essential, not only for future generations of humans but for descendants of nature's creatures, too. In fact, think of the positive environmental impact of using a digital camera: You no longer have your film developed by chemicals and there are no disposable packages or lousy photos to toss out.

Now go out in the field and take some pixel perfect pictures!

Gentoo penguins, Antarctica. Nikon D1X with Nikkor AF VR 80-400mm lens

Photographing animals is always a fun assignment to give yourself. I cropped in close on these penguins but still showed enough of their surroundings to provide the viewer with some information on their location.

ASSIGNMENT IDEAS

LANDSCAPES*

1. High f-stop ($f/11$–$f/22$) to obtain a high depth of field

2. Low f-stop (f-4.5–$f/2$) to obtain a low depth of field

3. Sheer lighting to show texture

4. Cloudy light to accentuate color

5. Silhouette to emphasize shape

6. Add some flare

* (use your tripod for every shot if possible)

MOTION

1. Stop action using a fast shutter speed

2. Blur action using a slow shutter speed

NIGHT SHOTS

1. Sunsets, underexposing for maximum color saturation

2. Long exposures of at least 1 second

ANIMAL PORTRAITS

1. Tightly cropped

2. Frontlit

3. Backlit

4. Action

5. Making the subject look powerful

6. Making the subject look vulnerable

DESIGN

1. Use the rule of thirds vertically

2. Use the rule of thirds horizontally

3. Draw the viewer in using one of the target zones

4. Compose a pattern without focusing on anything in particular

MANIPULATION

1. Combine two or more images to create one realistic image

2. Change the exposure and color to intensify an effect

3. Change a color image to black and white then to sepia, adjusting contrast and brightness as needed

GLOSSARY

aperture. An adjustable hole in the lens, referred to as an *f*-stop, that allows light to be captured by the camera.

aperture priority. A camera mode in which the photographer chooses an *f*-stop because he or she wants a certain depth of field. The camera then chooses a shutter speed to obtain a correct exposure.

autofocus. The camera function in which the camera focuses on the subject where the photographer is aiming. Many cameras allow the photographer to select the area in the frame where they want the focus to be.

aspherical lens. A high-quality lens produced to prevent a spherical image by adding multiple radiuses of curvature. If you're photographing a horizon that includes the ocean, this is the type of lens you'll want. Otherwise there will be a curve in the image.

bracketing. Taking a series of the same scene or subject in which you change the shutter speed or *f*-stop usually by half- or one-stop increments to capture various exposures.

buffer. Allows the photographer to capture multiple exposures without waiting for the image to be stored on the digital media.

bulb. A setting that allows the photographer to take as long an exposure as desired by keeping the shutter fully depressed.

cable release. A device that eliminates photographer shake; used when taking long exposures or when the photographer needs to be separated from the camera.

calibration. The adjusting of equipment so that the color balance is consistent from one item to the next. You would calibrate your computer monitor and printer colors so that they match.

charge-coupled device (CCD). A type of digital image sensor used by many digital cameras. The number of sensors, which form the imaging surface, determine how high the resolution will be.

CMYK. These are the basic colors used in ink cartridges: cyan, magenta, yellow, and black (K). Epson's new line of inks also uses a light cyan, light magenta, and light black.

color temperature. Calibrated in degrees Kelvin. Photographers use this when describing a cool or a warm scene. A sunny day at noon would have a color temperature of about 5500K. A lower temperature—about 3000K—scene has a warm light whereas as high temperature—about 7000K—has a cool light.

complementary colors. Pairs of colors that fall directly opposite one another on the color wheel (red and green, blue and orange, and yellow and violet). Complements result in maximum color contrast when used together in an image.

compact flash card, type one and two. A type of digital media used in many digital cameras to store images.

compression. Compression is a way to reduce the size of an image, which saves the digital media memory. The most common type of compression is jpeg (or Joint Photographic Experts Group).

depth of field. The plane in an image appearing to be in focus; it is controlled by the size of the aperture, known as the *f*-stop. A large aperture or *f*-stop of *f*/2 will have a limited plane in focus, whereas a high *f*-stop of *f*/32 will have a large plane in focus.

diffuser. Anything from a cloud of mist to a piece of wax paper that can disperse light to reduce contrast in an image.

digital zoom. Zooming in on an image by electronically cropping in on the subject. By contrast to an optical zoom, this is a simulated zoom feature found on some digital cameras. The quality of an image captured with a digital zoom is much lower than the quality of an image taken with an optical zoom.

electronic flash. A device used to artificially light a subject; it may be used directly with a camera's TTL (through-the-lens) metering system.

exposure. The final tonal quality of an image created by the combination of shutter speed, *f*-stop, and ISO setting.

extension tubes. Hollow metal tubes placed between the lens and the camera body to magnify a subject's size, allowing a photographer to obtain close-up images.

eyespot. An overexposed highlight in an animal's eye that gives a subject "life."

filters. Pieces of glass added to the end of a lens to create or intensify a lighting effect.

focal length equivalency. Photographers are accustomed to 35mm lenses, so manufacturers often state digital camera lens lengths using these specifications. For example, a 35mm camera lens with a focal length of 70mm may have a focal length equivalency of 105mm when used on a digital SLR camera.

graininess. The higher the ISO setting, the grainier an image will appear.

image resolution. Usually measured in pixels per inch (ppi), this refers to the amount of pixels per square inch in an image. The higher the resolution, the higher the quality of the image.

info-lithium. A rechargeable battery that tells you how much time is left on it before it runs out of power.

inkjet. A type of printer that creates an image by spraying dots of ink onto paper. A printer that sprays on a high number of dots per square inch has a high resolution; an example of this would be a printer spraying 2880 dots per square inch.

interpolation. The process of increasing or decreasing the size of an image by adding or subtracting pixels in an imaging program. Used when you want to print an image larger or smaller than your current resolution allows.

ISO (International Organization for Standardization, more commonly referred to as International Standards Organization) equivalency. Based on 35mm film ratings, this gives a value for setting the digital camera's sensitivity to light. Digital cameras usually start at around ISO 100 and may be adjusted to higher ISOs to increase the sensitivity to light depending on the camera make and model.

jpeg (Joint Photographic Experts Group). An image-file format that compresses an image to enable the storing of more images on a camera's digital media. The amount of compression can be adjusted depending on make and model of the camera.

LCD (liquid crystal display). A screen on a digital camera used for composing and viewing your images.

lens distortion. An inward or outward bending effect in an image caused by the quality of the lens. A plug-in can be purchased to combat this effect.

lens hood. A tube placed on the end of a lens to reduce flare caused by light directly hitting the glass of the lens.

macro lens. A lens that can focus within inches of a subject, obtaining close-up images that are even life-size or greater.

manual focus. A camera function that allows you to adjust the focus. This is very useful for close-ups, night shots, and action shots when the cameras focusing device may not work the way you want.

megapixel. One million pixels. A 2 megapixel camera will have a resolution of 2,000,000 pixels.

memory card reader. A device that accepts digital media and is used to rapidly download images onto a computer.

monitor resolution. Usually measured in dots per inch (dpi), this refers to the amount of pixels per square inch on a monitor screen.

NiMH (nickel metal hydride). A type of rechargeable battery with a constant voltage.

noise. Graininess in an image caused by using a high ISO number.

optical zoom. Altering the focal length of a lens, thereby altering the angle of view of the image. Resolution remains constant when you use an optical zoom.

overexposure. When an image or part of an image appears brighter than the photographer wanted it to appear.

pixel. Derived from a combination of the words *picture* and *element,* a pixel is a dot and is the smallest element that makes up an image. When all other aspects of a camera are equal, the camera with more pixels will produce a higher quality image.

pixelation. This occurs when the resolution in an image is too low for the size at which you are viewing it. You will see actual pixels of color in the image.

plug-in. An additional piece of software added to a program. For example, you can buy a plug-in to combat lens distortion.

ppi (pixels per inch). A measurement of pixel density that describes the final printed image. For example, a higher ppi of 300 will yield a higher quality image than a ppi of 150.

pre-flash. Used to reduce red-eye in a subject by closing the pupil down with a preliminary flash that goes on before the flash that is used to illuminate the image.

printer resolution. Usually measured in dots per inch (dpi), this refers to the amount of ink dots per square inch in an image. A printer with a higher dpi will produce a higher quality image.

recycle time. The amount of time it takes for a flash to charge to full power after it has fired.

red-eye. A red effect in a subject's eye that can be reduced or eliminated with a pre-flash.

retouching. Changing the appearance of an image after shooting to increase the quality of the image.

resizing. Changing the size of an image either by upsampling, which increases the size, or by downsampling, which decreases the size.

RGB. A common color profile of digital cameras and computers, which use the three additive primary colors of red, green, and blue. When these three colors are added together, they make pure white light.

shutter. The device in the camera that opens to allow light to be recorded.

shutter priority. A camera mode in which the photographer selects the shutter speed and the camera selects the aperture to capture the suggested exposure.

shutter speed. The amount of time the shutter stays open, letting light into the camera. A longer shutter speed will allow more light to be recorded whereas a fast shutter speed will allow less light to be recorded.

slave unit. A device that will cause another flash to fire at the same time as the camera's flash. This allows a photographer to use more than one flash without linking them together with cords.

slow synch. A camera mode in which the flash fires for only part of the exposure. This allows the photographer to have control over the exposure of the background.

stopping down. The increasing of the f-stop so that the size of the aperture is smaller, allowing less light to be recorded. The result is an increase of depth of field.

syncro-light. Using a flash and natural light to expose an image.

tiff (Tagged Image File Format). An image-file format. An images is usually shot as a tiff, and then the camera converts it to a jpeg to save digital media memory. You can open a tiff file, change the image, then resave it as a tiff file without losing any quality due to compression.

tone. The darkness or brightness of an image, caused by the intensity of the light source.

TTL. An abbreviation of the term through-the-lens, which is a system of metering a subject through the lens of the camera regardless of additional equipment attachments.

underexposure. When an image or part of an image appears darker than the photographer wanted it to appear.

USB. A Universal Serial Bus computer port, which allows for rapid transfer of data.

white balance. This is when a digital camera measures the color temperature of a scene, then adjusts it so that white areas in the image do not take on extreme color casts. The white-balance setting is set by the camera but can also be set by the photographer depending on the camera make and model.

wide-angle lens. A lens used to capture a broad view of the subject or scene.

working distance. The distance between the lens and the subject.

zoom lens. A lens with a variable focal length that is very useful in nature photography.

RESOURCES

MANUFACTURERS & RETAILERS

Adobe Systems, Inc.
(800) 833-6687
www.adobe.com/products
Manufacturer of Photoshop, Acrobat, and other software programs. Website offers in-depth product information and answers to frequently asked questions.

AircraftSpruce
(877) 4-SPRUCE
(800) 861-3192
www.aircraftspruce.com
On-line catalog with various items, including Tri-floTeflon lubricant. Order on-line, through mail-order catalog, or over the phone.

Apple Computer, Inc.
(800) 767-2775
www.apple.com
The website offers product and service/support information for all their computers and accessories. Apple retail store listing also provided.

B&H Photo
420 Ninth Avenue
New York, NY 10001
(212) 444-6614
(800) 606-6969
www.bhphotovideo.com
Retail store and mail order. Call or go on-line for a catalog. All equipment, both for digital and traditional film cameras, including used equipment.

Digi-Frame, Inc.
(914) 937-4090
www.digi-frame.com
Digital picture frames. Website provides nationwide lists of on-line and store retailers.

Epson America, Inc.
(800) 922-8911
www.epson.com
Manufactures printers, ink cartridges, scanners, paper/media, and software, and has a mail-order catalog. Go on-line to order directly or request a catalog, and for listings of authorized Epson dealers throughout the country.

Gitzo
www.gitzo.com
Manufacturer of tripods.

Lexar Media, Inc.
(510) 413-1200
www.lexarmedia.com
www.digitalfilm.com
Maker of removable digital media and card reader products, including SmartMedia cards, CompactFlash, Memory Stick, card and Memory Stick readers, and Image Rescue software.

Light Impressions
P.O. Box 787
Brea, CA 92822-0787
(800) 828-6216
email: LiWebsite@limpressions.com
www.lightimpressionsdirect.com
Mail-order catalog for archival matting, framing, and storage supplies.

Manfrotto
www.manfrotto.com
Maker of tripods, heads, and various photo accessories. The company website includes a listing of distributors.

Nikon Corporation
www.nikon.com
www.nikonusa.com
Maker of digital and conventional cameras, scanners, and other equipment.

Pelican/CPD Industries
(310) 326-4700
(800) 882-4730
www.casesbypelican.com
Manufactuer of waterproof equipment cases. See website to order.

RoadWired
(585) 334-6960
(877) 435-5679
www.roadwired.com
Maker of various equipment cases and photo bags. Order on-line or see website for list of retailers.

CAMERA MANUFACTURERS ON-LINE

www.canon.com

www.fujifilm.com

www.kodak.com

www.minolta.com

www.nikon.com

www.sony.com

DATA RECOVERY

DriveSavers Data Recovery, Inc.
400 Bel Marin Keys Boulevard
Novato, CA 94949
(800) 440-1904
www.drivesavers.com

ON-LINE DIGITAL PRINTING

dotPhoto
(609) 434-0340
www.dotphoto.com
Internet photo printing and image/sound archiving service. Website also offers helpful digital photography advice and tips.

ON-LINE DIGITAL PHOTOGRAPHY STORES

www.amphotoworld.com

www.bhphotovideo.com

www.bwayphoto.com

www.cameraworld.com

www.focuscamera.com

www.ritzcamera.com

ON-LINE DIGITAL PHOTOGRAPHY REVIEWS

www.dcresource.com

www.dpreview.com

www.imaging-resource.com

www.megapixel.net

www.steves-digicams.com

PHOTOGRAPHY MAGAZINES ON-LINE

Digital Camera
www.digicamera.com

Digital Capture Magazine
www.digitalcapture.net

Digital Photographer
www.digiphotomag.com

Outdoor Photographer
www.outdoorphotographer.com

PC Photo
www.pcphotomag.com

Popular Photography
www.popularphotography.com

Shutterbug
www.shutterbug.net

INDEX